I premiati dell'Accademia
1682-1754

Prize winning drawings from the Roman Academy
1682-1754

Accademia Nazionale di S. Luca – Roma
dicembre 1989 – gennaio 1990

National Academy of Design, New York
30 May – 2 September 1990

ACCADEMIA NAZIONALE DI SAN LUCA

I premiati dell'Accademia
1682-1754

a cura di
Angela Cipriani

testi di
Gerardo Casale, Dieter Graf, Riccardo Lattuada, Olivier Michel,
Antonella Pampalone, Stella Rudolph, Michael Tomor

QUASAR

PALMER MUSEUM OF ART
THE PENNSYLVANIA STATE UNIVERSITY

Prize winning drawings from the Roman Academy 1682-1754

edited by Angela Cipriani

catalogue by Gerardo Casale, Dieter Graf, Riccardo Lattuada,
Olivier Michel, Antonella Pampalone, Stella Rudolph, Michael Tomor

translation by Julia Triolo

QUASAR

© 1990 Casa Editrice Quasar s.r.l.
Via Quattro Novembre 152 – 00187 Roma

ISBN 88-7140-013-5

Printed in February 1990

FOREWORD

Jacopo Recupero
General Secretary
Accademia Nazionale di San Luca

The present exhibition represents a selection of the drawings awarded prizes in the competitions of the Accademia di San Luca between 1682 and 1754. The exhibit accompanies the appearance of the second volume of *Disegni di figura* (Figure Drawings 1702-1754), a series dedicated to the entries presented at the academic competitions from the 17th through the 19th century which are conserved in the historic archives of the institute. This series complements the two volumes of architectural drawings published in 1974.

The Accademia intends as well to publish the extremely interesting and almost completely unknown collection of terracotta sculptures, the competition entries of the young sculptors, thus putting at the disposition of scholars a corpus of material which in its present circumstances is not easy to study.

The choice of the drawings presented in the exhibition has been made from among works of the Seicento and Settecento which, though executed by youths and sometimes even adolescents, succeed in communicating the artistic climate of that period. The reason for this is that they depend upon the teachings and taste of the masters of the Academy which, it may be said (notwithstanding a few rare disagreements of the period), included the artists who were most esteemed and patronized during their epoch.

The competitors include (especially if they were foreigners) young artists who were already well established and who were determined to obtain the prestigious award and the recognition which it signified, a fact which confirms how much international authority the Roman institution enjoyed.

Perhaps to us, heirs of Romanticism who have given a negative connotation to the role of the Academy, judging it the gathering place of reactionaries, it will seem strange that in other periods the taste which it expressed, and the artistic methods which it imparted to the students were esteemed as *optimum*, and the great occasion of the conferring of the prizes was applauded and celebrated with great solemnity!

On the other hand, these youths who had done their best to enrich the works they presented with the style and taste of their accademic professors as well as of the celebrated Renaissance masters, thus abdicating, in a certain sense, their own personalities, immediately regained their freedom upon graduation as painters, sculptors or architects from the Accademia, and as "masters" of the profession, very shortly became themselves the dictators of taste, and the new teachers.

The cases are numerous: it is enough to compare the list of competitors with the register of the names of the academicians to gain an idea of how distinguished were the students later

deemed worthy to join the Accademia from which they had acquired the discipline, and even to occupy the aspired post of "principe" (principal) as, for instance, happened to the painters Charles-Françoise Poerson and Benedetto Luti.

Obviously not all of the creators of these drawings achieved fame or even notoriety; many apparently left only the graphic documentation shown here, and remained in the ranks of humble, correct professionals who authored the anonymous works of the 17th and 18th centuries.

After its residence in Rome, the exhibit will travel to the Art Museum of the Pennsylvania State University in the United States, in the hopes of contributing to the better understanding of our artistic civilization on the part of the young people of other institutions. An enterprise with the same scope was realized at Penn State in 1981 with the architectural drawings from the Accademia di San Luca. The organizer on both occasions has been Prof. Hellmut Hager of the Pennsylvania State University, whom we warmly wish to thank.

The works exhibited here have been examined and restored by the Istituto Nazionale per la Grafica for whose collaboration we express our gratitude. We are also grateful to the Bibliotheca Hertziana, Rome, where our entire collection of figurative drawings has been photographed.

The catalogue, under the care of Angela Cipriani, gathers the contributions of a group of Italian and foreign specialists: to the curator, and to the collaborators Gerardo Casale, Dieter Graf, Riccardo Lattuada, Olivier Michel, Antonella Pampalone, Stella Rudolph and Michael Tomor I wish to convey the thanks of the Accademia as well as my own, and to especially compliment them for having attempted to give a more precise definition to the less fortunate protagonists of these competitions who, though having lacked a documented history, in no way merited oblivion.

FOREWORD

Randy Ploog
Assistant Curator
Palmer Museum of Art
The Pennsylvania State University

In 1981, the Penn State Museum of Art organized an exhibition titled *Architectural Fantasy and Reality: Drawings from the Accademia Nazionale de San Luca in Rome. Concorsi Clementini 1700-1750*, which consisted of the prize winning entries from the Accademia's student competitions. The current exhibition, *Prize winning drawings from the Roman Academy 1682-1754*, is the figurative counterpart of its architectural precursor; representing the painting division of the Concorsi Clementini of 1682 through 1754. Like the earlier exhibition, this is the first time these drawings have been exhibited outside of Rome.

The availability of these exhibitions to Penn State, indeed their visits to the United States, are the direct result of the dedicated efforts of Hellmut Hager, Chairman of Penn State's art history department. Dr. Hager's intimate knowledge of the Accademia's collection, the Accademia's respect for him as a scholar and a gentleman, and his desire to bring original Italian art to Penn State are what made these exhibitions possible. I am grateful to Hellmut, not only for proposing these exhibitions, but for his invaluable assistance throughout the development of this exhibition and for accompanying me to the Accademia to arrange for the export of the drawings and the printing of this catalogue.

Dr. Hager hopes to instill his enthusiasm for Italian art in students by soliciting their involvement in these projects. Michael Tomor, graduate student in art history, with guidance from Dr. Jeanne Chenault Porter, associate professor of art history, researched four of the artists represented in this exhibition. My congratulations and appreciation go to Michael for his fine contribution.

I also thank the staff members of the Accademia Nazionale di San Luca for their generosity and cooperation. Dr. Jacopo Recupero, secretary general, and Dr. Angela Cipriani, archivist, are deserving of our gratitude for lending the drawings and arranging for them to travel to Penn State.

INTRODUCTION

Hellmut Hager
Head of the Department of Art History
The Pennsylvania State University

The figurative drawings in this exhibition were chosen from three time periods that can be considered of crucial significance for the historical orientation of the Accademia di San Luca and the development of the arts in the era of the Roman Late Baroque.

The first of these periods coincides essentially with the last quarter of the 17th century and is marked by the union of the Accademia di San Luca with the French Academy in 1676. The effect of this union on the Academy with regard to exchanges within the field of architecture has been intensively studied by Dr. Gil R. Smith, recent graduate of Penn State and now Professor at Ball State University in Muncie, Indiana, whose research provides a completely new understanding of the results and far-reaching repercussions of this momentous amalgamation.

Whether, and to what degree the hopes entertained by the painters and sculptors found their fulfillment at the time of the union with the French Academy, can be gleaned from the drawings on display and especially by consulting the catalogue of the exhibition, as well as the comprehensive catalogue of the Academy's entire collection of figurative drawings, mentioned above by Professor Recupero.

The second period under consideration is nearly identical with that of the pontificate of Clement XI (1700-1721) and his famous efforts to revitalize the activities of the Accademia by institutionalizing the sporadic academic competitions of the 17th century, which after 1702 became known as the "Concorsi Clementini".

Carlo Maratti, the leading exponent of the baroque classical movement, was consistently reelected *Principe* of the Academy from 1702 until his death in 1713. The appointment of Maratti, who, although a painter, held much in common with the artistic convictions of his predecessor in the late *Seicento*, the architect Carlo Fontana (though their incompatability on the personal level was notorious), guaranteed to the Academy a continuation of the classical orientation well into the 18th century. This was the case also because of Maratti's cooperation with Carlo Fontana's son, Francesco, who first represented Maratti as *Vice-principe* in October 1703, and on a permanent basis after 24 January 1706 when Maratti's health began to deteriorate. A baroque "classicist" like his father, Francesco seems to have been endowed with a more ductile character that facilitated his association with Maratti. (For an assessment of Carlo Maratti's tenure as *Principe* of the Accademia within the context of Clement XI's policies concerning the role of the arts, attention should be drawn to Christopher M. John's recent investigation titled "Papal Patronage and Cultural Bureaucracy in Eighteenth-Century Rome: Clement XI and the Accademia di San Luca", *Eighteenth Century Studies* 22, no. 1, 1988, pp. 1-23).

If one reviews the competition topics for the painters and sculptors the liberal attitude of Pope Clement XI becomes immediately evident. He obviously did not object to the fact that the vast majority of the *soggetti* assigned to the competing artists between 1704 and 1714 were chosen from the repertory of mythological and historical subject matter, with a special penchant for themes related to the early history of Rome. This preference with regard to the thematic choices had a certain tradition at the Academy, and is therefore not surprising. It is also consonant thematically with the inspirational quality of the fresco cycles of the Sala degli Orazi e Curiazi (and in the adjoining rooms) of the Palazzo dei Conservatori on the Capitol, where the award celebrations of the *concorsi* were staged as major events in the presence of cardinals and the nobility of Rome. Nonetheless this tolerance regarding the competition themes remains rather remarkable and is distinctive of the pontificate of Clement XI. On the other hand, the Pope did not hesitate to suggest topics of specific interest to him for the architectural competitions, and in 1713 even required the entire Academy – architects, painters, and sculptors – to celebrate in a cooperative effort the canonization of the four saints Clement had recognized on 21 May of the preceding year. A certain painting of these four saints appears to have been of great importance to him; it is described by Agostino Taja as present in the "museum" which Clement established in 1704 in the Appartamento di Pio IV and in the Belvedere of Innocent VIII. This facility was available as a resource to the Accademia di San Luca and, it seems, was also open to all other persons who had a legitimate interest in the subject. The collection comprised the models of the *Fabrica* (the building authority of St. Peter's); among them Antonio da Sangallo's model for the Basilica of St. Peter's, Michelangelo's model for the dome, and Juvarra's project for a new sacristy. The latter was preceded and inspired by the first class architectural competition at the Accademia in 1711. Of special interest to the painters and sculptors at the Accademia were many *bozzetti* by Bernini for sculpture to be cast in bronze.

Between 1713 and 1725 only one competition took place at the Academy (in 1716) and it was not until the third period under consideration – that of the successors of Pope Clement XI – that a genuine shift from profane to biblical subjects can be observed in the *soggetti*. At this time, after the death of Carlo Maratti in 1713 and of Carlo Fontana the following year, the Accademia was faced with the question of its future direction.

When the architectural competition drawings were shown at Penn State it was possible to observe that the traditional contrast between "Berninismo" and "Borrominismo" already attenuated after the death of the chief protagonists – especially in the second quarter of the *Settecento* – led to an overlapping of trends or even situations of cross fertilization of architectural styles. The question of an analogous polarization and eventual osmosis in painting and sculpture is more difficult to decide, especially since in the competitions of the painters and sculptors during the second quarter of the 18th century we do not find personalities among the entrants comparable in stature to Carlo Marchionni (first prize in the first class of architecture, 1728) or Bernardo Antonio Vittone (first prize in the first class of architecture, 1732). This is certainly commensurate with the situation in general under Clement XII (1730-1740) when architects like Ferdinando Fuga, Nicola Salvi, Alessandro Galilei and Luigi Vanvitelli were beginning to take the lead in artistic matters in Rome.

The painters at the Accademia were consistently very strong under the pontificate of Clement XI, with the major highlight in 1713, the above mentioned competition which is also remarkable because it attracted the conspicuous participation of outstanding foreigners, above all Cosmas Damian Asam from Bavaria (first prize in the first class), and William Kent from England (second prize in the second class). However, the level of

6

draughtsmanship remained remarkably high throughout the entire first half of the 18th century, as is demostrated by the drawings chosen for this exhibition. We are most fortunate to find this remarkably fruitful period in the history of the Accademia di San Luca brought to life for our enrichment for the first time.

Exhibitions like this one are always the product of many shared and combined efforts. I would like to thank Professor Jacopo Recupero, whose generous and enthusiastic committment made it possible for this show of figurative competition drawings from the Accademia di San Luca to travel to the Palmer Museum of Art at Penn State. This exhibit follows naturally and supplements our earlier show of the architectural competition drawings in 1981-1982. Such an occasion offers me the welcome opportunity to renew cordial experession of gratitude in the name of the Department of Art History to our friends and colleagues at the Accademia di San Luca, whose cooperation then and now is most warmly appreciated: Professor Angela Cipriani, Dr. Giulia de Marchi, and Mrs. Maria Grazia Castigliego. In addition I would like to congratulate Dr. Cipriani on her most effective editorial leadership and her successful gathering of a team of leading scholars in the field of Roman Late Baroque. They responded with admirable enthusiasm to her call for the production of the exhibition catalogue which we are proud to present at this time to our English speaking audience; this also in view of the very appealing and adequate editorial format the catalogue has received by the Casa Editrice Quasar in Rome. For the translation of the original Italian text I am grateful to Julia Triolo Gabrielli of the Department of Art History at Penn State.

Sanford Shaman, former director of the Palmer Museum of Art, was supportive of this exhibition project from the beginning as was Dr. Charles Garoian, acting director. I am particularly grateful also to Randy Ploog, curator of exhibitions, for his very dedicated and circumspective role in the realization of this exhibit at Penn State, and to Dr. Olga Preisner, curator of the permanent collection, whose high level of scholarship and strong support are ever present. I would also like to express my deep gratitude to Professor Jeanne Chenault Porter from the Department of Art History for her efforts to generate interest for our exhibition at Penn State, and for the guidance she provided for the entries that Michael Tomor contributed to the catalogue. Finally, I am most grateful to Dr. James Moeser, Dean of the College of Arts and Architecture, for his continued support of all the activities of the Department of Art History.

The opening of this exhibition happily coincides with the welcome appointment of Dr. Kahren Arbitman as the new director of the Palmer Museum of Art at Penn State. This exhibit is certainly an auspicious beginning for our continued cooperation and the sharing of exciting projects like this one, which will be a memorable and significant highlight for our University's scholars and students, as well as for the entire community.

INTRODUCTION

Angela Cipriani
Curator of the Archivio Storico
Accademia Nazionale di San Luca

The 77 figure-drawings here presented have been selected from the more than 350 extant in the Archivio Storico dell'Accademia Nazionale di San Luca (Historic Archive of the National Academy of St. Luke) which document nearly a century of the Accademia's educational and promotional activities, from the mid-17th to the mid-18th century. From 1663 until the Unification of Italy, the Roman Academy of Painters, Sculptors and Architects (founded in 1593), held competitions at various intervals for aspiring young artists. Evidence of these comes down to us in the entry drawings which were rewarded first, second or third prizes by the academic judges. This is an extremely rich, though very little known, corpus of material.

As it did fifteen years ago for the architectural drawings, the Accademia has now undertaken the publication, in three volumes, of this significant source of figure-drawings. The present exhibition, originated at the Accademia di San Luca, Rome, and brought in to being through the collaboration of that institution together with the Pennsylvania State University, University Park, Pennsylvania (U.S.A.) intends to highlight the various possibilities offered by this material from both a documentary and a critical viewpoint, through a preliminary sounding by specialists in the subject. The chronological limits have been imposed by the first two volumes of the archival inventory already published. The competitions for young artists held between the late 17th and first half of the 18th century strongly reflect the evident will of the Accademia to represent itself as the artistic center of Rome and of Europe. The Papacy, by means of the concrete financial support it offered the Accademia, conditioned its the direction and choices, and therefore made use of it as a political and cultural instrument. The Accademia's union with the French Academy in 1676 was therefore an action with a double significance – political as well as cultural. The appointment of Le Brun or Errard as President, and the awarding of prizes to young French artists were thus tied to the Pope's intention of maintaining good diplomatic relations with the French King. The Accademia attempted to establish the classical style as a model not only for young Italian artists, but also for the young Germans, Poles, Britons and others who came to Rome to study art. The common denominator for all was the assigned theme which the young artists developed over long periods of time (from three to nine months) in their own studios and in the workshops of their masters, the great artists of the period, who in all probability offered lavish advice as well as concrete suggestions. It often happened that these same masters were then called upon to judge the drawings, as official representatives of the Accademia. The young people who participated in these competitions had to be enrolled as students at the

Accademia; that is, they had to attend the weekly classes, and select a master from among the academicians to whom their work would be submitted. Academic teaching during these decades consisted in study from the model. Classes were held from October through May on weekday mornings, and were followed by theoretical lessons in perspective, anatomy and architecture.

The choice to enter the competition class was completely free. The third class, reserved for the youngest students, required a copying exercise which would demonstrate the presence of the basic talent necessary for the student who wished to embark on such an unusual career. Many young students obviously interpreted this as an occasion for displaying their own skill with a view to a profession as copyist from the antique, or in art dealing. Students in the second class were given the task of illustrating a given theme, one carefully chosen so that the composition would not require excessive articulation or crowding with figures. Finally, the first class saw artists who were already fully developed competing for first-place recognition on the list. Once awarded this ultimate prize, the artist was no longer eligibile to compete within the Academy, but the honor represented an official indication for the buying public. The drawings presented on the occasion of the competition tended to be actual 'paintings' on paper, far more finished technically and much larger than the usual studies or sketches. This large size was required by the same regulations which imposed the "sheet of open papal paper" both for the drawings and bas-reliefs. Only the architectural drawings were excluded from this restriction because of their particular exigencies.

The Accademia found itself obliged to establish a regulation size, because before the late 17th century when the rule went into effect, the entries were submitted on sheets of varying size. At the same time, in the notable dimensions permitted by the new rule the peculiarity of these test pieces was implicitly recognized. Here the specific pictorial ability, and hence, skill with color of the individual artists had to be translated into a graphic medium, because of the acclaimed preeminence of Drawing in the formation of each artist.

The definition of the size of the sheet was one of the many precise rules that the Accademia established in 1702 through the efforts of its secretary Giuseppe Ghezzi, and continually revised with the intention of guaranteeing an absolute impartiality in judgement. This gave further emphasis to the fact that success in the competitions would necessarily ensure universal acclaim for the winner.

At the beginning of the second half of the 17th century the academic competitions were extremely similar to those which had taken place in the preceding decades under the auspices of the Barberini family and their circle. Their subsequent opening to a broader public and the increasing importance assumed by the prize-giving ceremony – during which, from 1682, expecially conceived medals were presented to the winners – transformed these competitions by the end of the century into events with important political ramifications. In 1702, Clement XI entrusted Maratti with specific revenues which confirmed the Roman Academy's financial autonomy, and one almost has the sensation that Academy as a whole had defined a permanent artistic creed. Carlo Maratti, appointed when he was already quite aged, was the Perpetual President; because of the latter's advanced age, the architect Francesco Fontana was named vice-president to assist with the most demanding duties. But the real organizer of the Academy's affairs was the tireless secretary Giuseppe Ghezzi.

The careful organization of the competitions was both simple and effective. The themes, chosen for painting and sculpture by Ghezzi during the first decade of the century, and for architecture by Fontana, were proposed to all three classes months before the date when

the work was to be submitted. Once the entries had been collected, the young contestants were summoned to perform an extempore test piece, developing a theme given on the spot, which would prove the authorship of the works entered in the competition. The entries, like the extempore works, were signed only by the secretary, and theoretically the judges made their choices without knowing the names of the competitors.

Interference and appeals must have been numerous and therefore to guarantee the seriousness of the extempore test piece, the materials were furnished by the Accademia itself. But by 1710 a substantial change in the juridical formalities had occurred, establishing that the votes cast by the judges for the first, second and third prizes had to be made, without exception, on special voting papers.

The young contestants, while often direct pupils of masters who were also academicians, were perfectly aware of the stylistic choices most likely to be approved by these same accademic masters. As the copying of Raphael, Michelangelo and Bernini was certainly the basis of their Roman training, it is therefore not surprising that throughout these competitions it was classicism, even if expressed through various interpretations of Maratti'a teachings, which won the final victories in this Roman environment.

It is interesting to note how the regularity of the competitions of the earliest years of the 18th century, was not even disturbed in 1706, the year of Maratti's effectual retirement from active duty, by the introduction of several formal innovations whereby decisions regarding the Accademy would no longer be made by that body, but by the Pope himself. Thus it was Clement XI who nominated Fontana as Vice-Principe, and who overturned Ghezzi's decision to suspend the third class.

As it was designed, however, the mechanism of the Accademia's competitions continued to function perfectly, as an annual event, while Maratti was alive, except for the unique interruption in 1712 for the magnificent quadruple canonization, which polarized the attention of the Papal court. The themes assigned were usually taken from Roman history, and in particular from Titus Livy. Instead, in 1713 in order to celebrate the anniversary of the multiple canonization of 1712, religious subjects from the lives of the four saints were assigned. And in the competition immediately following, of 1716, various themes on the hoped-for triumph against the infidels were given.

The deaths of Maratti (1716) and then of Ghezzi (1721), and changing political and economic conditions gradually required a redefinition of identity on the part of the Accademia.

The competitions until the middle of the century were numerically few, held only during the years 1725, 1728, 1732 and 1739, 1750 and 1754. In the Holy Year of 1750 and again in 1754 there was an attempt to renew the regularity of the competitions with the general intention of renewing the Accademia as a whole, beginning with the competitions.

The selection of the graphic works in this exhibition has been made to provide a panoramic view of the quality of this material, a view which contributes to a more complete understanding of the complex and variegated reality of Roman culture between the 17th and 18th centuries. Italian and foreign artists confronted the same themes, in the same temporal and environmental conditions, but their final works clearly emphasize the differences in their training and culture, as well as illustrating their personal abilities.

The catalogue which follows presents the stimulating result of research into these hitherto unknown works of art. The quality of the entries is owed to the enthusiasm and expertise of the scholars who have applied themselves to their task. In the individual entries they have offered critical perspectives and have indicated problematic areas. Owing to their careful methodology they have been able to recognize, in other collections, first drafts and variations upon the drawings created by the re-working of expressive formulae already

approved by the great masters. From the evidence of the wide influence of such formulae, it can be assumed that a public display of the competition entries was held already by the late 17th century. A comparison of the competition pieces with other, usually less 'finished' versions of the drawings, has further contributed to an understanding of their ideational origin and evolution. In many other instances, these competition drawings, works by almost unknown artistic personalities, form a solid and important basis for future study, for often they testify to juvenile, ideological or formal artistic choices which may clarify solutions adopted by these same painters many years later.

Thus, both within this catalogue and exhibition, an invitation is offered to consider these drawings from varying points of view and to read them as an autonomous voice within the complex culture with which they are contemporary, a culture which today is very much the focus of lively debate. It should finally be remembered that the drawings remain an invaluable and unique document by which the importance of the Accademia di San Luca within the artistic culture of 18th century Europe may well be evaluated.

Catalogue

Names of contributors

Gerardo Casale (G.C.), nos. 7, 8, 9, 10, 12, 13, 19, 20, 37, 38.
Dieter Graf (D.G.), nos. 21, 22, 23, 24, 28, 34, 35, 44, 45, 48, 49, 59, 60, 65, 68.
Riccardo Lattuada (R.L.), no. 53.
Olivier Michel (O.M.), nos. 1, 2, 3, 5, 6, 26, 33, 36, 40, 41, 64, 66.
Antonella Pampalone (A.P.), nos. 11, 14, 16, 17, 18, 31, 32, 47, 51, 52, 69, 70.
Stella Rudolph (S.R.), nos. 4, 15, 25, 27, 30, 39, 42, 46, 50, 57, 61, 62, 63, 67.
Michael Tomor (M.T.), nos. 54, 55, 56, 58.

The catalogue entries by Stella Rudolph were submitted in English by this same author.

1 CHARLES-FRANÇOIS POERSON (Paris 1653 – Roma 1725)

Alexander the Great presents Campaspe to Apelles

1673, First Class of painting, second prize, inv. A.28.
pen, watercolor and white chalk, mm. 535×760.
at the top on the right: *D = 1*; at the bottom on the left: M. *Parson francese 33*; at the bottom on the right: *B 20*.

There were at least five French contestants who took part in the competition of the Accademia di San Luca in 1673: two scholars of the king who had just arrived in Rome from Paris, Charles-François Poerson and Jean Tortebat, Louis Dorigny who was on the point of breaking away from the Royal Academy of Paris, and two unknowns, "Monsù Plancet" and "Monsù Dubusson" (Disegni, I, p. 8 and p. 49).

It was Poerson who obtained the highest recognition among the French though he was awarded only the second prize. This Parisian artist had learned the first principles of art from his father, a painter who was originally from Lorraine, and had been a pupil of Vouet. Charles-François entered the atelier of Noël Coypel, who compensated the youth for the modesty and calm acceptance he showed on his defeat in the Grand Prix by taking him to Rome when he was appointed Director of the Académie (C.D., I, 1887, p. 39 and P.V.A.R., I, 1875, p. 400).

In 1673 at least nine prizes were awarded, as the quality of the works submitted was so high. In fact on this occasion two distinct schools confronted each other: the Italians chose to compose several figures on a grand scale in a simple design, while the French displayed their virtuosity in assembling a mass of small figures within a grandiose setting. Giuliano Moretti, who took the first prize with a drawing notable for its sobriety and classicism, has left posterity no further examples of his work. Poerson, in contrast, succeeded in grouping together some thirty figures without in any way endangering the immediate legibility of the narrative. He was careful to include several citations from Raphael, but above all worked according to a spirit derived from the style of the large canvases which Le Brun with more theory than spontaneity, had dedicated to the histories of Alexander.

Upon his return to France, Poerson was admitted to the Académie Royale in 1677, and became a member in 1682, with an allegory dedicated to the "Union of the Academies of Rome and of Paris" (P.V.A.R., I, 1878, p. 214 and Disegni, I, p. 9). He then followed the *cursus honorum*, becoming successively associate professor, professor and councillor, before returning to Rome in 1704, to succeed René-Antoine Houasse in the post of director of the Academie de France. He became an academician of the Academia di San Luca in 1711, and in the same year received the Knight's Cross of the Order of Our Lady of Mount Carmel and of St Lazarus from the King (C.D., 3, 1889, p. 454). In the following year the Arcadian Academy welcomed him with the name of Timante Cochiano (A.M. Giorgietti Vichi, Rome 1977, p. 251). He was still vice-Prince with Maratta in 1713 and Principal of the Accademia di San Luca during two periods, from 1714 to 1718 and from 1721 to 1722. He then abandoned grand compositions to dedicate himself to portraiture, in which he excelled, and to half-length portraits, which he sold primarily to foreigners.

O.M.

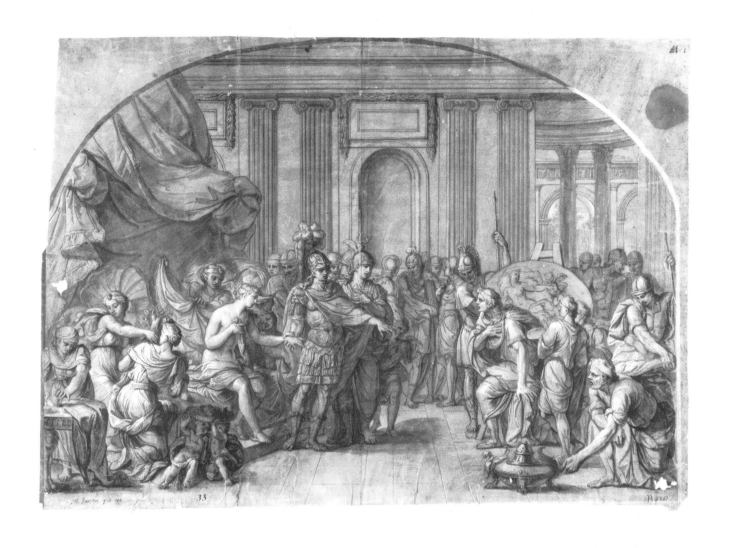

2 LOUIS DORIGNY (Paris 1654 – Verona 1742)

Alexander the Great presents Campaspe to Apelles

1673, First Class of painting, fourth prize, inv. A.30.
pencil, pen, watercolor and white chalk, mm. 560(580)×985 (1000).
towards the bottom on the left, on the carpet: *Monsieur Ludovico Dorignij*; at the bottom on the right:
B. 300 34.

Louis Dorigny's humiliation must have been complete when he found himself with the fourth prize in the competition of 1673 of the Accademia di San Luca. He had raised a tremendous stir when awarded only the second prize in the Grand Prix of 1671 and again in 1672; he had counted on placing first in order to be sent to the Académie de France in Rome (P.V.A.R., I, 1875, pp. 358 and 388). One of his most direct rivals, Charles-François Poerson, attained second place in the Academy of Rome competition. Poerson had already had the King's scholarship, even though he had only placed fifth in the Paris competition of 1671 (P.V.A.R., I, 1875, pp. 358 and 400). Such an injustice was really too much for the nephew of Simone Vouet!

Born in Paris in 1654, he was taught by his father, the painter and engraver Michel Dorigny, and then by Charles Le Brun. Mariette, in his note on the *Abecedarian* of Father Orlandi (P.J. Mariette, 1854, vol. 2, p. 115), praises Louis's capacity for invention, and the fluency of his intelligence, which compelled him to look for effects and compositions which were singular and lively.

His drawing corresponds fully to this judgement and for this reason the judges surely must been placed in an uncomfortable position. Behind its academic exterior one cannot but discern a strong personality given to excesses of immagination. Smoke screens and apparitions transform the story into a fantastic tale cloaked in the manneristic charm of the Fontainebleau school. The sensual fascination of his Campaspe, draped upon a sumptuous couch, is much closer to Sodoma than to Raphael, from whom he has even neglected to extract the obligatory citation.

Dorigny remained in Rome for four years before establishing himself in Venice and then Verona, where his abilities as a decorator and fresco painter blossomed (N. Ivanoff, 1963, pp. 114-152; G. Menato, 1967, pp. 152-172).

In 1704 he applied for membership to the Academie Royale of Paris but suffered another setback. Fortunately, as the Abbot of Fontenay noted in his *Dictionnaire des Artistes* "the esteem of foreigners compensated Dorigny for the indifference and perhaps jealousy of his compatriots" (L.A. de Fontenay, 1776, I, p. 522). In fact we subsequently find him working in Vienna, in Prague and again in Verona, where, married to the daughter of a goldsmith, his tormented but fruitful life came to an end in 1742.

O.M.

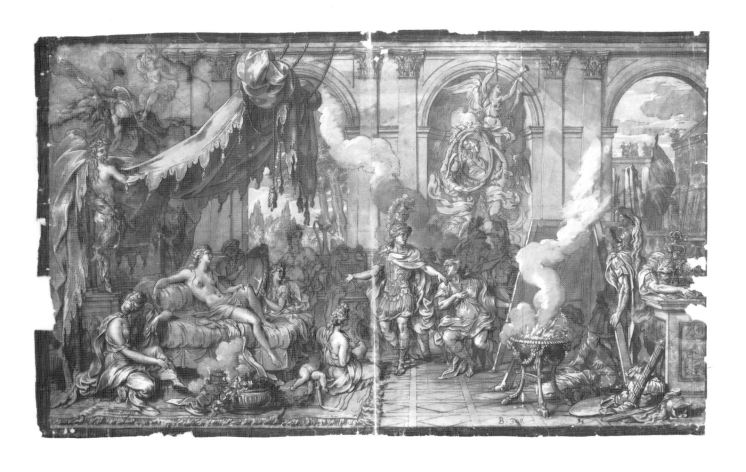

3 LOUIS de BOULLOGNE (Paris 1654 – 1733)

Alexander the Great cuts the Gordian Knot

1677, First Class of painting, third prize, inv. A.38.
pen, pencil, watercolor white chalk, mm. 700×820.
towards the bottom on the left, on the plinth: *Ludovico Bologna Terzo Premio 1677 36 41*; on the reverse, at the bottom: *N 45 A..*

Louis de Boullogne the Younger is without doubt the best known of a respected family of artists. His father, Louis the Elder (Paris 1609 – 1674), a good painter and excellent copyist, was one of the founders of the Académie Royale of Paris. He had undertaken his journey to Rome around 1630. His eldest son, Bon (Paris 1649 – 1717) was one of the earliest pensionnaires of the French Academy, where he worked under the guidance of Charles Errard, obtaining the first prize in the first class of the competition of the Academia di San Luca in 1672, with "Medea kills her children". The second born, Louis, followed in the footsteps of his brother and in 1673 won the competition for the scholarship established by the King (P.V.A.R., 2, 1878, p. 7). He arrived in Rome in 1675 (A. Schnapper – H. Guicharnaud, p. 9) and, as his first work, copied the *School of Athens* and the *Disputa* on a life-size scale (C.D., I, 1887, p. 67). Charles Errard wrote to Paris in December 1676: "He is gifted with intelligence and ability, and applies himself to study and to work with greater diligence than any of companions" (C.D., I, 1887, p. 63).
In 1677 he entered the competition of the Accademia di San Luca, which in that year was totally dominated by the French. It was Charles Le Brun, as Principal, who selected the subjects, while Louis XIV offered the medals (F. Boyer, 1950, pp. 127-128 and Disegni, I, p. 8). Louis de Boullogne obtained only third place, behind Arnoldo de Vuez di Saint Omer and Alessandro Ubeleskj, whose drawing is now lost. It is possible that the Italian judges wanted to assert their independence by awarding a prize to an artist who was not directly connected to the Academie de France. According to their taste, they may have been especially moved by the monumentality given the characters. In depicting Alexander in the act of cutting the Gordian knot, Louis de Boullogne created a dreamlike composition animated with a crowd of astonished characters. The placing of the groups is carefully considered, without endangering the precision of the details. Everything is enlisted to increase the solemnity of the occasion. A first draft of this theme exists in a sheet in the Hamburge Kunsthalle (studied in a forthcoming work by H. Guicharnaud). Louis de Boullogne, who had excellent reasons for being proud of this work, recalled it on his return to France in the composition of *Augustus orders the Doors of the Temple of Janus to be closed*, his 'morceau de réception' for the Academy of Paris in 1681 (the picture is in the Museum of Amiens, the preliminary sketch in the Art Museum, Rhode Island School of Design, Providence). Here one finds the same general lay-out, the same small figures against the backdrop of an enormous portico, the same breadth of a monumental landscape, all very much in the style of all Poussin. Over time he would acquire greater freedom in the drawings themselves but until this point he defines his figures with a firm stroke which recalls the assurance of Le Brun or, even more so, of Vouet, if not of Annibale Carracci (A. Schnapper – H. Guicharnaud, p. 8).
Replete with recognition, having passed through all the stages of the academic *cursus honorum*, he stopped painting around 1715 to dedicate himself entirely to drawing.

O.M.

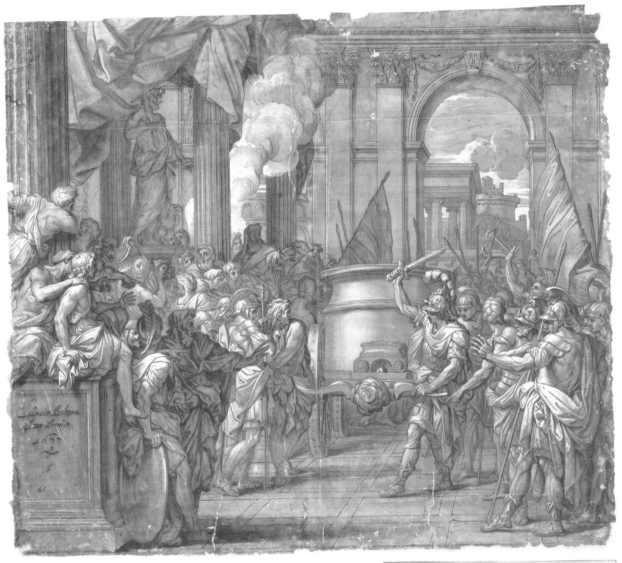

Hamburger - Kunsthalle

19

4 BENEDETTO LUTI (Firenze 1666 – Roma 1724)

Moses receives the offerings for the Construction of the Tabernacle

1692, First Class of painting, first prize, inv. A.87.
pen and brown ink, black and white chalk on twelve sheets, mounted on a single sheet (some tears on the borders and in the upper central portion), mm. 720×1170.
Inscriptions: on the upper right margin, "+", and on the *verso* in the lower right corner, "N. 55A".

On 2 September, 1691, some six months after his arrival in Rome, Luti wrote to his master Anton Domenico Gabbiani in Florence: "Here in Rome they have revived the ancient custom they used, as You already know, of awarding prizes in a competition; and for the subject of the first class they have given when God commands Moses to build the Tabernacle; and they require the representation of when the populace contributed, each according to his means, to the construction of the said Tabernacle. I am somewhat of a mind to enter the competition, but I shall not be so bold as to do so without your leave. I am composing the idea to my satisfaction and from Baldesi you shall hear in what manner, and should you not approve of my competing, I shall then continue it for my own study" (Bottari-Ticozzi, II, 1822, n. XXX, p.73). In another letter, dated 26 January 1692, Luti informed his master of the happy outcome of the *concorso*, adding a few comments on the other contenders: "[...] yesterday morning they had all the participants execute a *prova*, and after luncheon the judges met once again to decide who merited the highest recognition, and I have been awarded, by the grace of God, the dignity of the first of the first prizes, since in the first class five drawings were chosen, which is not a very usual occurance [...]. Tomorrow at twenty-one hours the ceremony of the prize-giving will take place with cardinal Barberini officiating; and it is said that all will be performed with grand pomp, with cardinals and other great gentlemen invited [...]" (ibid., n. XXXI, pp. 74-75).
A.M. Clark published this drawing in 1963 (indicating also the existence of the extempore *prova*, which is now lost) with a brief comment that pointed out the lingering Tuscan taste it expresses and the inappropriateness of the label of "follower of Maratti", customarily attached to Luti but hardly applicable to the author of this exquisite specimen of the Florentine Late-Baroque. Even its few academic passages (for example, the woman reclining in the foreground) derive from the figural repertory of Gabbiani, who had already been influenced by Maratti during a Roman sojourn years earlier, and the beauty of certain heads also reveals the imprint of artists like Volterrano (the youth riding a camel) and Pignoni (the kneeling woman holding an urn and the standing figure next to her), whose work had evidently been studied with care by Luti in Florence.
This thronged panorama is disposed with what might be termed a symphonic ordering of parts in a type of pattern that also stems from Luti's Florentine experience. Another even larger version of the subject, recently illustrated by G. Sestieri (1983-84, figs. 1 and 3; London, coll. Kate de Rothschild), doubtless represents a first attempt by the artist to tackle the assignment. That composition is conceived in the current Roman mode, with figures ranged in the foreground so as to produce a strip of large, shadowy forms in a rather indistinct setting. In the measure that such an arrangement consented a close-up view of details, it also compressed the narrative to the point of incoherence.
If this is the *pensiero*, as is probable, that Luti was preparing in September, it may be supposed that he discarded it before the end of 1691 in favour of the drawing here exhibited, in which the multiple episodes are scaled in depth in a manner that enabled him to sort them out according to subtle gradations of modelling, that fade to the lightly sketched hill teeming with diaphanous figures. By such means Luti succeeded in clarifying each of the phases of the Biblical story, leading from the caravan of donors on the left to

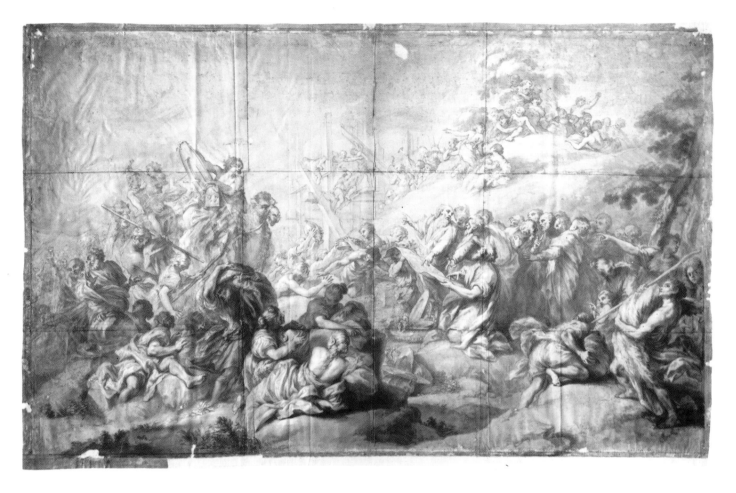

the group clustered around Moses, discussing the plans for construction, and concluding with the building already underway on the heights. Luti thus contrived the scene in zig-zag strophes of figures on the terrain in a scheme that echoes the atmospheric strata projected in the frescoes that his master, Gherardini, Pier Dandini and others were then painting on the ceilings of the Corsini Palace in Florence. The novelty of this solution within the Roman context where Luti found himself becomes evident when it is compared with the other prize-winning drawings that represent the schools of Baldi (G.A. Martinetti, Disegni, I, A.88, first prize *ex aequo*; F. Luzzi, Disegni, I, A.92, third prize *ex aequo* with A. Aleri, Disegni, I, A.91) and Ferri (A.Barigioni, Disegni, I, A.90, second prize).

For its sheer quality, scope and assurance in the use of a composite technique, this drawing occupies a place of honor in the Academy collection and remains a significant early document of the artistic maturity of Luti who portrays himself with the sheet in hand, on the right margin. As little as two years later he was elected a member of the Academy, which conserves his later *Self-Portrait* (Incisa della Rocchetta, 1979, cat. 142, fig. XII), and after the turn of the century he became one of the finest interpreters of the Rococò in Roman painting, especially in his small canvases and delicate pastels.

Bibliography: A.M. Clark, 1963, p. 59, fig. X; L. Salerno, 1974, p. 341, fig. 19; G. Sestieri, 1983-84, p. 283, fig. 2

S.R.

5 ANTONIO BALESTRA (Verona 1666 – 1740)

The Fall of the Giants

1694, First Class of painting, first prize, inv. A.100.
pencil and tempera, composed of four sheets mounted together mm. 1016×726.
at the bottom: *73 Prima Classe della Pittura M. Antonio Balestra veronese. Primo premio 1694 A. 18.*

Four candidates fiercely contested the prize in the competition of 1694 on the difficult theme of *The Fall of the Giants*. Antonio Balestra was declared the winner, together with Felice Nardi, a painter from L'Aquila. Of the latter there is no further information other than that in 1704 he painted the portrait of Pope Clement XI (Thieme-Becker, 1931, 25, p. 344).

Born into a rich merchant family from Verona, Antonio Balestra (M.A. Novelli, D.B.I., 5, pp. 547-549) was already 28 years old when he entered the competition. He had received a careful education, beginning with literary studies, followed by an artistic apprenticeship in Venice with Antonio Bellucci, and then in Rome at the school of Carlo Maratta. His decisively classical taste pushed him towards the study of Raphael, the Carracci, Reni and Domenichino, though he did not fail to make a journey to Naples as well, where he obviously preferred Lanfranco to Giordano and Solimena. His friends in Rome were the Florentine Benedetto Luti (Luti in 1695 painted Balestra's portrait, cf. "Bollettino d'Arte", 1963, pp. 363-364), and Francesco Redi. Together "they opened, at their own expense, in the palace of Campus Martius an academy of the nude, which was attended by a large group of young scholarly painters and sculptors" (L. Pascoli, 1981, p. 123).

This course of study and his artistic choices contributed to make him an ideal candidate for the Accademia di San Luca prize of 1694 which was the crowning achievement of his Roman period. The drawing's unfortunate state of preservation consisting of four sheets mounted together, certainly damages its presents legibility. However, the jury must have been impressed by the simplicity of the broad shaped movement which leads the eye from Jupiter who is throwing the thunderbolts, to the final accumulation of supine giants, in a skillfully organized whole in which the neutral areas of the rocks alternate with the superimposed nude bodies, to great effect.

Upon his return to Venice, this classicism gained him much recognizion, and he had numerous pupils, including Pietro Rotari and Giambettino Cignaroli in Verona, Rosalba Carriera, Giuseppe Nogari and Pietro Longhi in Venice; he even succeeded in influencing Piazzetta and Tiepolo. Nor did the Accademia di San Luca forget its brilliant pupil, for he was elected "by all votes, Accademician of merit" on the 30th September 1725 (A.S.L., vol. 48, f. 131 v.). But the distance from Rome eventually affected the classical purity of his style and the rococo influence of painters like Sebastiano Ricci and Antonio Pellegrini is already visible in the *Blessed Virgin with St Andrew and St Gregory* which Cardinal Antonio Maria Querini sent to the church of S. Gregorio al Celio in 1735.

O.M.

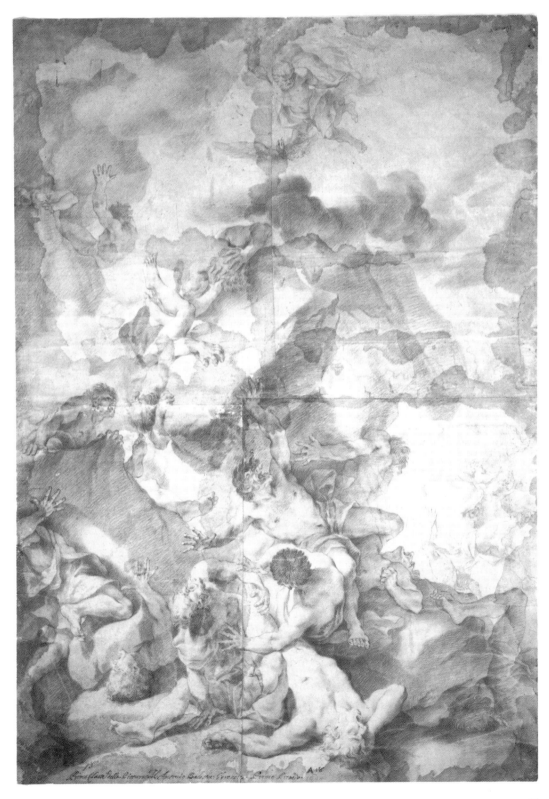

6 ANTOINE RIVALZ (Toulouse 1667 – 1735)

The Fall of the Giants

1694, First Class of painting, second prize, inv. A.103.
pen, pencil, watercolor and white chalk, composed of several sheets mounted together mm. 1245 (1260)×630(730).
at the top on the right: 3; at the bottom: *Prima Classe della pittura 2s premius. 74*; in pencil: *Marcus Ant.us Rivalz Tolosanus*; on the reverse, at the bottom on the right: *N.o 61 A*; at the top on the left: *Marco Antonio Rivalz B 24*.

Antoine Rivalz, winner of the second prize behind Antonio Balestra and Felice Nardi, was certainly not a novice. Born in Toulouse in 1667, son of a painter of some renown, Jean-Pierre Rivalz, he was taught by his father and by Raymond Lafage, both of whose work had been enriched by a period of residence in Rome during which the latter took a first prize, in 1679, at the Accademia di San Luca (Disegni, I, 1988, pp. 8, 69). The younger Rivalz underwent his apprenticeship in Paris, then spent some time in Marseilles, and finally came to Rome where, soon after his arrival, he entered, also with success, the competition of the Accademia (R. Mesuret in B.S.H.A.F., 1954, p. 94-97).

Toulouse historians (*Biographie toulousaine*, vol. 2 Paris, 1823, p. 302), concerned to explain why their greatest painter did not take the first prize, concluded that the young man with his head full of the verses of *Hesiod's Theogony* (v. 397 ff), added the figure of Victory, daughter of Styx, who fights at the side of Jupiter to Ovid's description (*Metamorphoses*, I, 3); the judges, bewildered by this anomalous feature which was not present in the other drawings, placed him only second. But the tale becomes even more complex: at the moment of the formal presentation of the prizes, which for the first time took placed in the Campidoglio, a discussion arose between Cardinal Giovanni Francesco Albani and the young painter. As it was not possible to alter the positions already decided, the future Clement XI therefore awarded him with a prize for poetry... of which evidently no traces are to be found in the archives of the Accademia di San Luca! The four contestants of that year were of an exceptionally high quality and an impartial judgement was difficult. As was their custom, the judges most probably rewarded the greatest clarity of composition and above all the greatest figural monumentality, characteristics evident in the two works which took the first prize *ex aequo*. The Michelangelesque quality of Rivalz's piece therefore worked against him. The multiplicity of figures, which forced the artist to work in greater detail, did not however impede the precision of his stroke. A great virtuosity is already apparent in the grouping of the people, in the search for constructive lines, and the subdivision of the lighting. A juxtaposition of Rivalz's entry with that of the fourth prize winner, Antonio Creccolini, leaves no doubt as to the Frenchman's superiority.

Moreover, Antonio Rivalz was so taken with his Roman composition that when in 1727 the canons of the cathedral of Narbonne asked him to execute a *Fall of the Rebel Angels*, he re-adapted the same composition. And in his *Self-portrait* in the Augustinian Museum in Toulouse, he presents himself in the act of drawing the same composition (P. Rosenberg, 1975, pp. 182-185). Proud of this success, the painter kept a preliminary drawing which his own son, the Cavalier Pierre Rivalz, also a painter, lent in 1779 to an exhibition of the Academy of Toulouse (R. Mesuret, 1972, p. 357, n. 3763). "The air of Rome was more favourable to him than that of Paris" wrote Chennevières and in his "obsession with the ancient" and wishing to feel "more Latin" the painter added «Marco» to his name, although he abandoned it upon his return to France.

O.M.

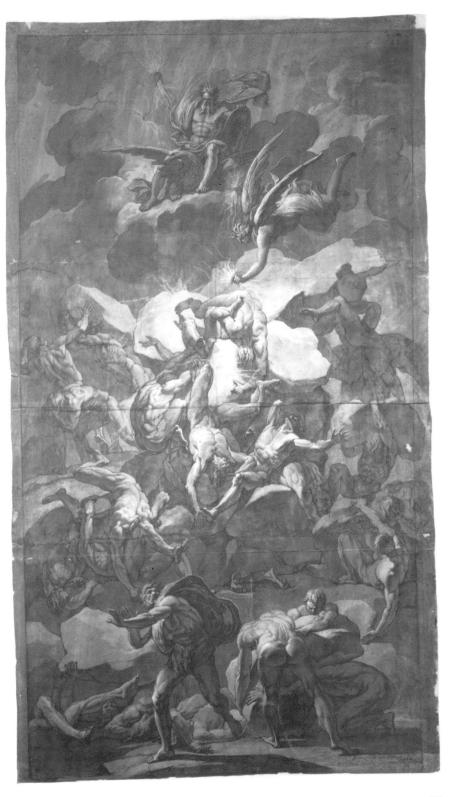

7 GIOVANNI ANTONIO CRECCOLINI (Roma 1675 – 1725)

The Disastrous Effects of the Flood

1696, First Class of painting, second prize, inv. A.114.
pen, watercolor, white chalk mm. 525(550)×755(780).
at the bottom on the left: *Antonio Crecolini 1676*; on the right: *Antonio Crecolini Roma A 20*.

Giovanni Antonio Creccolini was born in Rome in 1675. The sources record his first apprenticeship with the Roman Giovanni Battista Lenardi and, on his death, with Benedetto Luti "where his work grew bold and lively, with graceful colour" (Pio, 1977, p. 19).
He participated in various competitions at the Accademia di San Luca: in 1692 in the third class of painting, in 1694, in 1696, and in all the years up until 1702 (cf. catalogue entry no. 10).
In 1718 together with eight other professors, he requested admission to the Accademia di San Luca (*Sebastiano Conca*, 1981, p. 388) and in 1719 he was present at the meeting of the Congregation (A.S.L., Libro delle Congregazioni, vol. 47, f. 2).
Creccolini practiced his profession as painter primarily in Rome, producing works for various churches in the city, although he also worked for the court of Turin and for foreign collectors (Pio, 1, 1977 p. 19). His participation in the decoration of the now destroyed Patrizi villa where he worked alongside the young Panini (Guerrieri Borsoi, 1989, pp. 181-184, 202) and his presence in the circle of Cardinal Ottoboni (Pietrangeli, 1980, p. 400) should also be recalled.
His artistic production has been reconsidered recently by Vittorio Casale (Casale 1984, pp. 744-747) who has identified in the artist a *retro attitude*, due in all probability to the teachings of Lenardi, a pupil of Lazzaro Baldi, an attitude which survived despite the successive apprenticeship with Luti. However, the influence of this Florentine artist should not be underestimated; it is present above all in the softening of the volumes and the enrichment of the pictorial quality.
A relationship with Maratti and his school was unavoidable and powerful enough to 'oblige' the young painter in some of his works to control his late baroque exuberance in favour of compositions more in line with the Maratta's classicism. His art may certainly be compared to that of painters such as Triga or Piastrini, who also came from the school of Luti. However it is not merely fortuitous that his name should have been assigned to works which are now attributed to Imperiali and to Mazzanti (*Il Settecento a Roma*, 1959, pp. 122-123; Clark 1964, p. 229; Griseri, 1962, p. 36; Santucci 1981, p. 36).
Creccolini's career in Rome was fully launched by his participation in the decoration of the nave of San Clemente for which he executed the fresco of the *Martyrdom of St Clement* (Gilmartin, 1974, pp. 305-310; also *Sebastiano Conca*, 1981, pp. 110-113). Here, working alongside protagonists of the Roman Settecento like Sebastiano Conca and Pier Leone Ghezzi, his style, as I mentioned, becomes comparable to the works of Triga and Piastrini (Esuperanzi, 1987, pp. 67-68). Relatively little is known of his graphic output (Prosperi Valenti, 1983, pp. 144-145. 151 note 93), although the numerous portraits of artists undertaken for the *Vite* (Lives) of Pio, now conserved in Stockholm (Clark, 1967, pp. 118-119) must be mentioned.
He died in Rome on 24 May 1725 (Guerrieri Borsoi, 1989, p. 194 note 50).
The drawing with which he won the second prize together with Giulio Solimena (whose entry has been lost) in 1696 fits in well with the late baroque climate of Rome, but the teachings of Lenardi clearly prevail over the classical Marattesque component. In passing it may be noted that Lazzaro Baldi was one of the judges of the competition. Numerous references to the style of Cortona are evident in the rhetoric gesticulation and in the

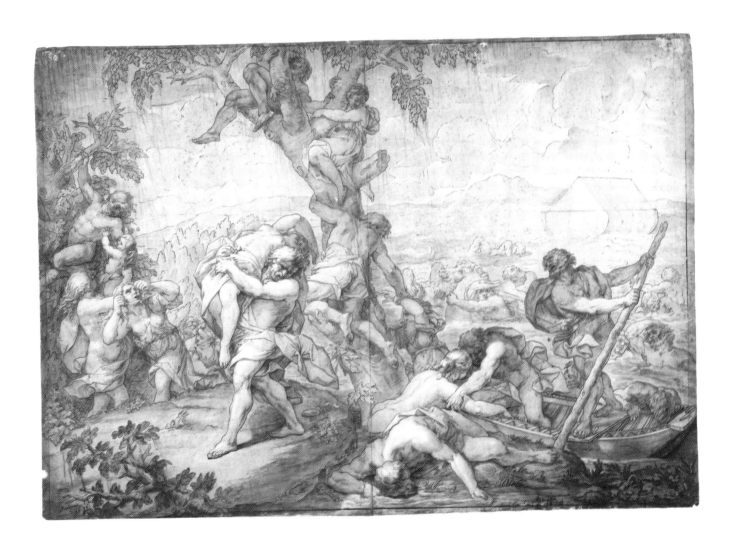

rather swollen anatomy of the figures while the faces are more graceful, their physiognomical traits recalling the work of Ciro Ferri. Several of heads, and in particular, that of the man standing in the boat, seem to be true studies after the antique. The figure in the background who is clinging to the back of the horse, derives from the Vatican Loggia fresco showing the Flood, which in turn is taken from scene XXXI of Trajan's column (Dacos, 1986, p. 161). The outlines of the figures are neat and slightly rounded; the white highlighting is added over the pen to heighten the suggestion of light.

In addition to the models and influences already mentioned, it should be noted that the young artist seems to have looked with extreme attention at sculpture. Such study is evident for example in the treatment of the draperies of the male figures in the foreground and the clothes worn by the man who carries a fainting woman have the consistency of carved marble.

G.C.

8 GIULIO SOLIMENA (Caggiano 1676 – Roma 1722)

The Massacre of the Innocents

1702, First Class of painting, first prize, inv. A.123.
pencil, red chalk, white chalk (composed of several sheet mounted together), mm. 780×1235
at the bottom: *Primo Premio Giulio Solimeni Napoletano*; on the reverse: *Giulio Solimena da Caggiano nel Regno di Napoli.*

Giulio Solimena is known almost exclusively through the short biography dedicated to him by Pio in his *Vite*. The biographer states that he was born in Caggiano, near Naples, in 1676, a date which also appears on his self-portrait, undertaken for Pio, now in Stockholm (Clark, 1967, p. 14). However the death certificate of 25 December 1722 (Michel, 1977, p. 267, note 11) which documents his demise in Rome at the age of 55, pushes his birth date back by ten years, to 1667, a date which seems somewhat early given the documented career of the artist. Pio again states that Giulio is a relation of Francesco Solimena and a pupil at Rome "in the extremely flourishing school of the great Carlo Maratta" (Pio 1977, p. 144).

The works cited by Pio in the biography are generally lost or untraceable. The only documented work undertaken by Solimena was in the Ruspoli palace in 1715 (Michel, 1977). A document recently found in the Archivio Storico del Vicariato, dated 10 March 1716, has permitted the attribution to him of a fresco of the Pietà on the rear wall of a small underground cemetery found in the church of the Stigmata (Ferraris, 1989; Asv, vol. 45, Congr. Gen. Segrete, f. 144). Unfortunately its poor state of preservation renders the painting illegible. The artist also drew a large number of portraits of artists for Nicola Pio, in which Clark distinguished references to Paolo De Matteis and Francesco Solimena (Clark, 1967, pp. 17-18).

In this drawing the composition which unfolds along two diagonals, leads from a tangle of figures at the bottom right, towards the left. It may recall a painting of the same subject by Luca Giordano, though little else connects Giulio Solimena to the Neapolitan environment from which he seems to have originated, outside of his attempt here to give greater dramatic force to the scene, charging the facial typologies of the individuals with great expression. The artist is instead very readily placed (as in fact Pio testifies) into the cultural environment around Maratti to whose inspiration the entire composition owes. Of those who participated in the competition of 1702, Solimena was the most faithful to the teachings of the master.

His style is characterized by a well-defined stroke with clear outlines and shadows separated from the darks; his work could almost be taken for a preparatory drawing for an engraving. In addition to a generic capacity for gesticulation and an attempt towards dramatic characterization in the expressions, the group in the foreground is resolved without depth or volume. The architecture has no consistency and is rather uncertain. The artist betrays some difficulty in inserting the figures into space, while he is more at ease in the descriptive and decorative aspects of the design; the cloth wrapped around the two columns in the background is perhaps the best feature of the composition. Giulio's ability to decorate was exploited in subsequent commissions, for instance, in the above-mentioned Ruspoli palace, and in the Vatican, where, together with other collaborators, he was given the task of painting "putti with flowers" on some canvases for the ceilings of the Gregoriano Etruscan museum (Moroni, 1848, XLVII, p. 111). He also painted "different putti likewise in fresco" over each of the arches in the chapels of the church of San Nicola in Arcione, demolished between 1907 and 1908 (Pio, 1977, p. 144).

G.C.

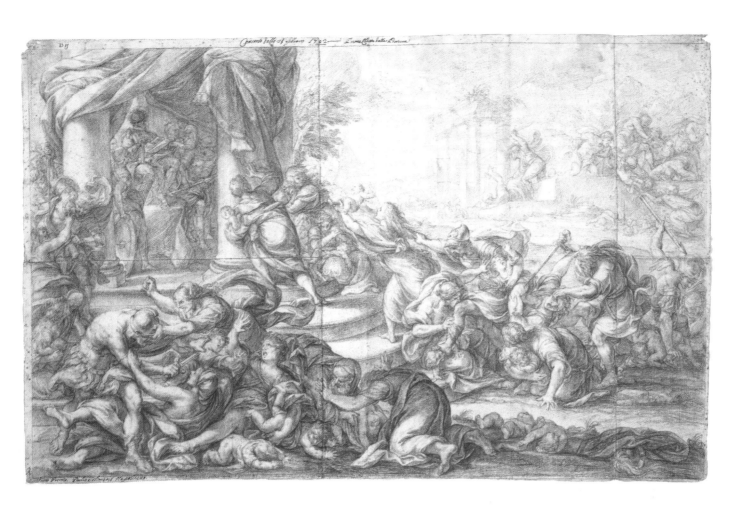

9 ANTONIO CALDANA

The Massacre of the Innocents

1702, First Class of painting, first prize, inv. A.124.
pencil, white chalk (sheet composed of several parts mounted together), mm. 780×1030.
at the bottom on the right: *Concorso delli 25 febbraio 1702. Prima Classe della Pittura. Secondo Premio. Antonio Caldana Livornese. 1. C21*; on the reverse: *N 62 A.*

The documents preserved in the Archive of the Accademia di San Luca record Antonio Caldana from Leghorn as the winner of the second prize in the first class of painting in the Clementine competition of 1702. This is the first mention of this artist (the archive of the Accademia di San Luca contains no other documents relating to him), who is said by other sources to have been from Ancona (Ricci, 1834, II, p. 29; Ferretti, 1883, pp. 36-37), before a document of 1707. This latter tells of a painting executed by him for the sacristy of the church of San Nicola of Tolentino at Rome showing *The Miracle of St Nicholas in Cordoba* (Zandri, 1987, p. 73; the work already cited by Titi 1763, p. 336, has unfortunately disappeared.

The most recent documentary evidence for the artist comes from the census of the parish of San Lorenzo in Lucina where he lived, with his wife and three children (the eldest, Anna, was twelve years of age), until 1713 (ASV., S. Lorenzo in Lucina, St. d'An. 1713, f. 69). By 1705, he was already living there, for on February 18 the second child Andrea was baptized (ASV., S. Lorenzo in Lucina, Lib. Bant., f. 171 v.). Nothing further is known about the painter's life, training, or his artistic production.

On examining this drawing one finds that the composition is balanced in favor of the group in the foreground, an impression which is confirmed by the precise and accurate stroke used in this area and by the better plastic definition of volumes. The figures in the planes behind are drawn more rapidly; those standing on the stairs are lightly sketched and the spatial arrangement of the architecture and landscape in the background is weak and uncertain. A striking feature of the style of this artist is his use of white chalk on light blue paper by which he obtains a remarkable lighting effect.

For the moment this drawing by Caldana is a true *unicum* (unique item). Given that it is, furthermore, a juvenile work and in any event an entry for a competition of the Accademia, it is not easy to define and analyse in it the stylistic components of this painter who, beyond Raphaelesque citations, demonstrates a somewhat eclectic taste. Beyond his general classicistic approach there is a clear interest in realism and an attention to detail which almost recalls genre painting.

G.C.

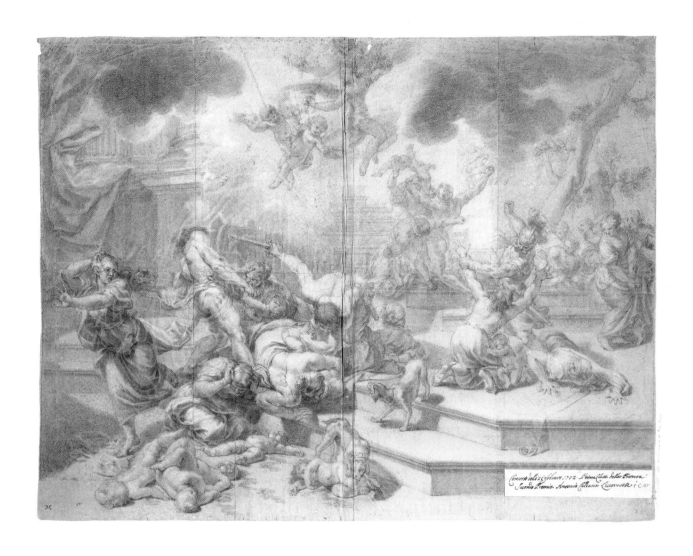

31

10 GIOVANNI ANTONIO CRECCOLINI (Roma 1675 – 1725)

The Massacre of the Innocents

1702, First Class of painting, second prize, inv. A.125.
red chalk, mm. 540×780.
at the bottom: *Concorso delli 25 febraro 1702. Prima Classe della Pittura. Secondo Premio. Antonio Creccolini Romano A 22*; on the reverse: *N 38 A.*

In 1692 Creccolini participated for the first time in the competitions of the Accademia di San Luca, obtaining second prize in the third class of painting. He also competed in 1694 and again in 1696 (cf. catalogue entry no. 7) in the first class, obtaining a third and second prize respectively. He re-entered in 1702, now twenty-seven years old, but on this occasion as well did not get beyond the second prize, being beaten by Giulio Solimena (cf. catalogue entry no. 8).

With respect to his entry of six years earlier this drawing shows a greater maturity in composition and greater ability in the spatial construction of the groups which however still remain distinct from each other, almost as if they were not participating in the same event. To increase the dramatic force of the event, Creccolini once more turns to the repertoire of the baroque gestures typical of Cortona's school. A clear affinity with the manner of Lenardi, a pupil of Lazzaro Baldi, is evident. The dramatic quality of the gestures is diluted by the theatricality of the poses which are restricted only by his attempts to achieve the necessary decorum.

In these years, the style of Creccolini, while revealing the predominant influence of Maratti, seems to move in the direction of a style which was essentially Cortonesque, following his master Lenardi. He thus belongs to a cultural trend parallel to that of Maratta, and not always easily distinguishable from it. It may be that, since Maratta was principal of the Accademia he saw that the first prize went (unjustly, in my view) to Giulio Solimena, an artist who was loyal to his teachings.

In the same competition the little known Giovan Battista Brughi and Giacomo Triga were also awarded second place; both of their entries were more in line with the dominant artistic culture of the Accademia.

It is also important to note the evident attention which Creccolini paid to contemporary sculpture. This can be clearly seen in the drawing of some of the drapery as well as in the composition of the groups. The background with the fortified city and the ruined walls on the right is very well constructed. Compared with his drawing of 1696, Creccolini has acquired greater skill as a draftsman; this is evident in his diverse handling of the technique – the red chalk allows him to achieve "sfumato" (delicate gradation) effects of particular softness and chromatic relief.

G.C.

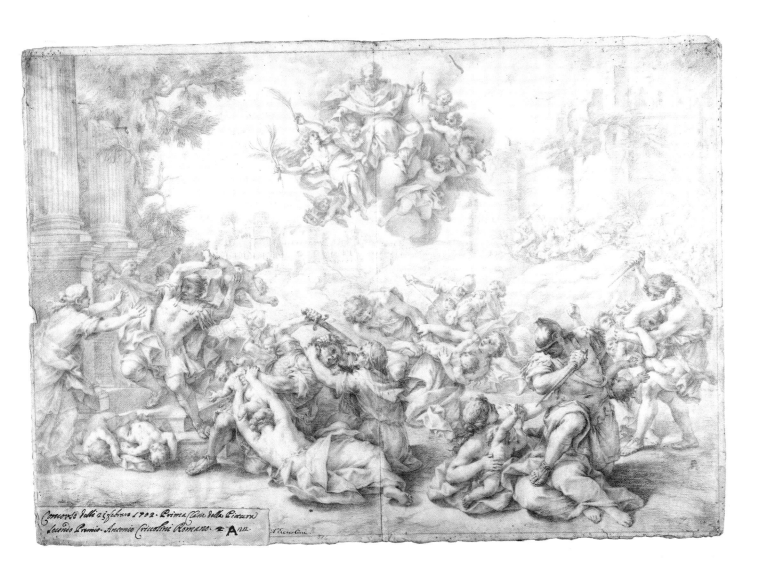

Concorso delli 23 febbraio 1702. Prima Classe della Pittura
secondo Premio Antonio Grisostomi Romano A_{nn}

11 NICOLÒ RICCIOLINI (Roma 1687 – 1772)

The Supper at Emmaus

1702, Second Class of painting, first prize, inv. A.132.
red chalk, mm. 185(230)×250(320).
at the top: *Prova di Niccolò Ricciolini V 2.a.*

Lanzi (1808, p. 392), the only writer who cites this artist's name includes Nicolò Ricciolini among the followers of Cortona active at the beginning of the 18th century. Lanzi reports that he "had a name as a good draftsman". His critical comment is of undoubted accuracy, especially given the note on Ricciolini's graphic ability. The artist's stylistic adherence to the Cortona school was actually more superficial than profound for reasons implicit in the evolution of events in the Roman art circle. The most faithful pupil of Cortona and his most direct heir in terms of his decorative conception, Ciro Ferri, had died in 1684; the other servile disciple, Lazzaro Baldi, had adopted Cortonesque characteristics with some success, modifying them with the introduction of greater classical decorum, a stylistic direction taken by Maratti. In the last years of Baldi's active working life, which ended in 1703, his students did not have the cumulative strength to constitute a school and continue a tradition (with the single exception, perhaps, of the trio Baldi-Lenardi-Creccolini). This is something which did happen, by contrast, with the pupils of Maratti, who eventually formed a compac, clearly defined school. The course of painting at the beginning of the century was necessarily directed towards classical and academic formulae more closely related to the classical baroque tendencies found in painting during the first half of the 17th century which at the time resulted from a Roman-Emilian alliance. The instruction received by Ricciolini testifies to the validity of this trend: he was first a pupil of his father Michelangelo, and later studied with Giovan Angelo Canini, whose style had its roots in Domenichino.

In 1702 the young Nicolò, then only fifteen years old, appeared in the second class of the competition. Winner of the first prize, his work shows the moderate influence of Cortona which probably refers to Pietro Berrettini only indirectly, through two Cortonesque "sui generis", Giacinto and Ludovico Gimignani, cautious interpreters of the art of Pietro da Cortona who as well revived elements of Domenichino, Cozza, Maratta, Bernini and Gaulli. The clear sources of his motifs define the direction his research was taking as he strove to define his own style. Especially notable is the surprising scenic setting, with the figures seated frontally around a table whose angles accentuate the diagonal perspective recession of the floor. In this way the picture space is increased on the right making room for the secondary figures who accompany the gestural dynamics of the two disciples, visibly shaken by the sacred sign of Christ who is about to vanish from their sight, according to Nicolò's literal reading of the gospel text (Luke, 24, 30-31). The rather incisive and graphic style of the drawing, with the sculpturally posed stigmatization, the intense, baroque gestures and expressions recalling Pietro da Cortona and Bernini, and the Gaulli-style drapery with crests of light on the folds, becomes delicate and almost blurred in the face of the Reniesque Christ as a result of his painterly use of the red chalk. From the delicate shading in dark tones intended to solidify the physical masses of the objects, to the *chiaroscuro* evident in the two servants, Ricciolini shows a remarkable grasp of his technical means. Thus the composition is given the value of a fragment of a painting with references to the naturalism composed of humble objects like that visualized by Giuseppe Maria Crespi in Bologna at the same date. Ricciolini's chromatic use of red chalk suggest yet again the presence and influence of another emergent artist on the Roman scene during this period: the Florentine Benedetto Luti, who had moved away

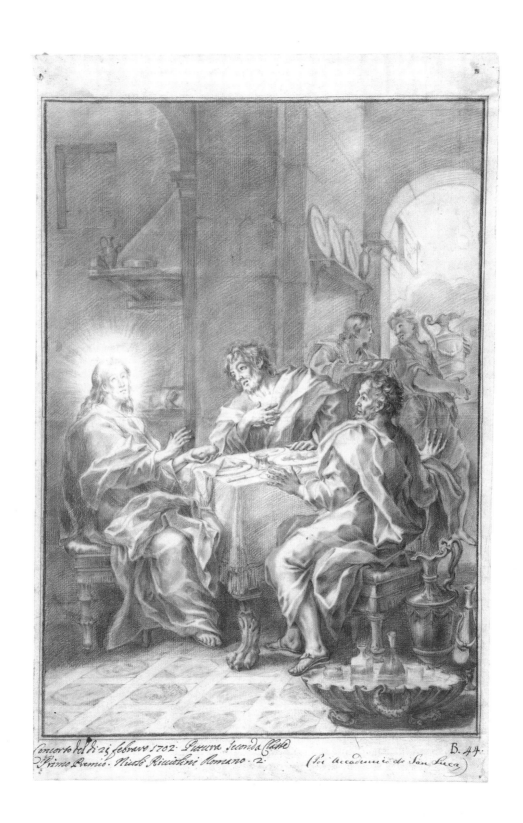

Concorto del di 25 febraro 1702. Pittura seconda Classe
Primo Premio. Niccolò Ricciolini Romano. 2. (Poi Accademico di San Luca)

Б. 44.

from the Cortonism he had absorbed from Gabbiani, his master, in the direction of Maratta's style. The *Supper in the House of Simon the Pharisee* (Kedleston Hall, collection of Viscount Scarsdale), painted by Luti in circa 1691-92, soon after his arrival in Rome, may be considered a model for Ricciolini's test piece; it is referred to in the synthesis of the formal, spatial and pictorial-lighting values. It is interesting to note that in 1706 Luti painted a *Supper at Emmaus* (Rome, Gallery of the Accademia di San Luca, where a copy made in 1707 of Luti's *Supper in the House of Simon*, now in England, is also conserved), in which he revives the same spatial conception, softens the chromatic quality, and gives Christ's face the same inspired intensity that Ricciolini conveys in this drawing.

Nicolò's activity is still little known and therefore does not allow for critical hypotheses beyond those advanced here. However, it would be interesting to study the connections between the two artists and the extent to which Luti had had an impact on the younger artist. Luti was undoubtedly a congenial painter, as is evident years later in his preliminary sketch for the *Assumption of the Virgin* (Rome, Gallery of the Accademia di San Luca) of 1721, whose setting and typology are still a reminder of this *Supper at Emmaus*. The arrangement of a figurative nucleus at the base of a brick parapet set on an angle certain met with success in the following years, as demonstrate the famous angle views of the Juvarra style setting, and the pictorial results of Benefial's *Adoration of the Shepherds* (Rome, Instituto del Bambin Gesú) already in place in 1736. Nor should it be forgotten that Benefial was one of those primarily responsible for the *neosecentismo classicistico* an artistic experience shared by the young Ricciolini right from the moment of his debut. Bibliography; M.B. Guerrieri Borsoi, 1988, "Bollettino d'Arte", n. 50-51, pp. 161-185.

A.P.

12 ANTONIO BICCHIERAI (Roma 1688 – 1766)

Copy of the Bas-Relief by Raggi in Piazza Navona

1702, Third Class of painting, second prize, inv. A.137.
red chalk, mm. 485×410(430).
on the reverse: *Antonio Bicchierari.*

Antonio Bicchierai was born in Rome on November 29, 1688 (Michel, 1977, pp. 267-268 note 12), and participated in various competitions of the Accademia di San Luca from 1702 until 1709, when he obtained third prize in the first class of painting.

An initial reconstruction of his artistic output was made by Mancini on the basis of entries in the *Diario Ordinario* (Mancini, 1976, pp. 42-43 note 62). Additional information was uncovered by Gigli (1977, p. 12, see also Titi, 1977, ad indicem). Although little is known about him, he was a prolific painter during the mid-18th eighteen century and left a large number of works, especially vault decorations in churches and private palaces. Completely at home in the Marattesque tradition (Rudolph, 1983, p. 751), Bicchierai showed himself to be an able, though superficial, decorator, and his style falls perfectly within the confines of late baroque painting.

His first recorded official commission was in 1715 for the Ruspoli palace, (Michel, 1977). There followed works in the palace of the Consulta (Del Piazzo, 1975, p. 274) and in 1756-1757 in the Albani villa, where he was given the task of decorating the ceilings of seven rooms, perhaps his most prestigious commission (Schröeter, 1982, pp. 185-299;

36

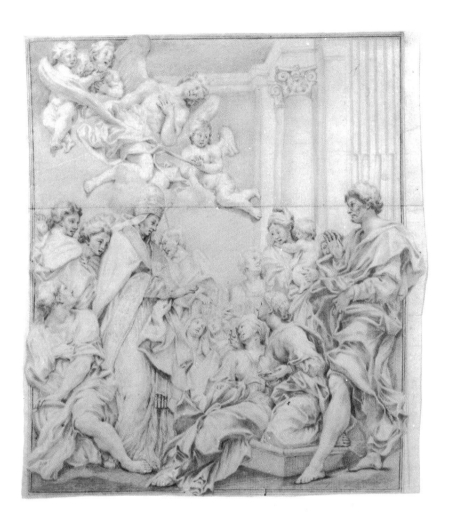

Prosperi Valenti Rodino, 1985, pp. 237-243). He undertook other work in the Chigi villa (Belli Barsali, 1970, p. 334 note 6). Throughout his career he was also the creator of ephemeral displays (Mancini, 1976, pp. 42-43 note 62). He also produced an "...oil-painting of the model of the statue of St Michael Archangel which will be made of metal, and placed on the summit of the Mola Adriana..." documented in 1746 (Contardi, 1987, pp. 20-22).

He became an academician of the Accademia di San Luca in 1758 (A.S.L., vol. 51, ff. 114, 16) and was a member of the Congregazione dei Virtuosi (Noack, MS). He died in Rome on March 14, 1766 (Michel, 1977, pp. 267-268 note 12).

He participated in the Clementine competition of 1702 while very young, obtaining the second prize in the third class together with Marco Benefial (cf. catalogue entry no. 13). His red chalk drawing, though still somewhat hesitant in design (there are for example some anatomical distortions), reveals characteristics which are found in the artist's subsequent graphic output. The contours of the figures are poorly defined, only slightly suggested, and the facial typologies, particularly those in the background, are not well characterized. However, he already demonstrates a knowledgeable use of *chiaroscuro*, as may be seen in the dense parallel hatching for the shaded parts and the more sparing

treatment in the lighter areas. The overall result is intensely painterly, an effect which, while pleasing, lacks depth and volume.

One is dealing, in short, with Bicchierai's personal interpretation of the *bas-relief*, which, while almost perfectly reproducing its design arrives at a result which almost diametrically opposes the aims of Raggi's original. A comparison with the competion entry of Benefial makes this very clear. The latter was more faithful to the work in marble not so much for details but above all in the "sculpturesque" realization of the drawing, obtained through a strong, clear stroke and the gradation of shadows according to depth.

Bibliography: Petraroia, 1980, p. 373.

G.C.

13 MARCO BENEFIAL (Roma 1684 – 1764)

Copy of the Bas-Relief by Raggi in Piazza Navona

1702, Third Class of painting, second prize, inv. A.138.
red chalk, white chalk, mm. 730×530.
at the bottom: *Di Marco Benefial Romano. Secondo Premio della Terza Classe della Pittura. Nel Concorso del dì 25 febraro 1702*; on the reverse: *N 53 B.*

Marco Benefial was born in Rome in 1684, and from an early age he was apprenticed to Bonaventura Lamberti with whom he remained from 1698 until 1703 (Petraroia, 1980, pp. 371-380). His beginnings as a painter were not easy and only from the second decade of the 18th century does he stand out as clear-cut personality in the artistic environment of Rome, obtaining prestigious commissions (Falcidia, 1978, pp. 24-51).

He was admitted as an academician of the Accademia di San Luca in 1741, there after assuming various offices, until in 1754 when he was appointed Principal. But his relations with the institution were always polemical. The fact, for example, that he took a stand against the papal brief of Clement XI of 1720 according to which only those who were enrolled in the Accademia di San Luca could teach the arts of drawing (Borea, 1966, p. 466), deserves mention. Subsequently in 1755, after he had denounced the incompetence of the members of the Accademia, and because of "the lack of propriety he used in talking both and of the other academicians of the Accademia itself in June and July to the students entrusted to him in the nude classes of the school at the Campidoglio" (Missirini, 1823, p. 197), he was temporarily expelled (Susinno, 1974, p. 251; cf. also Longhi, 1956, pp. 68-70). He died in 1764. (Besides the references already cited, cf. Rudolph, 1983, pp. 750-751).

The drawing with which he entered the Clementine competition of 1702 for the third class of painting (the only competition in which he seems to have participated), is a copy of Raggi's bas-relief in Sant'Agnese in Agone, depicting the Death of St. Cecilia. It was with this drawing that he won the second prize, together with Antonio Bicchierai (cf. catalogue entry no 12).

The sheet is irregularly framed with the figures who overlap the edges; the stroke is sometimes hesitant, with re-touching to strengthen the outlines, and there are several anatomic uncertainties. However on the whole the drawing is good, and quite correct in the execution of the details, and the young painter already reveals some of the characteristics typical of his mature style. Benefial gives care to the plastic rendering of his relief

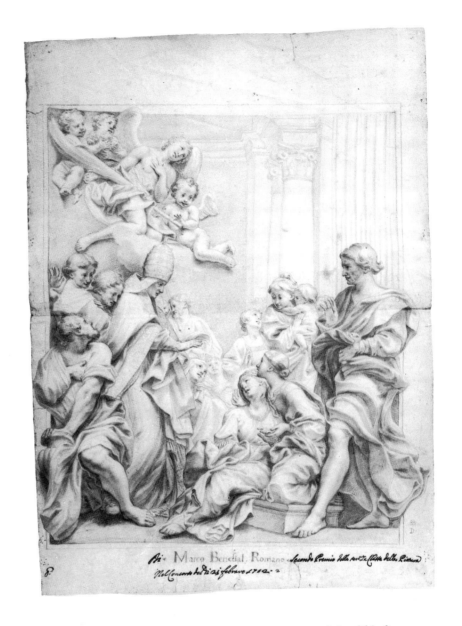

subject, the graded shadows creating all levels of depth. The drapery of the fifth figure on the right is especially well rendered, creating the effect of an actual sculpture.

A comparison of Benefial's test piece with of Bicchierai demonstrates immediately the different artistic aims of these two young men. Bicchierai, interested primarily in the pictorial effects which an intense *chiaroscuro* could achieve, produced a drawing which is pleasing enough. But Benefial, evidently more solid and mature, already reveals his search for compositional simplicity in his ability to synthesize with a few lines the baroque virtuosity of Raggi.

Bibliography: P. Petraroia, 1980, p. 373.

G.C.

14 NICOLÒ RICCIOLINI (Roma 1681 – c. 1772)

Moses striking the Rock

1703, First Class of painting, first prize, inv. A.141.
red chalk, white chalk, mm. 560×365.
at the bottom: *Concorso dell'anno 1703. Pittura Prima Classe primo premio. Nicolò Ricciolini Romano 25 A poi Accademico di San Luca*; on the reverse: *N 27 A.*

The award of the first prize in the first class of painting to this drawing by Nicolò Ricciolini is symptomatic of the cultural situation in Rome at the beginning of the century, which was sustained by the academic assertions of Maratta. The "Cortonism" of the artist has been tempered with respect to his competition piece of 1702: it is imposed, formally speaking, upon the two recumbent foreground figures, while in order to represent a miracle, it reappears in the divine intervention between clouds and putti. For the rest, the composition reveals the stylistic features of the Bologna-Rome axis which aimed at a careful theatricality sustained by the numerous affected presences engaged in a choral recitative around the centralized action of the protagonist. At the appearance of the phenomenon everything moves, operates, is thrown into disorder, and the gesture of Moses is echoed by the two secondary figures at his shoulders. The foreground groups of miraculously healed people and awe-struck, prayerful observers are balanced in symmetrical counterpoise by means of their different gesticulations. The group on the right is particularly meaningful for its reference to the frescoes of Domenichino in the chapel of St. Cecilia in San Luigi dei Francesi in Rome, a fundamental 17th century work which was highly praised and greatly influential, and whose fame had been emphasized by Bellori in his "Vita di Andrea Sacchi" (Bellori 1672, 1876, p. 557). Of similar interest is the group on the left which offers a critical re-reading of the *St. Charles amidst the Plague-stricken* painted by Giovanni Bonatti (c. 1635-1681) for the Spada chapel in S. Maria in Vallicella (where Maratti's altarpiece, the *Madonna with St Charles* is still in place). The relationship of Ricciolini to Bonatti, whose formation and adherence to the art of Emilia was the main reason for the esteem shown to him by contemporaries, becomes more convincing by a comparison of the present drawing with Bonatti's preliminary sketch for the painting, also in red chalk (Rome, private collection). The latter is characterized by a compositional solidity and mobility of stroke, tractable to the luminous effects of the white highlighting. Ricciolini (who must have known Bonatti's finished work since it was in the possession of the Spada family in Rome), here adopts the same methods, though emphasizing the quality of the light with pictorial rather than volumetric intentions which approach the expressive search of Luti in these same years. The "contaminatio" (use of elements of different styles) of Ricciolini at an iconographic and stylistic level was a frequent practise in the Roman school of the early 18th century, and is completely justified in an artist at the beginning of his career, a career that was officialized by his admission to the Accademia di San Luca in 1721 (A.S.L., vol. 48, fol. 66).

A.P.

40

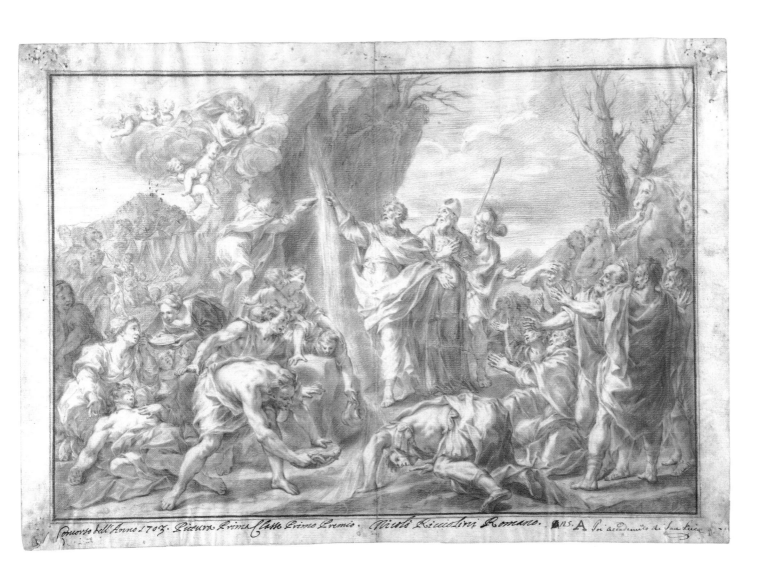

Concorso dell'Anno 1707. Pittura Prima Classe Primo Premio. Nicolò Ricciolini Romano. N.S. A Poi accademico di San Luca

41

15 GIOVANNI BATTISTA ARMILLI

Moses striking the Rock

1703, First Class of painting, first prize. Inv. A.143.
red chalk, mm. 530×770.
Inscriptions: on the lower left border, "Concorso del 1703. Pittura Prima Classe Terzo Primo Premio. Giovanni Battista Armilli Riminese", and to the right, "B. 55".

In 1703 this artist from Rimini entered the Clementine *concorso* straightaway in the first class of painting, without having progressed through the other two in previous competitions, and took a third prize *ex aequo* with the Sicilian Pellino (cf. catalogue entry no. 16) and the Parisian Forestier. The following year he competed once more, bettering his result with a second prize; but Pellini superceded him to win the first, and Armilli did not try his luck again.

It might be thought that his career never developed beyond this initial point, since his name is not recorded in any published sources, let alone in the usual biographical repertories. Yet Armilli is mentioned several times in archival documents relative to the last years in the life of Carlo Maratti (which will be published in full in my forthcoming monograph on that master). On 5 May 1711 he signed as witness, together with Andrea Procaccini, Agostino Masucci (cf. catalogue entry no. 31) and Francesco Rivette, the codicile to the will of Francesca Gommi, Maratti's wife; two months later he was again a witness in the same company, which now included G.B. Calandrucci (cf. catalogue entry no. 21), to the will of Maratti himself, and together with Procaccini he signed the codiciles added in July and November 1712. Lastly, his copy of a picture by Maratti representing a *Diana bathing with two figures fleeing in the distance*, on canvas measuring three *palmii* and without a frame, is listed in the 1711 augmented version of the inventory of Francesca Gommi's possessions that had been drawn up in 1701. Although these sparse references hardly compensate for the dearth of paintings attributed to him, they do at least retrieve him from the anonymity to which he was hitherto relegated. In fact they show that Armilli still resided in Rome towards the end of 1712 and that he must have been not only a pupil of Maratti, but actually one of the chosen few who coalesced into the elderly master's circle of intimates some years prior to his death in 1713.

This notwithstanding, Armilli's prize-winning drawing of 1703 would seem to indicate, beyond its generically Marattesque stamp, a particular adhesion to the modes of Giuseppe Chiari, by now the doyen of an older generation of Maratti followers and indeed one who was in the process of evolving the master's grand manner with a discreet touch of 18th-century sensuousness. A like proclivity emerges in Armilli's handling of this drawing with a scumbling of contours and thick hatching that give the surface a softly mat finish, and also in the suavity of the heads, some of which display an almost Alexandrine tenderness (the woman kneeling at the edge of the rivulet; the soldier leaning to drink there, etc.). The technical proficiency evident in Armilli's execution is superior to his eye for the layout of the scene, which reveals a certain lack of perspicuity in the distribution of the figures, alternately so densely packed or scattered as to obfuscate the landscape structure, which barely manages to contain them, and to reduce Moses from the protagonist to a secondary detail in the episode. Pellino's rendering of the subject is no more successful on this count, but Niccolò Ricciolini showed considerable mastery in the composition of his dramatically turbulent representation (cf. catalogue entry no. 14) that won the first prize in the same class. In fairness to Armilli it must be said that his red chalk drawing of *King Amulus of Alba slain on his throne by Romulus and his companions* (Disegni, II A. 161), awarded the second prize *ex aequo* with the Venetian Croster in the 1704

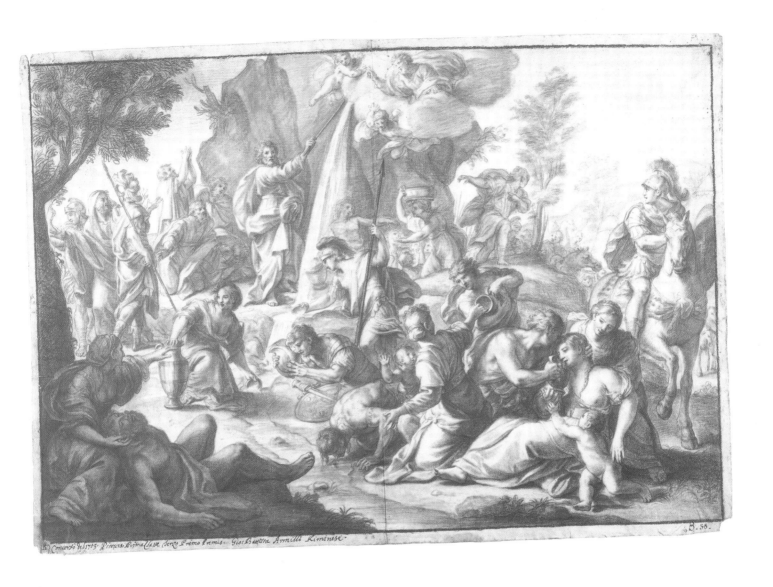

competition, demonstrates that he was capable of making good his earlier deficiency in the coordination of figures within a given setting, thanks to the prominent architectural background that frames and disciplines the crowd in this scene of violence. It may be added that the anonymous extempore sketch of *Rebecca and Eliezer at the well* (Disegni, II A. 165), executed on that occasion, is in all likelihood by Armilli, judging by its connotations that, despite the cursory delineation, are so similar to the taste and graphic style of Chiari.

S.R.

43

16 PIETRO PELLINO (Agrigento *c.* 1675/80 –)

Moses striking the Rock

1703, First Class of painting, third prize, inv. A.144.
pencil and white chalk on grey paper, (sheet composed of two pieces mounted together), mm. 500×650.
at the bottom: *Concorso del 1703. Pittura Prima Classe Terzo Secondo Premio Pietro Pellino Siciliano. B. 53*; and, written by another hand; *ritrovato fra i disegni di architettura gennaro '78*; on the reverse: *N. 21 A.*

This unknown artist who is completely absent from the sources, is cited at the bottom of an academic drawing in the Accademia di San Luca as a native of Agrigento, and known only from the two entry pieces submitted to the competitions of 1703 and 1704. The two sheets, drawn a year apart, reveal the same executive method, linear flexibility and compositional setting, all of which betray his knowledge of Neapolitan culture. The scenic animation, the positioning of the groups, the passages of landscape, all align themselves with the methods of the Giordanesque school, to which also belongs the sketchy depiction of the figures in the background. The hazy luminarism infusing the composition emulates the clear chromatism of the scenographic decoration of Giordano, but without attaining to the musicality typical of this master who, using a palette rich in tonal ranges, was able to produce a series of variations absent in Pellino's monochromic drawing. The figurative group in the foreground, is conspicuous for the plastic density of the figures and the intense use of *chiaroscuro*, (almost too strong in the man who proffers the drink), an intensity which seems to point towards Solimena and, through him, to a revival of Mattia Preti in his preliminary sketches for *The Plague*, (1656) an "ancient" but still vital figurative text for Neapolitan culture. Direct knowledge of these pictorial sources ,is of course probable; Pellino may well have acquired it during his (hypothetical but logical) stay in Naples on the journey to Rome from Sicily. Here the painter very likely would have received his first training from local sources who, we may suppose, had already acted as an assimilative filter of that earlier cultural trend.

It may be that Pellino upon his arrival in Naples was anxious to arrange for his apprenticeship, and tried to discover the most significant bases of that city's culture between the late 17th and early 18th centuries which offered a continuity of the baroque pictorial tradition. He thus may have felt compelled to study the results of contemporary artists of the same age. This may explain why the most important components of Pellino's artistic language are found in the works of Giacomo del Po (Rome 1652 – Naples 1726) and Domenico Antonio Vaccaro (Naples 1678 – 1745). In these two painters Pellino would have discovered the most up-to date solutions within the Giordanesque and Pretian tradition which, in these earliest years of the 18th century, were even unusual for Solimena himself. This may explain Pellino's exigency for diffuse luminosity, *chiaroscuro*, and plasticity. In order to gain the desired effect, Pellino used a light greyish-blue paper, pencil and white chalk, but was not yet able to assimilate in practice the changes introduced by the two painters mentioned above.

This inability is evident in the chaotic result of the scene which appears confused, despite the pyramidal foreground scheme. The figures are distributed in separate, non-related groups, and do not give the proper emphasis to the part of the narrative where the action of the protagonist is in progress. The passionate temperament of the artist is clear; with an entirely baroque sensibility he aims to show effects rather than causes, and so creates an intensely expressive passage in the group on the right, whose figures are pale with thirst, listless and desolate, though balanced and accurate in terms of composition. With this drawing the artist was awarded third prize in the first class of the competition, winning *ex*

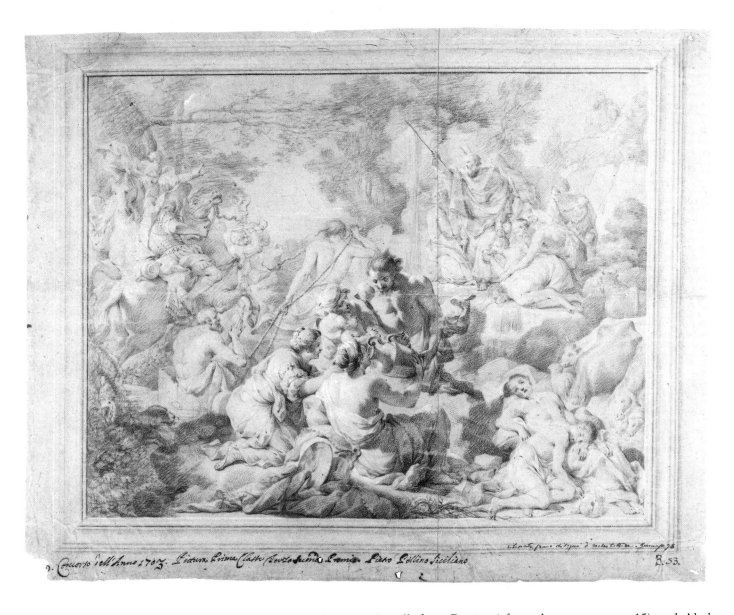

aequo with Giovanni Battista Armilli from Rimini (cf. catalogue entry no. 15) and Abel Forestier from Paris. In terms of stylistic expression their drawings all belong to different pictorial trends.

A.P.

17 PIETRO PELLINO (Agrigento *c.* 1675/80 –)

King Amulius of Alba slain on his own Throne by Romulus

1704, First Class of painting, first prize, inv. A.157.
pencil and white chalk on grey paper, mm. 710×980.
at the bottom: *Prima Classe della Pittura. Primo Premio Pietro Pellini da Agrigento in Sicilia. Il Re Amulio, Re d'Alba, ucciso da Romolo e Compagni nel proprio trono*; on the reverse: *Pietro Pellini P.a Classe P.o Premio 1704 N. B 60.*

In the competition of 1704, again competing against G.B. Armilli who won the second prize *ex aequo* with Antonio Bicchierai and Angelo de Coster, Pietro Pellino took the first prize with a truly new drawing. Above all, it contrasts with the theatrical cortonism and superficial show characterizing the test pieces of the other competitors (including Bernardino Baroni who was awarded third place).

Only a year later than his previous entry, Pellino demonstrates that he has consciously brought to maturity the Neapolitan formulae of Giacomo del Po and Domenico Antonio Vaccaro. He now reveals a synthesis between a vigorous plasticism and a refined luminosity which has acquired softness, pictorial mellowness, and diaphanous transparencies equal to those of a pastel. Working with great interpretive agility Pellino puts into effect an incredible capacity for critical reading of the most *avant-garde* intentions of the Neapolitan painters. His drawing represents a revision of baroque style according to the 18th century interpretation created by Luca Giordano in the final period of his activity, also demonstrating a lucid awareness of the Roman scenographic contributions of Andrea Pozzo. The furor of the animated figural groups is placed within a solemn and monumental architectural setting, which is, however anticlassical as much in the use of the perspective scenes which do not imply formal regularity, as in the divided and agitated profile of the flight of steps. The scenic vivacity and the painterliness of the highlights are indications of openness to precociously "rocaille" solutions. An early sign of this characteristic is also found in the extempore drawing presented in the same year (cf. catalogue entry no. 18).

A.P.

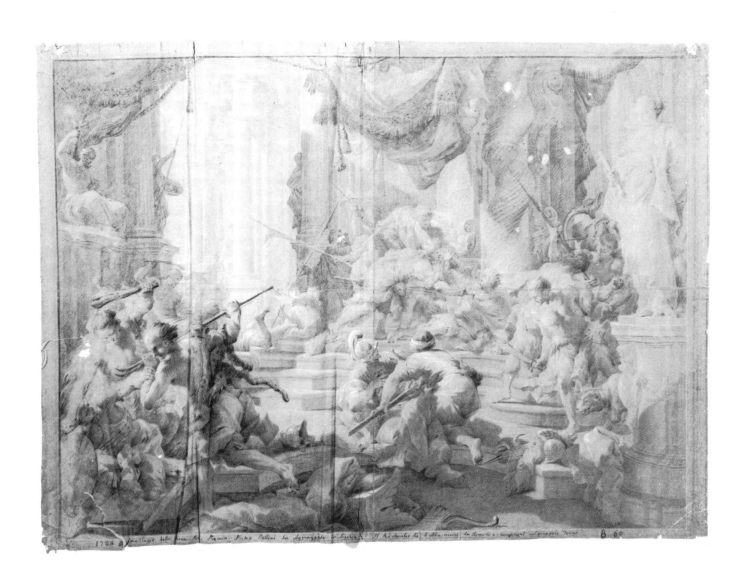

1704 A *una classe della luce fu Premio: Pietro Pellini da Agrigento in Sicilia. Il Re Amulio Re d'Alba viene in Roma e compiange nel proprio trono* B. 60

18 PIETRO PELLINO (Agrigento *c.* 1675/80 –)

Rebecca at the Well

1704, First Class of painting, extempore piece, inv. A.158.
pencil and chalk on bleu paper, mm. 420×600.
at the bottom: *Prova di Pietro Pellini Siciliano. 1704. C.*

The drawing, executed in black pencil and chalk, depicts *Rebecca and Eliezer at the well*, a theme which is nearly as common in the Roman environment of the early 18th century, as is *Christ and the Samaritan Woman*. Here, Pellino renounces landscape possibilities and concentrates the attention on the two protagonists, leaving the fountain to perform a side-show. The simplicity and concentration of the scene, of Roman rather than Neapolitan taste, reflects the extent to which Pellino was attentive to Maratta's teachings as well. However, the gestural mimicry of the figures together with the bizarre swirling of the draperies give an unconventional freshness to the biblical in episode which would have found confirmation, even in compositive style, in the *Christ and the Samaritan* painted by Sebastiano Conca during his first decade in Rome (*Sebastiano Conca*, 1981, p. 120). One should recall that Conca did not arrive in Rome before 1707, coming from Naples where he had been a pupil of Solimena. Cultural similarities and coincidences in artistic development and aims pair these two artists who were unwittingly linked by the similar events occurring in Rome and Naples at the turn of the century. However the stages of Conca's itinerary are known to all, while those of Pellino are not. He disappears mysteriously from the public scene, though his works continued to be sought after as examples of Conca's workshop or, more evasively, of the Neopolitan school. A stimulus for identifying him more accurately is provided by this prize drawing of 1704, a precocious year for the horizontal designs and architectural frameworks as well which mark both the work of Conca and of Solimena, just as the taste for the curvilinear profiles and twisted columns are typical of the scene-painting of Juvarra and Vanvitelli. What has been said does not aim at exalting Pellino, but as a reflection upon the fertile possibilities arising from the meeting of trends substantially similar in Naples and Rome. In this sense Pellino himself is indicative, for within a fluid, changing cultural reality his healthy capacity for eclectically assimilating that culture, enabled him to advance with fresh receptivity towards the innovative possibilities inherent in the early years of the new century.

A.P.

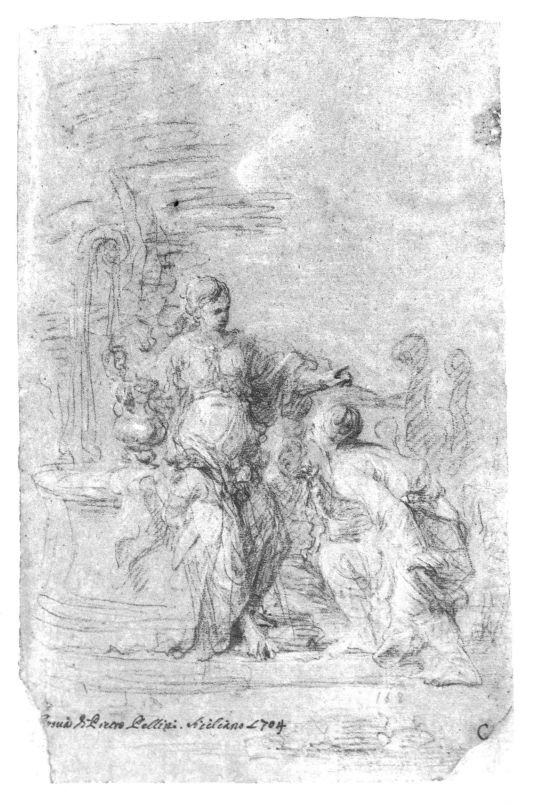

49

19 ANTONIO BICCHIERAI (Roma 1688 – 1766)

King Amulius of Alba slain on his own Throne by Romulus

1704, First Class of painting, second prize, inv. A.159.
red chalk, white chalk, mm. 420×600.
at the bottom: *1704. Prima Classe della Pittura. Secondo Primo Premio. Antonio Bicchierari Romano. B 62.*

After having competed in the Clementine competition of 1702 in the third class of painting (cf. catalogue entry no. 12), as well as in that of 1703 in the second class, in 1704 Antonio Bicchierai entered the first class of painting and won the second prize. In subsequent years this artist again took part in the competitions announced by the Accademia; in 1705 and in 1706 he competed in the sculpture classes, and in a final attempt in 1709 he won the third prize in the first class of painting.

The assignment of 1704 required the artists competing in the first class of painting to design a composition for an episode from Roman history, chosen, as always in those years, by Giuseppe Ghezzi. The specific episode selected was the point at which Romulus and his companions kill Amulius who had usurped the throne of Alba Longa from Numitor, father of Rhea Silvia. The deserving winner of the first prize was the Sicilian Pietro Pellino (cf. catalogue entry no. 17) who produced a composition of truly extraordinary spatiality. In comparison Bicchierai's work appears rather less effective and more rigidly academic. The young artist sets the episode in an interior composed of great arcades under which the warriors are gathered, which opens onto a landscape background. In the foreground Amulius is about to be struck down by Romulus.

The composition is animated and lively; the figures are light and seem almost to be dancing, even if, drawn according to academic precepts, emphasis is given to their powerful anatomies. This emphatic effect is, however, achieved using red chalk to create luminous effects rather than plastic connotations. The lights are obtained by a sparing touch, while the darks are achieved through a close and regular hatching.

With this drawing Bicchierai confirms such characteristics as are already present in his test piece of 1702, emphasizing even more the overall pictorial effects.

The young artist thus shows himself to be well adapted to the cultural climate of Rome of the first years of the 18th century, dominated by Carlo Maratti and his school. However, to this writer it seems that he also reveals a close study of Trevisani from whom he takes the strong interest in chromatic effects. But above all, this drawing should be compared with the contemporary entries of Niccolo Ricciolini with whom, especially from the point of view of drawing, Bicchierai undoubtedly had many points of contact.

Only recently has a study been made of the graphic output of Bicchierai, and in particular of the drawings produced towards the middle of the century for the decoration of the Albani villa. As Rodinò rightly noted, rather than with "refined and cultured" artists such as Chiari and Masucci, to whom Schröeter refers (1982, p. 188), Bicchierai may be compared with that group of able and superficial decorators "who are characterized by having fused, in their eclectic language, trends of the late classicism of Maratti with fading echoes of the baroque style" (Prosperi Valenti Rodinò, 1985, p. 240).

G.C.

Prima Chefio della Pittura. Secondo Primo Premio. Antonio Bicchierari Romano.

B 62

20 ANTONIO BICCHIERAI (Roma 1688 – 1766)

Rebecca at the well

1704, First Class of painting, *extempore* work, inv. A. 160.
red chalk, mm. 265(360)×180(235).
at the bottom: *Prova di Antonio Bicchierari 1704 B.*

While the drawing to be submitted on the day of the competition had to represent an episode from Roman history, the 1704 extempore assignment which the artist had to produce on the spot in order to guarantee his competition drawing required the depiction of a scene from *Genesis*: the meeting at the well between Rebecca and Eliezer, the servant sent by Abraham. This subject was chosen, as was usual, by Giuseppe Ghezzi.
Bicchierai exploits the verticle possibilities of the sheet, producing a symmetrical composition which is iconographically rather ordinary. Not being able to take complete advantage of the *chiaroscuro* effects possible with the red chalk because of the restricted time available, the artist preferred a rapid stroke with an irregular and jagged course. It is this touch which gives lightness to the figures and a vague idea of movement, an impression accentuated by the agitated and almost transparent drapery.
The extempore obviously should be read in relation to the finished work submitted in the competition (cf. catalogue entry no. 19). Such a comparison is quite interesting because in the extempore sketch, leaving his academica training behind, Bicchierai produced a drawing which was more fluent, and which better reveals his personality as a skilled, if superficial, decorator. More immediate, however, is Bicchierai's relationship with the Roman environment of the early 18th century to which Prosperi Valenti Rodino refers (1985, p. 240), when analyzing Bicchierai's graphic production as a mature artist.

G.C.

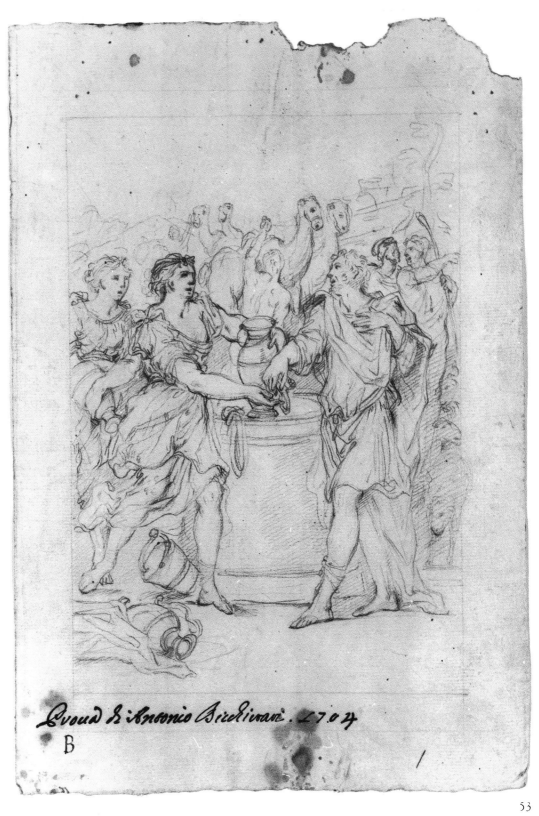

Qvovd di Antonio Birdiivani. 1704

B

1

21 LUDOVICO MAZZANTI (Roma 1686 – Viterbo 1775)

Romulus and Remus pursue and kill the Thieves

1704, Second Class of painting, first prize, inv. A. 166.
red chalk, mm. 490×770.
at the bottom: *H 1704. Pittura Seconda Classe Ludovico Mazzante Romano Primo Premio. Remo e Romolo fatti Adulti perseguitano e uccidono li Ladroni, B 59.*

Ludovico Mazzanti became a pupil of Giovanni Battista Gaulli in 1700. He took part in the Clementine competitions of 1703, 1704, 1705 and 1708. In 1744 he became a member of the Accademia di San Luca. His first documented works were painted for several churches in Orvieto, his family's city of origin. There followed, in 1720, the frescoes for the Chapel of the Annunciation in the church of S. Ignazio in Rome, and between 1721 and 1725 he completed the four paintings for the church of S. Andrea on the Quirinal. Between 1733 and 1739 Mazzanti worked primarily in Naples. A large number of oil paintings and frescoes for the Neopolitan churches of the Gerolamini, Gesù Nuovo, Nunziatella and S. Maria delle Grazie at Marigliano result from this period. Other works by his hand are found in Perugia, Viterbo and Città di Castello (for a list of his works cf. P. Santucci, 1981).

Treading initially in the footsteps of Gaulli, Mazzanti's attachment to Neapolitan painting continued for the rest of his life. After his period in Naples however, he reattached himself to the compositional style of his first master, and his painting taken as a whole, demostrates extreme discontinuity.

In Mazzanti's copy of the ancient relief with the *Emperor Marcus Aurelius receiving the Vanquished* (Rome, Palazzo dei Conservatori), the assignment given to the third class in 1703, the influence of Gaulli's school was already apparent. In relation to this drawing it should be noted here that in the successive period of annotation and attribution, the drawings of Mazzanti and Pietro Marchionni were evidently exchanged. (Thus, in Disegni, II, drawing A 155, attributed to Marchionni, in reality is probably that of Mazzanti, while drawing A 156, attributed to Mazzanti, is more likely the work of Marchionni).

In illustrating the second class theme in 1704, Mazzanti held himself tightly to the artistic dictates of his master Gaulli with regard to composition, stroke, typology of the figures and drapery style. The figure of one of the animal thieves lying on the ground is simply a paraphrase of one of the Damned painted by Gaulli on the ceiling of the church of the Gesù. And the figure of Remus on the extreme left of the drawing, is similar to that of the boy with the ram in Gaulli's painting, *The Thanksgiving of Noah* (Atlanta, The High Museum of Art). The figure of Romulus, the central character of the composition, betrays the same errors committed by Gaulli of in the drawing of figure's legs in profile: the observer is not able to distinguish which of the legs is nearest to him. And as occurred frequently in the compositions of Gaulli, the intermediate figures (in Mazzanti's drawing, the man with the sheep on the left between the tents, and the other man in the center leading the herd of cows) appear considerably shrunken. Given the numerous borrowings and citations from Gaulli's formal repertoire, the direct involvement of Gaulli himself in the forming of the idea of the drawing seems probable.

D.G.

1704. Pittura Secondà Classe. Ludovico Mazzanti Romano Primo Premio. — Romolo e Remo fatti Adulti perseguitano, e uccidono li Ladroni. B.59.

22 FILIPPO EVANGELISTI (Roma 1684 – 1761)

The Rape of the Sabine Women

1705, First Class of painting, first prize, inv. A. 176.
red chalk, white chalk, mm. 545×800.
on the reverse: N 28 B; and, by another hand: *1705. Prima Classe, Primo Premio Filippo Evangelista.*

Filippo Evangelisti participated in the Clementine competition twice. In 1702 he won first prize in the second class with a depiction of the "Supper at Emmaus". In 1705, he reentered the competition with the present drawing, and won one of the two first prizes. The other was awarded to the Sienese Bernardino Baroni (Disegni, II, A. 177).

Filippo Evangelisti was a pupil of Benedetto Luti, and his influence is recognizable in the soft forms of the figures which are rather blurred against the background and evidently not very well preserved. Confronted with this subject, the young artists vied not with bright ideas but, above all, with paraphrases and citations of famous groups of the *Rape*, both to give proof of their culture and to create the effect of "recognition" required by the Accademia judges and by the more expert public. For example, one finds two figural variations, one from the *Rape of the Sabine Women* of Pietro da Cortona (Rome, Pinacoteca Capitolina), and the other from the *Rape of Persephone* of Bernini (Rome, Galleria Borghese) on the steps leading to the throne of the king. Filippo Evangelisti later became an art impresario, and employed Marco Benefial. In 1736 he was nominated a member of the Accademia di San Luca.

D.G.

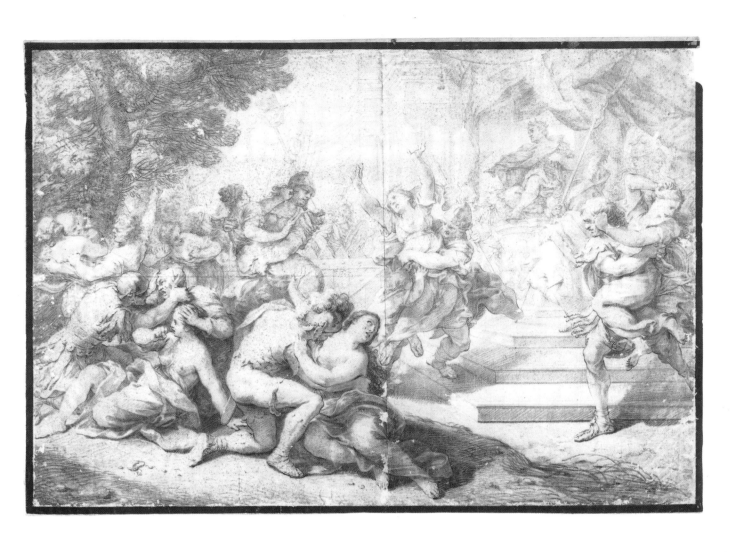

57

23 LUDOVICO MAZZANTI (Roma 1686 – Viterbo 1775)

The Rape of the Sabine Women

1705, First Class of painting, second prize, inv. A. 179.
red chalk, white chalk, mm. 510(550)×705(785).
at the bottom: *11. 1705. Pittura Prima Classe Secondo Premio Ludovico Mazzante Romano poi Accademico di San Luca. B 71.*

As in a frieze, the action develops through pairs of figures in a foreground which is closed on the left, by a tree and, on the right, by an architectural structure. In the compositional form and in the particulars of the figures and drapery, one notes here Mazzanti's total adaptation of the art of Gaulli, with complete citations of motifs and images.
For example, the sovereign seated on the throne, on the right, and the warrior standing at his side are directly taken from Gaulli's painting, *St Julian before the Judges*, which we know thanks to Jacob Frey's engraving (Graf, 1976, fig. 797). The architecture of the palace in the background is an exact copy of the Belvedere castel which appears, also in the background, in Gaulli's painting, *Joseph reveals himself to his Brothers* (Ajaccio, Musée Fesch, *Seicento Le Siecle de Caravage dans les collections françaises*, 1988, no. 7, with color plate). From this same painting is taken the idea of the single harmoniously interwoven units of figures.
Comparing this drawing with that submitted by Mazzanti in the 1708 competition of the first class (Disegni, II, A.218), with which he won first prize, one notes immediately that, while this earlier drawing is still very close to Gaulli, the entry piece of 1708 in general shows a more personal style but is qualitatively inferior. Here he still refers to Gaulli in the group of warriors in the left foreground.

D.G.

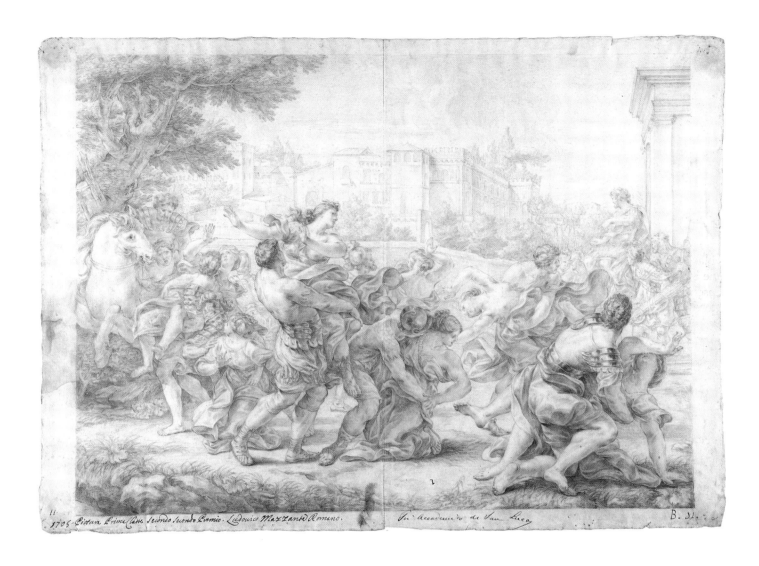

1705 Pittura Prima Classe Secondo Secondo Premio. Lodovico Mazzante Romano. Per Accademico de San Luca B. 21.

24 GIOVANNI BATTISTA CALANDRUCCI (Palermo ? – Roma 1749)

The Rape of the Sabine Women

1705, First Class of painting, third prize, inv. A. 180.
pencil and red chalk, mm. 540×780.
at the bottom: *12. 1705. Pittura Prima Classe Terzo Premio Gio: Batta Calandrucci palermitano B 69*; on the reverse: *N 29 B*

Giovanni Battista Datino, who called himself Giovanni Battista Calandrucci, was the nephew and pupil of Giacinto Calandrucci (1646-1707). Together with Giacinto's brother, Domenico, who died in Rome in 1710, Giovanni Battista worked in the studio of Giacinto until the latter's death. In his will of 1710 Domenico left him "the paintings and the drawings concerning the study of painting". (I thank Olivier Michel for information concerning the will of Domenico Calandrucci preserved in the Archivio Storico Capitolino. Cf. also Guerrieri Borsoi, in *Studi Romani*, 36, 1988, p. 273, who likewise examined the will and published further information on the Calandrucci family).
Titi mentions two paintings: a *Birth of the Virgin* and *Education of the Virgin*, in the first chapel on the right of San Lorenzo in Piscibus, now both in the Istituto dei Padri Scolopi, as works of G.B. Calandrucci. The two lateral pictures in the chapel of St. Elia in S. Maria in Transpontina in Rome are also probably attributable to Calandrucci. Two sketches artistically of a very modest level, depicting episodes from the life of St. Oliva, were reproduced in engravings by G.B. Sintes and G. Frezza. In addition G.B. Calandrucci provided the drawing, a copy of P.A. Pucciardi's painting, *St. Margaret of Cortona* for the engraving of G.B. Sintes. Finally, G.B. Datino (that is G.B. Calandrucci) and G. Calandrucci are cited as the designers of the engraving by Francesco Aquila with *David and Abigail* (Graf, 1986, vol. 1, p. 215 ff.; vol. 2, fig A 111, A 114).
It is still not possible to identify Giovanni Battista Calandrucci as an autonomous artistic personality. In his present drawing a loggia on the left divides the composition into two parts. In the foreground and the middleground of this bipartite stage Calandrucci develops the theme of the rape of the Sabines, relying heavily on the painting with the same subject by Pietro da Cortona (Rome, Pinacoteca Capitolina). His study of the *Rape of the Sabine Women* by Giovanni Bologna (Florence, Loggia dei Lanzi) and the *Rape of Persephone* by Bernini (Rome, Galleria Borghese) is also evident. In addition the motif of the kneeling woman with arms raised in imploring gesture from Raphael's *Burning of the Borgo* is notable.
The military captain beneath the loggia is copied from an analagous figure in Poussin's *Rape of the Sabine Women* (Louvre), a work etched by Etienne Baudet. A second painting by Poussin on the same theme, (now in the Metropolitan Museum, New York), was known during this period from Jean Audran's reversed engraving.
As in Passeri's painting now in the Louvre, the space is delimited in this drawing by the architecture on the left, though somewhat less severely. Beyond the loggia on the left, the view opens onto a temple, close to which stands a circular building, half-covered by the pilaster of the loggia. The space on the right is closed by the battlement walls of a city with gate and towers. These architectural structures, placed one against another as if unrelated side-scenes are, like the principal group of the scene, simply visual citations.
A second example of this drawing, identical in size and reproduced here on a smaller scale, is in the Kunstmuseum of Düsseldorf (Graf, 1986, cat. no. 1028, fig. 1146). In this work, however, the architectural elements are drawn in pen and shaded in grey, clearly the work of another hand. This leads to the supposition that a student from the architecture class helped G.B. Calandrucci with this detail. The groups of figures, in

60

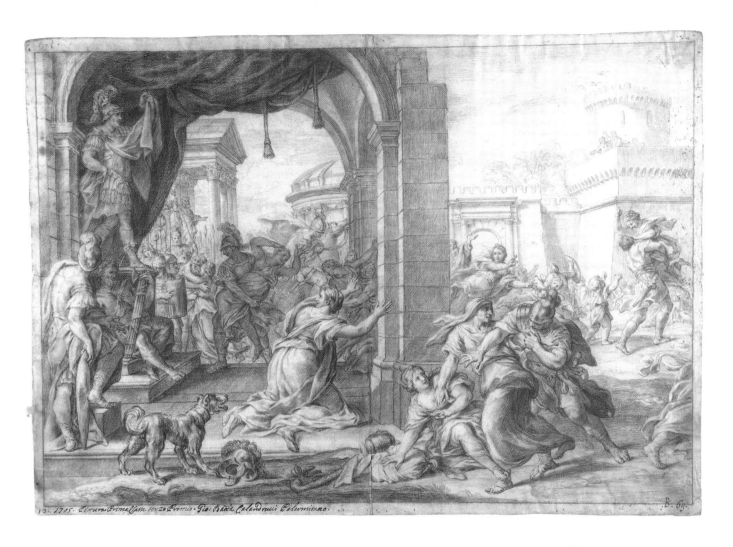

Düsseldorf - Kunstmuseum

contrast, betray the influence, if not help of Giovanni Battista's uncle Giacinto Calandrucci. In fact the closeness of these figures to the formal repertoire of the uncle is clear; the dog, on the left, in the foreground, and the young boy, in the middle on the right, are actual citations from the paintings of the uncle. The examination of such details throws light upon the various phases of the production of the competition entries. Without doubt, the masters in whose studios the pupils participating in the competition were working furnished, at least occasionally, partial help in the drafting of the composition. In this way a first draft was probably made; the sketch in Düsseldorf functioned as such. From this, the pupil then elaborated the final drawing which he submitted for the competition.

D.G.

25 CRISTOFORO GIUSSANI

The Sabine Women intervene to make Peace during the Battle between Romans and Sabines.

1706, First Class of painting, second prize, inv. A. 188.
red chalk, mm. 575×797.
Inscriptions: on the lower left border, "5. 1706. Prima Classe della Pittura. Primo Secondo Premio. Cristoforo Giusani Milanese. C=5"; al verso N 97 C.

Cristoforo Giussani came to Rome in time to compete in the Clementine *concorso* of 1703, in the second class of painting, from which both his red chalk drawing awarded the first prize and his extempore sketch in black and white chalk in the Academy collection (Disegni, II, A. 146; 147) are derived. Three years later he reappeared to win this second prize in the first class, shared by the Genoese Pittaluga and the Spaniard Pont (cf. catalogue entries ns. 26, 27).
From the absence of any mention of his name in the usual contemporary sources, it may be inferred that Giussani did not pursue his career in Rome but instead soon returned to Milan, where local guidebooks register two altarpieces from his hand: a *Resurrection of Lazarus* in San Bernardino alle Ossa and a *St. Lucy* in the church of San Calogero, demolished in 1951 following bomb damage in the last World War (Lattuada, I, 1737, p. 186; II, 1738, p. 253). This scarsity of pictures by him even in his native city (he should not be confused with Giovanni Giussani from Como, a specialist in ornamental frescoes discussed in the same entry in Thieme-Becker, XIV, 1921, p. 224) explains why he has not been the object of research, nor even cited in repertories such as the volume on 18th-century Milanese painting by M. Bona Castellotti (1986). But, on the whole, what was locally produced in the way of painting at the outset of that century has been scantily studied to date, despite the presence of Sebastiano Ricci there in 1695, that betokened the mutations in taste and style destined to condition artists of the generation to which Giussani presumably belonged. Above all it is the links with the Roman School, in this situation, that have yet to be brought into proper focus, beginning with the emergence of Stefano Maria Legnani, a talent of stature who already before the turn of the century had reached the Papal city and, significantly, gravitated within the orbit of Carlo Maratti. In this context Giussani's prize-winning drawing of 1706 acquires a greater interest than it

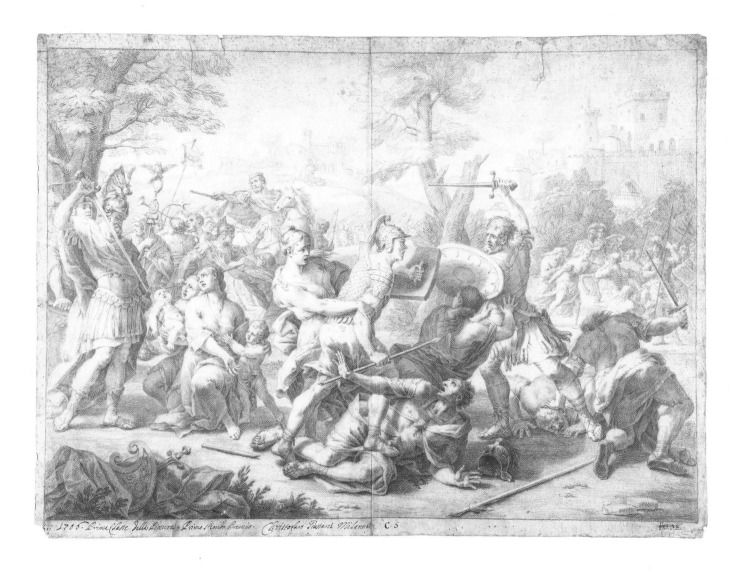

would merit on the grounds of its uneven quality. Indeed it incapsulates a miniature summary of the painterly culture then current in Milan, on which the grafting of innovations, often imperfectly amalgamated, was a reoccurrent characteristic when the twilight of the Spanish dominion solicited fresh orientations in one of the most prestigious capitals in the Italian peninsola.

It is therefore worth examining this drawing with a certain attention, although its syntax appears somewhat belaboured in comparison with the results of the other participants in the same class. Notwithstanding the coagulated grouping of figures, some rather awkwardly posed, Giussani offers a vivid glimpse of the brutality inherent in hand-to-hand combat and exemplifies both the rudimentality of his local training as an artist and the quota of vigorous expression that it could bring forth. The insertion of the panoply as *staffage* in the lower left corner is patently a scholastic exercise, if confronted with the

elegance of a similar detail in Pittaluga's representation of the same subject (cf. catalogue entry no. 27), and equally obvious are the citations from the Roman work of Pietro da Cortona (the king on horseback, from the *Battle of Alexander* now in the Palazzo dei Conservatori) and Mola (the felled soldier in a pose that harks back to *Saul* in a lateral of the Ravenna Chapel in the Gesù church, this in turn derived from Raphael's *Heliodorus* in the celebrated Vatican fresco). These features are leavened by the reminiscences of Giussani's Lombard heritage in the caricatured realism of some vaguely Leonardesque heads (the helmeted soldier in the foreground) and in the picturesque note provided by the Gothic portal of a castle that belongs to the Visconti period as much as to ancient Rome. Yet beyond the assorted ingredients, the truculence of the principal figures, frozen in torsion, probably owes something to the curious, Venetian-oriented *barocchetto* evolved by Paolo Pagani; conversely, the deft execution and differing style of those in the distance are consonant with the graphic manner of Pietro de' Pietri, a painter from Milan long established in Rome and one of the most esteemed pupils of Maratti. Thus Giussani emerges poised between the contrasting tendencies of Lombard painters 'abroad' in Italy, and his still mysterious development as an artist could well shed light on the rôle of de' Pietri as a point of reference in Rome for those of his compatriots who preferred to renew their art according to the dictates of academic-classicizing taste, rather than opt for the more decorative imagery that Venice was exporting to Milan in that period.

S.R.

26 MIGUEL PONT (Manacor *c.* 1686/1690 – Palma 1755)

The Sabine Women intervene during the Battle of the Romans and Sabines.

1706, First Class of painting, second prize, inv. A. 189.
red chalk, mm. 540×765.
at the bottom: *3. 1706. Pittura Prima Classe Secondo Premio Michele Pont Spagnolo Maiorchino C-6*; on the reverse: *N 92 C.*

The quantity of drawings which remains on this difficult theme may reflect the discomfiture of the members of the jury in choosing between the contestants. None had succeeded in rendering an easily recognizable scene as had, for example, Guercino in the Gallery of the Hôtel de la Vrilliére (*Seicento. Le siècle de Caravage dans les collections françaises...*, 1988, p. 246).
Michele Pont, from Majorca, was probably born between 1685 and 1690. He seems to have studied in Rome since for several years we find him among the prize winners of the Accademia di San Luca. He was first in the third class of 1704 (Disegni, II, A. 170) with three handsome copies of ancient statues then in the Verospi palace. In 1705 he took the first prize in the second class (Disegni, II, A. 181) with an accomplished, well-constructed drawing on the theme *The Beginning of Rome's Construction*. This drawing was without doubt of better quality than that which took the second prize in the first class the following year. Here the battling warriors are given more space than are the wives and the

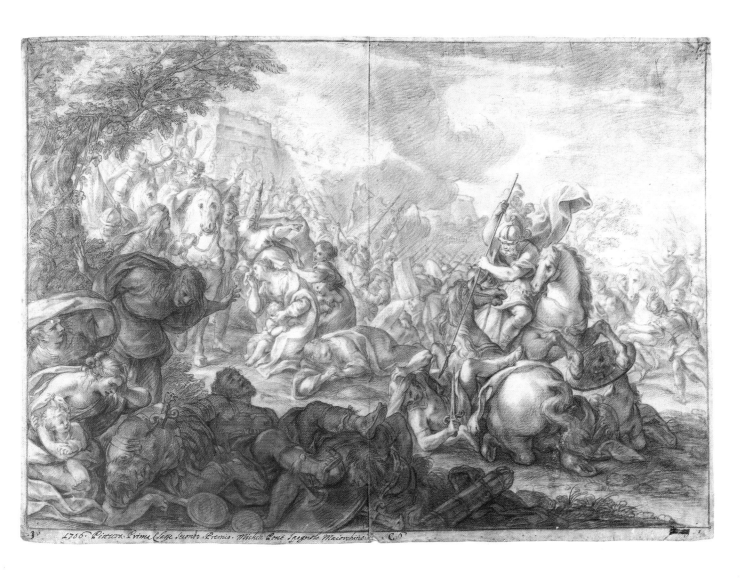

1706. Pittura Prima Classe Secondo Premio. Michele Conte Spagnolo Maiorchino.

65

27 GIOVANNI NICCOLÒ PITTALUGA

The Sabine Women intervene during the Battle of the Romans and Sabines.

1706, First Class of painting, second prize, inv. A. 191.
red chalk, mm. 540×785.
on the lower *N. 2. 1706. Pittura Prima Classe secondo Premio. Nicolò Piccaluva Genovese C. 7*; on the renverse:
n. 22B.

Pittaluga (or Piccaluva) was one of the most assiduous participants in the Clementine competitions held during the first decade of the 18th century. In 1704 he debuted in the third class of painting, (Disegni, II, A. 174) where he won a third prize; the following year he progressed to the second class taking another third prize (Disegni, II, A. 183) and in 1706 to the first class, in which he was awarded a first prize (Disegni, II, A. 225) that he duplicated in 1708 and once more in 1710 (Disegni, II, A. 249; cf. catalogue entry no. 39). Presumably he belonged to one of the durable and ramified families of artists that are a constant, indeed distinctive factor in the history of Genoese painting of the 17th and 18th centuries. His surname at least suggests some degree of parenthood with Gerolamo, a wood-sculptor active during the same period, with Francesco Maria (the xylographer who signed a print in Rome dated 1710; cf. Newcome Schleier, 1989, p. 174) and with Antonio (a practically unknown painter who died in 1716 at the age of forty). In any case, C.G. Ratti is the sole author to have drawn attention to the artistic potential of Giovanni Niccolò, unfortunately only many decades (1797, p. 68) after his demise and with the regret of not having been able to learn anything about his life and work: "About this time there was another Pittaluga who painted, by the name of Niccolò, and gained greater praise than the aforesaid Antonio, I myself having seen in Rome many of his drawings which merited the highest prizes that are dispensed there by that illustrious Academy of St. Luke; but I have no other information on his account, even though he was Genoese and deserves a more honourable mention". This oblivion is probably imputable to the nature of the work he did for the Princess of Piedmont in 1723-27. In fact, documents of payment in the archives of the Royal House of Savoy (Baudi di Vesme, III, 1968, p. 831) reveal that Pittaluga remained in Rome for years after the season of his competition prizes, regularly employed to provide her with "little fans painted in miniature". Thus, by choice or by necessity, he turned his considerable talent (judging by the group of drawings in the Academy, which is his total *œuvre* thus far known and understandably drew Ratti's admiration) to the sort of tasks commonly associated with the artisan category.

In effect, one can perhaps already note in this drawing of 1706, underlying the dainty meticulosity of the execution, a hint of the vocation for miniatures that would turn Pittaluga to the production of paintings "in piccolo", such as the some dozen fans recorded but still to be identified. We are here confronted with an artist of impeccable technique, who moreover appears cultivated and well cognizant of the Genoese tradition that was his heritage. Unlike the other participants in the first class, he extended the given subject in an ambitious scenic view of a vast battle receding to the distant horizon, the components of which are efficaciously brought into focus through graduations in *chiaroscuro*, ranging from the heavy shadowing that models the tangle of combatants in the foreground to the delicate transparency of the tiny figures plotted against the ruins of ancient Rome. Although the compositional scheme recalls the 17th century formulae for battle-scenes established by Tempesta, Le Brun and others, it is especially related, even in details of the armor and horses, to the popular series of engravings designed by Bernardo Castello to illustrate Tasso's *Gerusalemme Liberata*, published in several editions (including a widely distributed "pocket" one) after the first printed in Genova in 1590. Apart

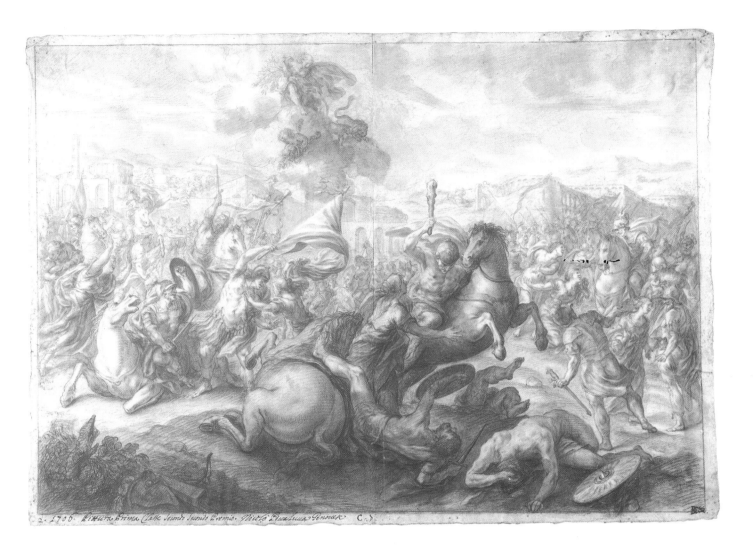

from sparse references to Cambiaso (the horseman wielding a club, etc.), the models of Valerio Castello imprint female figures such as the beautiful Sabine who forms the crux of the intricate whorl of soldiers and horses in the principal group. Within a conspicuous repertory of poses, highly studied yet fluidly delineated, one may note how the artist has aptly conveyed the sense of the legendary episode by placing in the midst of each group of soldiers a Sabine woman, who implores or enjoins them to cease fighting, and by the charming allusion to this placatory intervention in the lion paired with a lamb on the clouds, together with Peace herself and a putto bearing the cornucopia of Abundance.

S.R.

67

28 GIOVANNI BATTISTA CALANDRUCCI (Palermo ? – Roma 1749)

The Sabine Women intervene during the Battle of the Romans and Sabines.

1706, First Class of painting, third prize, inv. A. 192.
red chalk, mm. 540×770.
at the bottom: *4. 1706. Pittura Prima Classe Terzo Premio. Gio: Battista Calandrucci Palermitano C 49*; on the reverse: *N 20 B.*

The action, enclosed as if in a relief, unfolds on a very narrow band in the foreground, in front of a hill upon which towers a fortification. A young woman restrains the Sabine warrior who is about to hurl himself upon a Roman to the right, who in turn is restrained by another of the captive Sabine girls. On the ground lie the dead and wounded. In the background where a horseman stands over the remaining combatants, tight groups of ensigns, weapons and flags are visible. Other scenes of battle are seen in the distance. The principal Sabine woman who separates the warriors resembles the Miriam of Maratti. In fact the exemplary formal repertoire of Maratta, passed on by Giacinto Calandruci to his nephew, is clearly recognizable throughout the drawing (for the relationship between Giacinto and Giovanni Battista Calandrucci (cf. catalogue entry no. 24). Only with difficulty could a pupil come as close to his master as Giovanni Battista did to his uncle and teacher, Giacinto.

D.G.

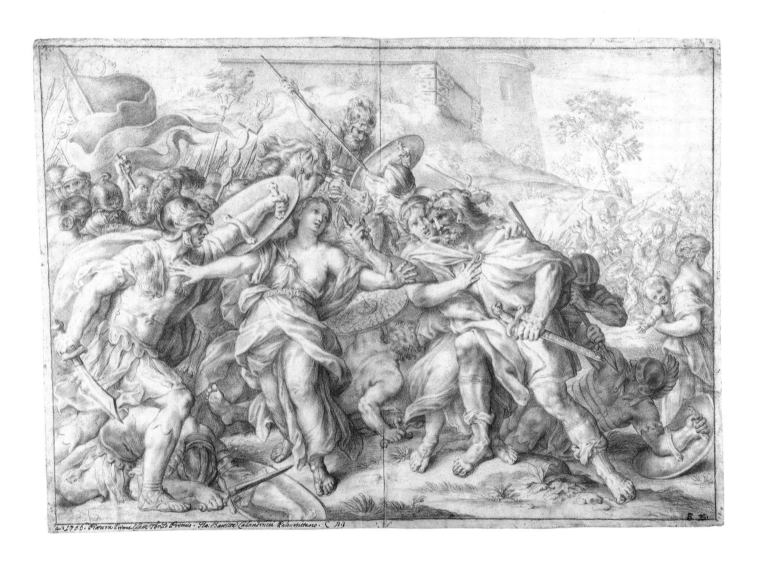

4. 1706. Pictura Prima Clas: Terti Premis: Jo: Baptista Calandruca Perusino. C 49

69

29 MARIANO PATRIZI Marquis (Roma 1663 – 1744)

The Sabine Women intervene during the Battle of the Romans and Sabines.

1706, not in the competition itself, inv. A. 194.
red chalk, mm. 595×(630)×820(845).
at the bottom: *Soggetto della Prima Classe della Pittura espresso dell'Ill.mo Signor Marchese Mariano Patrizij Accademico d'Onore e regalato all'Accademia nel Concorso in Campidoglio dell'Anno 1706.*

In addition to being a patron of the arts Marquis Mariano Patrizi was also a "dilettante painter". According to the most recent research of Maria Barbara Guerrieri Borsoi (but see also Michel, 1984, p. 412), he possessed his own studio "for painting", which was hung with pictures. From 1706 he was also an honorary academician of the Accademia di San Luca.
Both in the figures and in the faces, this composition of Mariano Patrizi betrays the evident influence of Giuseppe Passeri. This can be seen, for instance, in the weeping woman on the left, or the group of figures on the right in the foreground formed by a mother who is showing her children to the king on horseback to persuade him to put an end to the fighting. Also related to Giuseppe Passeri's characteristic style are the gracefulness and the mobility of the figures in this drawing, and also the buildings, isolated or in groups, visible on the hills in the middle and background. Such motifs in very similar forms are found in many of Passeri's paintings. This stylistic relationship is not surprising. Maria Barbara Guerrieri Borsoi has been able to document the close connections which existed between Giuseppe Passeri and the Patrizi family, for whom the painter executed (among other things), the frescoes on the ceiling of the family palace near S. Luigi dei Francesi, and those at their country house at Castel Giuliano. It is probable, in fact, that Passeri was the master of the brothers Francesco Felice and Mariano Patrizi, both amateur painters (Guerrieri Borsoi, Rome 1989, pp. 173-203, 381-403). We are not, however, at present able to ascertain whether Passeri was directly involved in Patrizi's Accademia composition or if Mariano Patrizi was in fact able to invent his own designs, imprinted, nonetheless, with Passeri's style. A drawing by the latter in the Kunstmuseum of Düsseldorf (Inv. n. FP 2538) on the same subject, may provide a clue regarding the help which Passeri hypothetically offered Patrizi, perhaps by furnishing preliminary sketches which Patrizi ably developed.

D.G.

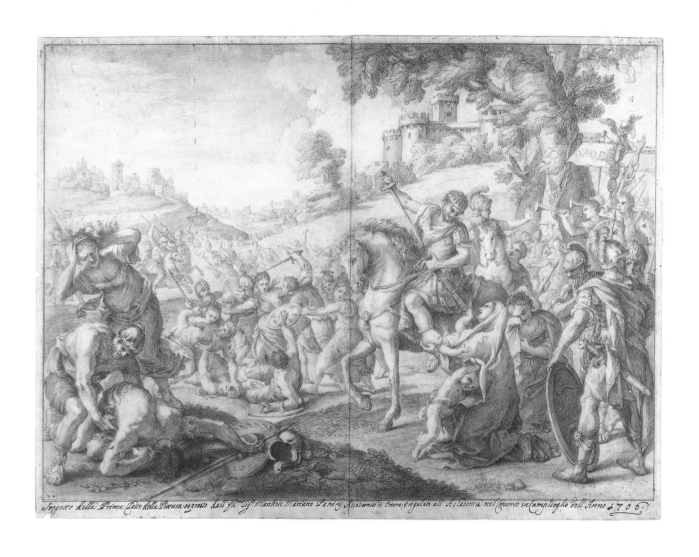

Soggetto della Prima Parte della Storia espresso dall'Ill.mo Sig.r Marchese Mariano Sacrip. Accademico di Onore, e regalato all'Accademia nel Concorso in Campidoglio dell'Anno 1706.

30 HENRY TRENCH (– London 1726)

The Romans slay the Traitress Tarpeia on the Capitol.

1706, Second Class of painting, first prize. inv. A. 195.
red chalk, mm. 510×710.
on the lower: *1706. Pittura 2d. Classe primo Premio Enrico Trench Ibernese C. 44*; on the reverse: *N 60 C.*.

Possibly Henry Trench came as early as 1700 to Rome, where he studied painting under Giuseppe Chiari. However his presence there is documented only from 1705, when he participated in the third class of painting in the Clementine *concorso* to win a first prize, together with Paolo Filocamo from Messina, for his copies of three antique statues (Disegni, II, A. 185). The following year he was awarded the first prize in the second class for the present drawing and his extempore sketch (Disegni, II A. 196), but only in 1711 did he enter the first class, taking a second prize (Disegni, II A. 259).

At that time the academic successes of this Irishman, rather than advancing his career, brought him into direct confrontation with the enterprising William Kent (cf. catalogue entry no. 50), who also aspired to capture the favour of Lord Burlington, the distinguished patron and later promoter of the Neo-Palladian movement in English architecture. According to Vertue (1936, p. 136), Trench was "look't upon to be the better painter of the two by much, having gained the first prize in the Academy – and well known to his Lordship also". Yet at this juncture he made a false move by writing a letter of self-promotion to Burlington, "setting forth the difference of merit on his side, more than Kent's": missive that effectively spoiled his chances in that quarter, "as sometimes Lord Burlington would read it to Kent, by way of mortification – and mirth" (ibid.). In actual fact, during the some twenty years he spent in Rome Trench produced, apart from the Academy drawings, an other representing *Soothsayers in a Classical Landscape* (London, British Museum, Inv. 1874-8-8-135), an etching after Raphael dated 1717 and little, if anything, else. Thus as late as 1718 Kent informed a friend, not without a touch of malice, that "he has not done one picture here" (Wilson, 1984, p. 29). This lack of productivity was perhaps due to the fact that Trench had launched himself into antiquarian activities, as results from a letter written by Lord Raby in 1710, recommending his services in fulsome terms ("rather take the advice of French [sic] than any other": ibid.).

It is unlikely that Trench developed a penchant for "History" painting in his native Ireland, where portraiture was still the mainstay of local artists (recently of a more Italianate variety, after Hugh Howard's Roman sojourn in the *milieu* of Maratti). The hypothesis of a stay in London could explain why he decided to pursue his studies on the Continent, which had lately supplied England with the masters (Verrio, Laguerre, Cheron) currently in demand for this sort of painting in the aristocratic and Court circles. In any case, the drawing he submitted to the 1706 *concorso* does not particularly evince his insular background, excepting the type of rusticated Ionic gateway, borrowed from the Venetian architectural tradition of Serlio and Sanmicheli that Burlington and his friends appreciated. On the contrary, the taste and manner of this academic essay indicate the degree to which Trench had diligently assimilated the lesson imparted by Chiari in a passable attempt to camouflage himself as a Roman.

The backdrop of the city wall angled towards the left is well imagined as a framing device for the savage episode, in which the actors are artfully deployed in a rhythmical sequence of gestures to batter the wretched Tarpeia with their shields. Trench seems to have approached the subject from the standpoint of a literal representation of the incident (the keys, used to open the citadel to the enemy, are clearly evidenced), cast in the decorum of a selection of Marattesque attitudes, whose accurate delineation does not however

countervail the enervated blandness of their facial expressions. In this sense a comparison with the cogency of Masucci's version of the subject (cf. catalogue entry no. 31) suffices to underline the superior artistic gifts of the latter, who drew inspiration directly from the source, that is Maratti himself, and possessed the talent to use it more effectively.

In the end Trench made his tardy debut in England as a fresco painter, in 1722-23, when he decorated a few ceilings in the house of Sir Thomas Hewet at Shireoakes (destroyed: see Croft-Murray, 1970, p. 278). In the intervening years he had nevertheless been preceded by such noteworthy Venetian masters as Pellegrini and Sebastiano Ricci: discouraged by a lukewarm reception in England, he took refuge once again in Italy, this time to perfect his color by studying under Solimena. His return was announced in 1725 by his friend William Aikman, who had proposed him to Sir John Clerk for the frescoed decoration of a stairwell (Wilson, p. 253, note 28): he died in London the following year.
Bibliography: L. Salerno, 1974, p. 352, fig. 26 (as "French")

S.R.

31 AGOSTINO MASUCCI (Roma 1690 – 1758)

The Romans slay the Traitress Tarpeia on the Capitol.

1706, Second Class of painting, second prize. Inv. A. 198.
pencil and red chalk, mm. 480(520)×720(765).
at the bottom: *20. 1706. Pittura Seconda Classe secondo Premio Agostino Massucci Romano C-2 (poi Accademico di S. Luca e Presidente)*; on the reverse: *N 61 C.*

With this subject from Roman history, Massucci took second in the second place class of the competition of 1706, sharing the prize with Paolo Filocamo from Messina. Born in 1690 (and not in 1692: Pio, 1977, p. 145), as is shown by the birth certificate in the Baptismal Register (Rome, Arch. St. del Vicariato, Parrocchia di San Martino ai Monti, Batt. VI, 1675-94), he began to paint at a very early age. For two years he followed the teachings of the Marattesque Andrea Procaccini (Pio, 1977, p. 201) who, recognizing the youth's gift for drawing, introduced him to the circle of Maratti's pupils. It is probable that this phase of his apprenticeship coincided with the courses which he took at the Accademia di San Luca, which made it possible for him to participate in the competitions of 1706 and 1707 under Maratti's direction. These circumstances permitted him to have close contact with Giuseppe Chiari, Luigi Garzi, Giovan Maria Morandi and Benedetto Luti, the judges in the competition of that year, who transmitted the ideas as well as methods of Maratti. This situation helps to critically explain Pascoli's affirmation that Masucci "although very detached from the style of the master, is a most worthy member of his school (Pascoli, Vite, I, 1730, p. 145). The Marattism of Agostino, reflects not only the formal appearance of the master's style, but also the his classical concepts. Massucci expresses Maratti's interpretative intentions in his entry drawing which, though remaining an academic exercise, is coloristically closer to Morandi than to Luti. It also demonstrates a careful and controlled graphic procedure: the red chalk neatly conforms to and encompasses the profiles previously drawn in pencil, arriving at a masterful result which renders explicit the subject matter. At this point Masucci's style still leans towards the baroque, as may be seen in the gestural poses of in the figures, a few of whom already exhibit a heroic character which looks ahead to the late 18th century. These are placed into a spatial composition studied with geometric rigor, as the division of the sheet into squares implies. The figurative dynamism is balanced by the monumental, closely-woven architectural backdrop which conceptually strengthens the importance of the action taking place in the foreground. For example, the entrance hall on the left is positioned diagonally to enliven the rush of the soldiers and the interweaving of the spears. This compositional form with lateral perspectives was used by Masucci at various times throughout his artistic career, for example in the *Judgement of Solomon* of 1738 (Turin, Palazzo Madama), and in *The Ecstasy of Saint Catherine de' Ricci* of 1747 (Rome, Galleria Nazionale d'Arte Antica).
Bibliography: A.M. Clark, in *Essays in the History of Art presented to Rudolf Wittkower*, 1967, pp. 259-260; L. Salerno, Rome 1974, pp. 348, 352.

A.P.

74

75

32 AGOSTINO MASUCCI (Roma 1690 – 1758)

The Battle of the Horatii and the Curiatii

1707, First Class of painting, first prize, inv. A. 204.
pencil and red chalk, mm. 520(540)×760(775).
at the bottom, on the left: *Agostino Masucci*; ont the reverse: *N 104 C.*

In competition against Stefano Sparigioni, Paolo Filocamo, Giovan Battista Calandrucci, who shared second place, and Claude Jacquard and Filippo Bruni, an equal third, Masucci obtained the first prize in the first class of the competition of 1707 for which the battle between the Horatii and the Curiatii was the assigned theme. The most organic and balanced entry drawings are those of Masucci and Calandrucci, nephew of the famous Giacinto (Palermo 1646 – 1707), who acted as an important disseminator of Maratti's style in the southern Italian centres. The jury selected the former artist as winner, for his certainly superior graphic ability, while Calandrucci's style appears hard and stentorian by comparison, (Disegni, II, A. 209, here reproduced on a smaller scale). The two young Accademia students must have worked together, exchanging ideas and discussing goals in the months preceding the submission of their drawings because the two sheets are conceived in the same way; closely based on the "model" of Cavalier d'Arpino with the same figurative arrangement, figure types, conception of landscape and even the same presentation of the struggle between the protagonists. In Masucci's drawing they are counterposed and placed in a more harmonious relationship which brings about a better coordination of the gestures. The artist here has intentionally discarded the dynamic baroque formula in favor of a more controlled sense of movement which clarifies the narrative idea to the detriment of the action. The composition includes two warriors on horseback, who accentuate the oblique position of the combatants in the foreground. The compact ranks of soldiers act as scenic corollaries; although they are regularly placed, the impression they give is not at all static because of the different expressions of the men who play a commentative role in the narrative. Masucci's graphic technique is responsive to the exigencies of the narrative, and the attention he pays even to ornamental details expresses his need to produce a "finished" drawing, a picture whose technical perfection will be praised. While this is symptomatic of his academic formation, it stifles much of his natural graphic ability which spontaneously emerges in the extempore work presented for admission to the competition. Masucci's extempore piece depicts the *Flight of Aeneas with Ascanius and his father Anchises* (Disegni, II, A. 205; reproduced here on a smaller scale). The drawing is fresh and immediate. Here, the red chalk is not limited to the outlines, but is supplely used to indicate the volumes of the figures. The placement of the figures close to the plane of the observer is symptomatic of an expressive urgency which does not yield to a fascination with narrative, but monumentalizes the figures in order to bring out the historical fact. Parenthetically it may be noted that the importance which Masucci achieved in the realm of official portraiture during the first half of the century was not fortuitous, for his representation of the figure in the foreground conveys a severe and austere grandiosity.

It is clear that the extempore piece and the winning drawing share a common intention, which is however expressed differently in each of the graphic renderings. While in the *Horatii and Curiatii* the clarity of composition and obstinate technicality give the drawing a rigid coldness, they also strongly reveal the influence of Garzi. In the *Aeneas* drawing the richness of the image reveals the language of Maratti mediated by that of Chiari, though both drawings as well clearly show Masucci's own formal directions.

Masucci made his officially debut in 1715 (with the picture for the exhibition in S.

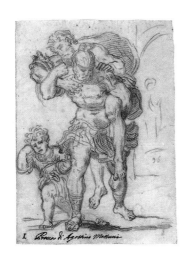

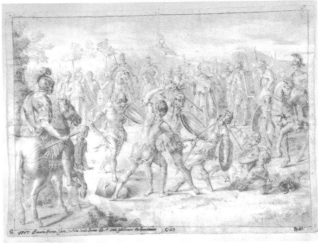

77

Salvatore in Lauro), and was proposed as a member of the Accademia di San Luca in 1722, appointed in 1724 (A.S.L., vol. 47, ff. 43. 51 r. and v., 72 r. and v., 75), and was Principal of the same from 1736 to 1738 (A.S.L., vol. 49, ff. 156, 165). He set out to interpret the last phase of "Marattism" especially after the death of Chiari in 1727, and assumed the role of mediator between Maratti's school and the burgeoning neoclassicism. Stylistically, the graphic works of 1706 and 1707 do not have much in common with the few drawings of Masucci known thus far (for which cf. Fenyoe, 1958, pp. 66-68; Clark, 1967, pp. 3-23; Dreyer, 1971, pp. 202-207; Pampalone, 1980, cat. 109; Mena Marques, 1988, p. 88).
Bibliography: A.M. Clark, in *Essays in the History of Art presented to Rudolf Wittkower*, 1967, pp. 259-260; L. Salerno, 1974, p. 352, fig. 25.

A.P.

33 CLAUDE JACQUARD (Nancy 1686 – 1736)

The Battle of the Horatii and the Curiatii

1707, First Class of painting, third prize, inv. A. 211.
black pencil and chalk, mm. 490(535)×730(770), composed of two sheets mounted together.
at the bottom: *1707. Pittura Prima Classe Terzo Primo Premio. Claudio Jacquardi Lorenese* C =8; on the reverse: *N 107 C.*

Claude Jacquard of Lorraine arrived in Rome already an experienced artist. Born in Nancy in 1686, the son of a carpenter, he was a pupil of the court painter Claude Charles, a skilled and prolific decorator. His sovereign, the Duke of Lorraine, took him under his protection. In 1719, in his letters Patent Herald at Arms (an honorary appointment in which he would have succeeded his master if he were to survive him), Jacquard was described as: "Our official painter; in Rome and in the other principal Italian cities where we have sent him and where he has stayed for several years to perfect his art, he has, during the eight or nine years he has travelled, on several occasions taken first prizes from the different academies" (Jacquot, 1986, 20, p. 707).
At his first Accademia di San Luca competition in 1707, he received the third prize, having to contend with rivals such as Masucci, Calandrucci, and others. The subject was a difficult one, not only because the battle between the Horatii and the Curiatii had already been dealt with a considerable number of times by great painters whose example it was difficult to disregard, (or to recall without copying), but also because the composition demanded a twofold and antithetic representation. It shows an immobile crowd, the two armies confronting each other, and the two champions engaged in a bitter duel upon which the victory depends.
Imitation of Cavalier d'Arpino's prototype in the Campidoglio was forbidden in the regulations announcement of the competition with a "... precise warning not to imitate, either with the actions or the disposition, the same story by Cavalier Giuseppe Cesari d'Arpino, painted in one of the rooms of the Campidoglio, because any drawing which does so will not be taken into account nor approved; each and every entry must present new ideas, so as to make recognizable a total diversity and observance of that which Titus

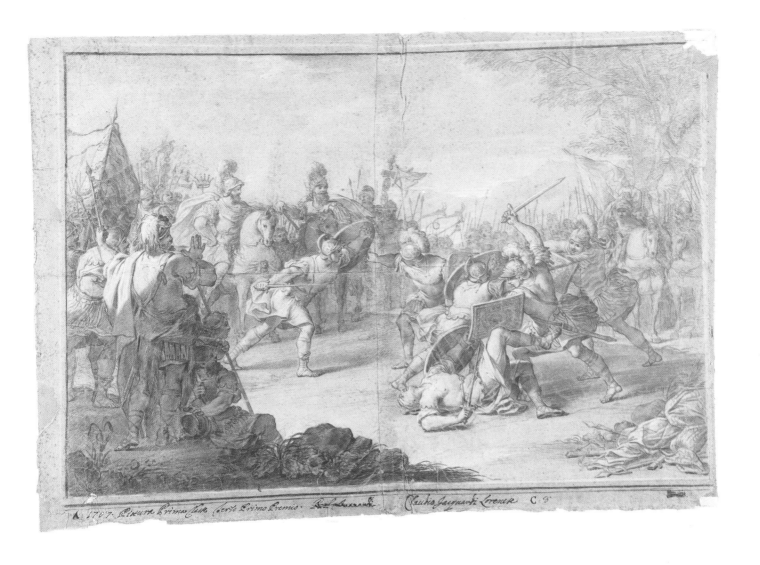

Livy said in the first decade of his History in the First Book" (A.S.L., Giustif. Concc. I, 1707, pp. 6-7). Nonetheless, all the contestants inevitably remembered the fresco. Jacquard in fact overcompensated to the extent that his attempt to distance himself from it becomes an element working against him, even though he succeeds in interrupting the symmetry, making the crowd less rigid and the central group more dynamic, and in fusing the two elements in an emotion-filled whole which excludes stereotyped formality.

Returning to Nancy in 1714 he pursued an honourable career until his death in 1736, painting the portraits of his sovereigns, creating designs for tapestries with battles, and several altarpieces. His best work is the fresco decoration of the cupola of the cathedral of Nancy, completed between 1723 and 1726 and inspired by that of the Val-de-Grace in Paris (Jacquot, 1896, n. 1, p. 697).

O.M.

34 GIOVANNI BATTISTA CALANDRUCCI (Palermo ? – Roma 1749)
The Torture of Mettius Suffetius ordered by King Tullus

1708, First Class of painting, first prize, inv. A. 219.
red chalk, mm. 500(540)×745(770).
at the bottom: *1708. Pittura Prima Classe Primo Premio. Gio: Battista Calandrucci Palermitano. C 20* on the reverse: *N 120 C.*

The horrendous torture of Mettius Suffetius, chained to two carts and torn apart, is recounted by Titus Livy in the first decade of his first book. The composition of this drawing is similar to that which he submitted for the competition of 1705 (cf. catalogue entry no. 25). Here too, in fact, the space is limited in the background by architectural elements, the figure representing the captain, on the left, is placed on a podium above which, as is found in the earlier drawing above the statue, a canopy-like drapery is unfurled. Additionally we find on the extreme left a soldier in a pose which is quite similar to a figure in the 1705 drawing. The whole composition contains numerous citations from famous masterpieces: for example, on the right, the group of overwhelmed people, the horses and the youth with the whip are all variations from the *Expulsion of Heliodorus from the Temple* by Raphael. Undoubtedly such citations were well thought of in the context of the competition. Several preparatory studies for this design are found in the Kunstmuseum in Düsseldorf, showing King Tullus and the soldier with the shield standing next to him (Graf. 1986, cat. n. 1032, fig. 1147). There is also a sketch for the entire composition (Graf, 1986, cat. n. 1031, fig. 1148; here reproduced on a smaller scale) in which, as noted above for the other sketch relating to entry no. 24, the architectural elements are the work of another hand, drawn in pen and shaded using, technique employed by architects. The figures, in contrast, are executed in red chalk over a preliminary drawing in black chalk. Thus after a first phase involving several hands, G.B. Calandrucci produced the definitive drawing in red chalk. Giacinto Calandrucci, Giovanni Battista's uncle, died in 1707 and therefore it is not possible that he helped his nephew also on this occasion. It is thus not surprising that the drawing departs from the style of Giacinto and moves closer to that of Agostino Masucci, the last and youngest pupil of Carlo Maratti. That there were close ties in these years between Masucci and Calandrucci due to their having the same master (either Maratta or Andrea Procaccini), is proven by the fact that Calandrucci's work submitted for the 1707 competition with which he won second prize is simply a repetition (more half-hearted and with minimal variations), of Masucci's drawing (cf. catalogue entry no. 32) which was awarded first prize. Masucci, against the explicit rules of the competition (cf. catalogue entry no. 33) based his composition closely on Cesare d'Arpino's fresco in the Palazzo dei Conservatori, Sala degli Orazi e Curiazi.

D.G.

80

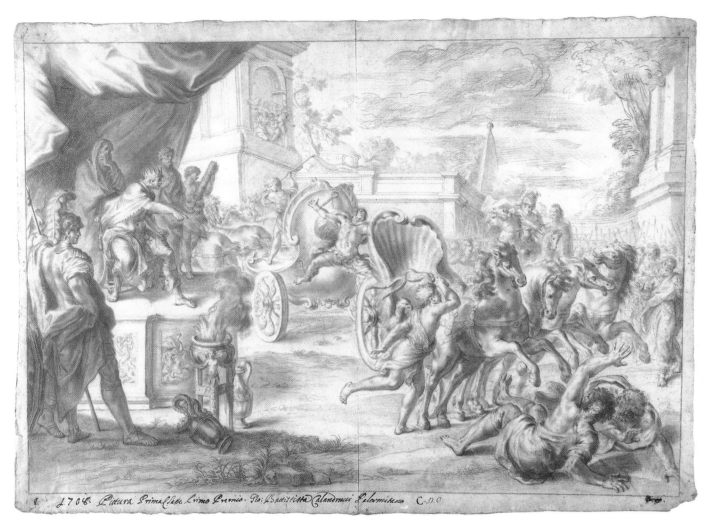

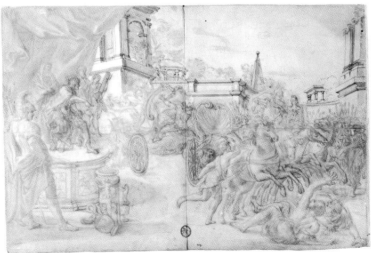

Düsseldorf - Kunstmuseum

81

35 STEFANO SPARGIONI

The Torture of Mettius Suffetius ordered by King Tullus

1708, First Class of painting, first prize, inv. A. 221.
red chalk, white chalk 515(540)×750(765).
at the bottom: G. 1708. *Pittura Prima Classe Primo Premio. Stefano Spargioni Romano C 18*; on the reverse: *N 119C*.

Stefano Spargioni, who had already participated in the Clementine competition of 1707 winning the second prize in the first class, is not traceable after the competition of 1708. In the competition of 1708 he shared the first prize in the first class with Ludovico Mazzanti (Disegni, II, A. 218) and Giovanni Battista Calandrucci (Disegni, II, A. 219; catalogue entry no. 34).

In his depiction of the hideous torture (cf. catalogue entry no. 34) Calandrucci showed Mettius Suffetius chained to two carts while King Tullus is about to give the order to tear apart the victim. But here, as in the drawing by Mazzanti, Spargioni shows four carts. In Mazzanti's work the traitor lies on the ground between the carts, but here the actual moment of the execution is shown. The view opens onto a broad flatland and in the distance are seen soldiers and the tents of the encampment. The charioteers are waiting for the blast of the trumpet, which will come from the group in the foreground on the left, to spur on the horses. The ropes tied to the wrists and ankles of the condemned man are already taut. Balancing the foreground group of soldiers on the left, near the weapons of Mettius Suffetius, is the figure of Tiber on the right. Much further back, beyond the tents, a chain of mountains is silhouetted against the cloudy sky.

From a compositional point of view, the drawing is similar to that of Ludovico Mazzanti, though Spargioni was not much influenced by Gaulli, Mazzanti's master, but rather by Giovanni Odazzi whose figures have, at times, a similar woodenness.

D.G.

G. 1700. Pictura Prima Case Prima Cremia Stefano Spargioni Romano. C 18

36 CLAUDE JACQUARD (Nancy 1686 – 1736)

The Death of Lucretia

1709, First Class of painting, first prize, inv. A. 236.
pencil, pen, watercolor, white chalk mm. 550×740(780).
at the bottom: *A. 1709. Pittura Prima Classe Primo Premio. Claudio Jacquard Lorenese C = 520*; on the reverse:
N. 1 C.

Claude Jacquard came to Rome to look for confirmation of his artistic ability. Thus he directly entered the first class competition of the Accademia di San Luca, even if, as we have seen, for his first attempt he took only the third prize (cf. catalogue entry no. 33). He was second in 1708, after Ludovico Mazzanti, with a forceful drawing of *The Torture of Mettius Suffetius ordered by King Tullus*, and finally, in 1709, arrived in first place.
His tenacity was justified because the talent of this young artist from Lorraine, who had come to Rome at the expense of the Grand-Duke Leopold, was in question: he had to prove with his own skill that Leopold's faith was well placed. It happened that Jacquard was in competition right from the start with several brilliant personalities so that, despite the fact that his drawings were more than competent, he did not succeed immediately in dominating the competition. In 1709 the situation was exactly the opposite. His adversaries, younger and less to be feared were Filippo Bruni, born around 1687 and Antonio Bicchierai, born in 1688 who went on to modest careers in Rome, primarily as fresco painters. Jacquard understood instinctively what was required for the task, that is, less immagination and greater subjection of his personal style to the theatrical mode with its dominant principle of expressivity.
The subject is narrated within a conventional, though well designed setting. Between a majestic canopy of weighty curtains which emphasizes the position of the central event, and a perspective which recedes towards the exterior (which explains the dress and gestures of Collatino who arrives from afar), the ancient sculpture and smoke from the sacrifice discretely evoke the people's justice and that of the gods, which will strike down Tarquinius, the cause of Lucretia's suicide. The young artist shows his ability above all in his grouping of a large number of people without harming the legibility of the narrative, making them express, by their expressions and the play of their hands, amazement, great distress and powerless rage.
Jacquard here falls into the line of the painters of the "Arcadia", protected by Cardinal Ottoboni, which goes back essentially to Sebastiano Conca and Filippo Trevisani.

O.M.

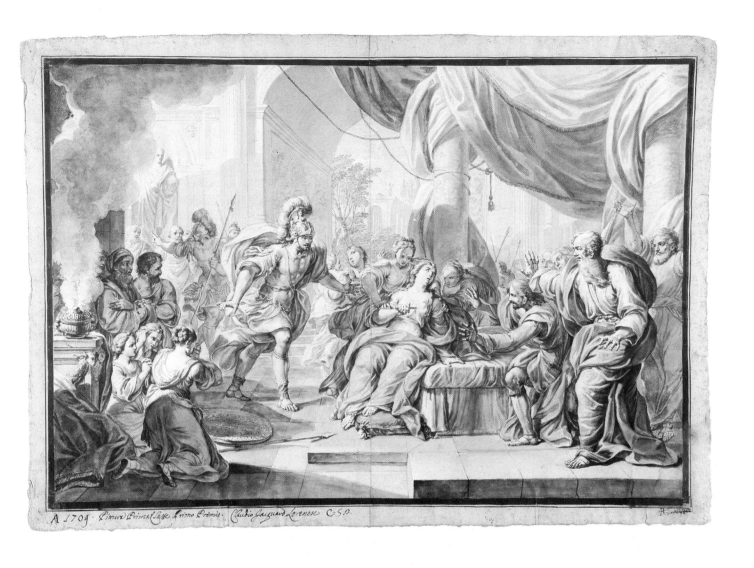

A 1709 · Pittura Primae Classe Primo Premio · Claudio Gaiquard Lorenese C=5.0

37 FILIPPO BRUNI (Rieti 1687 *ca.* – Roma ?)

The Death of Lucretia

1709, First Class of painting, second prize, inv. A. 237.
red chalk, white chalk, mm. 420(460)×580(600).
at the bottom: *I. 1709. Pittura Prima Classe Secondo Premio. Filippo Bruni Reatino C = 22*; on the reverse: *N B.*

Filippo Bruni of Rieti was probably born around 1687, a date which may be inferred from some documents preserved in the *Archivio del Vicariato di Roma* (in 1711 he lived in the parish of San Giovanni dei Fiorentini and was then 24 years old; cf. De Marchi, 1987, p. 241 note 3). Already by 1706 he had participated in the Clementine competitions, obtaining third place in the first class of painting; he then competed every year until 1710 when he won the first prize (cf. catalogue entry no. 38).
Very little is known of his artistic career, as he was almost completely ignored by contemporary historians; only Zani (1820, V, p. 84) cites him briefly. Recently De Marchi (De Marchi, 1987, p. 241 note 3) dedicated a brief informative note to him. This artist must, however, have carried out an activity of some importance at least for private individuals. He certainly worked for the Falconieri family for whom he painted some rooms in the villas of La Rufina at Frascati and at Torre in Pietra, information obtained from a *Stima* (appraisal) by Pier Leone Ghezzi on his works executed, between 1700 and 1733, for the two villas (Michel, 1977, p. 333; cf. also *Villa e Paese*, 1980, pp. 100, 103-104). His paintings were also held in private collections and were shown periodically in the exhibitions in Rome in the cloister of the church of San Salvatore in Lauro, specifically in 1709 and 1715, a year in which a sketch depicting *God the Father and Prophets* was presented (De Marchi, 1987, pp. 236, 328).
The assignment for the Clementine competition of 1709 was the depiction of the episode of the death of Lucretia. Filippo Bruni obtained second prize in the first class of painting, beaten only by the Frenchman Jacquard. Bruni produced a composition with an uncertain and simplified spatial structure based upon a central fulcrum, Lucretia, who is piercing her breast. Around her stand the spiralling figures of the men in armor with plumed helmets, while several young women rush in from the left. In the background on the left is a canopied bed and on the right, an opening guarded by other armed men. Characteristic of this painter are figures with elongated bodies and relatively small heads, and rather exaggerated drapery, with an altogether mannered effect. The chromatic rendering of the flags in the background is of interest. The overall effect is vivid and pleasing, and the baroque gesticulation is of tempered by the graceful, somewhat affected theatrical poses.

G.C.

I. 1709. Pittura Prima Classe Secondo Premio. filippo Brani Reatino C= ??

38 FILIPPO BRUNI (Rieti 1687 *ca.* – Roma ?)

The Consul Marcus Curius Dentatus refusing the Gifts offered by the Samnites in his humble Dwelling

1710, First Class of painting, first prize, inv. A. 246.
red chalk, white chalk, mm. 525(540)×760(780).
at the bottom: *1710. Pittura Prima Classe Primo Premio. Filippo Bruni Reatino C = 25*; on the reverse: *N 27 B.*

In 1710, having already competed on four occasions in the first class of painting (cf. Disegni, II, ad annum), Filippo Bruni entered the Clementine competition for the fifth time, finally obtaining the first prize.

The assignment proposed that year by Giuseppe Ghezzi (rather pompously, as usual) required the depiction of "The Consul Marcus Curius Dentatus refusing the gifts offered by the Samnites in his humble dwelling".

In his entry drawing Bruni confirms his narrative ability, placing the Roman consul on the left, seated on a stool in front of a meagre table, and in the foreground a bundle of kindling wood together with several household objects. These contrast with the richly dressed the Samnite ambassadors, (even the links of their armour are depicted meticulously), who present the lavish gifts of money and precious vessels.

The strong *chiaroscuro* and pictorial effects obtained through the knowledgeable use of the red chalk (the light areas are obtained by a sparing touch, and make the composition lively and pleasing. Bruni reconfirms the characteristics observed in the previous test piece which make his figures quite recognizable: elongated bodies with relatively small heads and graceful poses. Especially beautiful is the detail of the female face in the centr of the group of ambassadors, in its typology entirely 18th century.

It was probably these pleasing and rather easily achieved effects together with a natural narrative gift that permitted Bruni to become part of the circle of painters working for the Falconieri family (Michel, 1977, p. 333; *Villa e Paese*, 1980, pp. 100. 103-104) and to paint alongside, or rather under, an artist of the calibre of Pier Leone Ghezzi. From the competition of 1710 there also remains the extempore drawing depicting *The Angel comes to Hagar with her dying Son in the Desert* (Disegni, II, A. 247).

G.C.

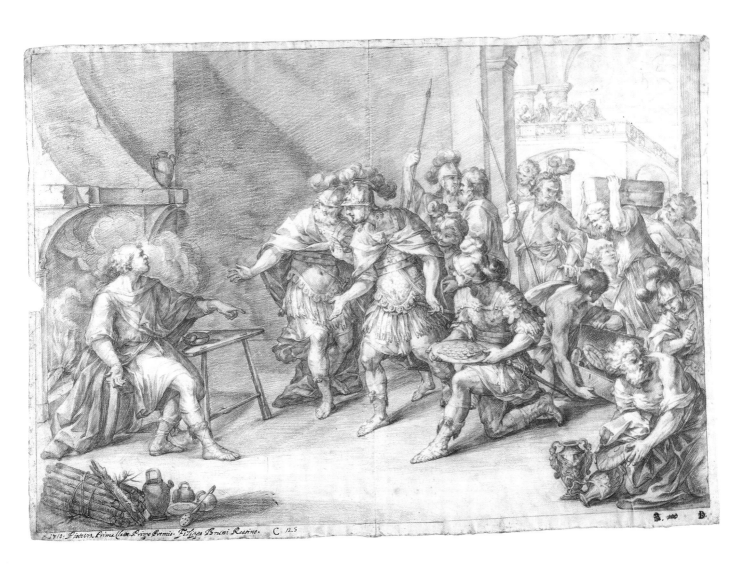

1710. Pictura Prima Classe Primo Premio. Filippo Bruni Reatino. C 125

89

39 GIOVANNI NICCOLÒ PITTALUGA

The Consul Marcus Curius Dentatus refusing the Gifts offered by the Samnites in his humble Dwelling

1710, First Class of painting, second prize, inv. A. 248.
red chalk, mm. 510×68.
on the lower right border; *1710. Pittura Prima Classe Secondo Premio Gio. Nicola Piccaluga Genovese* (above the last word "C"); *C. 126* (there follows another cancelled number).

With this drawing Pittaluga concluded the cycle of his five presentations in the Clementine *concorsi* held during the first decade of the 18th century. For the third consecutive time he was awarded a second prize, after which he abandoned his quest for professional recognition through the academic competitions. He was probably discouraged by the fact that the first prize continued to escape him and even fell to Bruni (cf. catalogue entry no. 38), whom he had bettered in the 1708 *concorso*. Yet the 1710 sample fully confirms the above-average gifts of this Genoese painter, who indeed stands out among the little-known and hardly distinguished candidates in the first class of painting. If his prize-winning drawing of 1706 (cf. catalogue entry no. 27) demonstrated Pittaluga's adeptness in the genre of battle scenes and the technique of a miniaturist that he later put to advantage in the decoration of fans, this representation reveals his potential as a history painter. It moreover underscores his Genoese culture, which had remained curiously intact after the years he spent in Rome. We know nothing of his life, but this latest specimen of Pittaluga's production suggests that he had at least revisited his native city, for it seems entirely in line with the taste propagated by the Piolas in both their graphic work and their paintings. This is readily evident in the figural types, of fluid mien and gracious smiles, and in the somewhat melifluous interpretation of an episode, from the history of ancient Rome, that required a more high-minded approach in order to evidence the virtues of frugality countering the corruption of luxury. Thus the blandishments of the Samnites proffering treasures are well imagined, as are the details of the rustic kitchen with the hero's armor pegged to the wall: but the hero himself appears so delightfully fatuous, in oriental garb appropriate for a carnival pageant, that he dilutes the edifying moral of the story, here reduced to an operetta.
Possibly this touch of levity ruffled the judges' pretensions to seriousness. Despite the superior quality of the drawing, something was amiss, and Pittaluga remained in obscurity after this final attempt to establish himself in Rome as a qualified artist. Perhaps his career failed to get underway because he drew better than he painted, but it is just as likely that he did not find the necessary support of a master there. For example, his compatriot Pietro Bianchi (cf. catalogue entries ns. 42, 46) had greater fortune, thanks to Luti, even though he advanced from much the same standpoint. In any case, Pittaluga's lack of success is a mystery that bears investigation, for it could shed light on the concrete value of the prizes awarded by the Accademia di San Luca. Evidently they were not sufficient to launch an artist of unquestionable talent when he showed himself reluctant to cede his autonomy yet maintained his adhesion to a provincial school (creative but anomalous, such as that of Genova at the beginning of the 18th century), in order to conform to the dictates of a Rome retrenched within the sanctioned taste of Maratti and his followers.

S.R.

90

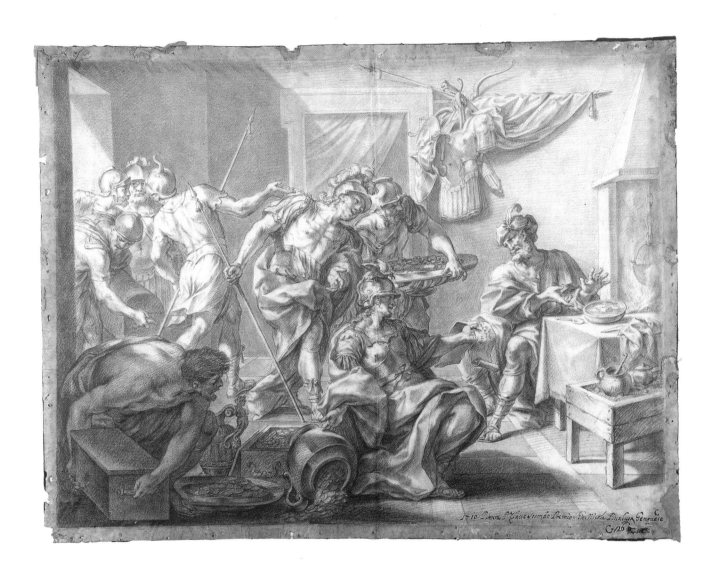

40 GUY-LOUIS de VERNANSAL (Paris c. 1689 – 1749)

Furius Camillus condemns the Pedagogue of Falerii

1711, First Class of painting, first prize, inv. A. 257.
black pencil and chalk, mm. 485×710.
at the bottom: *E 1711. Pittura Prima Classe Primo Premio. Guido Luigi Vernansal parigino C = 30).*

The director of the Académie de France a Rome, the painter Charles Poerson, wrote with pride on 26 September 1711 to the Surintendant des bâtiments of France, the Duke d'Antin, that he had gone to preside over the jury of the competition of the Accademia di San Luca and that "Mr de Vernansal, a pupil of the Académie (of France) took the first prize in painting with a very positive jury, all the judges except one having voted in his favor" (C.D., 4, 1983, p. 34). The same Duke, to emphasize his satisfaction, gave him the considerable additional sum of 200 pounds (C.D., 4, 1893, p. 42).

The young prize winner, Guy-Louis II de Vernansal, was the son of a painter of the same name who had been one of Le Brun's collaborators (Thoison, 25, 1901, pp. 108 ff.). Born around 1689, trained by his father, he had obtained more than one award from the Paris Academy, but not the Grand Prix, which was not awarded in those years (P.V.A.R., 4, 1881, pp. 32 and 73). However, the Duke d'Antin sent him to Rome where he stayed from 1709 to 1712, among other things copying a scene from the life of St Andrew in San Gregorio al Celio (C.D., 3, 1889, p. 419) and inventing original works with "a fire which must prevail" as Poerson wrote with admiration (C.D., 3, 1889, p. 338).

Of the three winners in the competition of 1711, it was Vernansal who best knew how to distance himself from the famous canvas of Poussin which illustrates the same theme. Instead of choosing the moment in which the treacherous pedagogue is beaten by his own pupils, he depicts the episode when Furius Camillus pronounces his judgement before the surprised and grateful boys, who are still on their knees at his feet. The composition is calm, and orderly; two well-defined groups frame and isolate the central figure of the righteous judge whose authoritative gesture governs the scene.

The same compositional vigor is to be found in the extempore work, (Disegni, II, A. 258), where the episode from antiquity (it may be Romulus killing Remus) recalls *The Martyrdom of St Peter* by Domenichino which we know now only through an engraving. It is this latter subject that, after his departure from Rome, he decided to copy in Venice from Titian's version. He sent this copy to the French Academy as a demonstration of the work he had produced (C.D., 4, 1893, p. 248).

His Italian career took him to Padova, in about 1720 (*Padova, guida ai monumenti e alle opere d'arte*, 1961, p. 649; N. Ivanoff, 1960, p. 450), and Brescia where he worked from around 1730 (*Brescia pittorica, 1700 – 1760*, 1981, p. 146). His numerous works demonstrate that the passion which Poerson admired so much certainly did not abandon him, especially in the immense *Paradise* in the dome of San Gaetano in Padova. This "genius full of fire" was still described in these terms in the 1741 *Guida di Lione* of André Clapasson (A. Clapasson, 1982, pp. 56 and 169) which refers to the Frenchman's works in this city (Lyons) in the refectory of the Celestines and in the chapel of the Casa della Provvidenza, dated between 1736 and 1738, unfortunately now lost.

Returning to Paris, he was accepted into the Académie Royale in 1741 "without passing through the usual stages... in consideration of the death of his father" (P.V.A.R., 9, 1883, p. 296), but died in 1749 without having presented his *morceau de réception*. In France he left paintings which testify to his great talent as a colourist strongly influenced by Titian and by Tintoretto.

O.M.

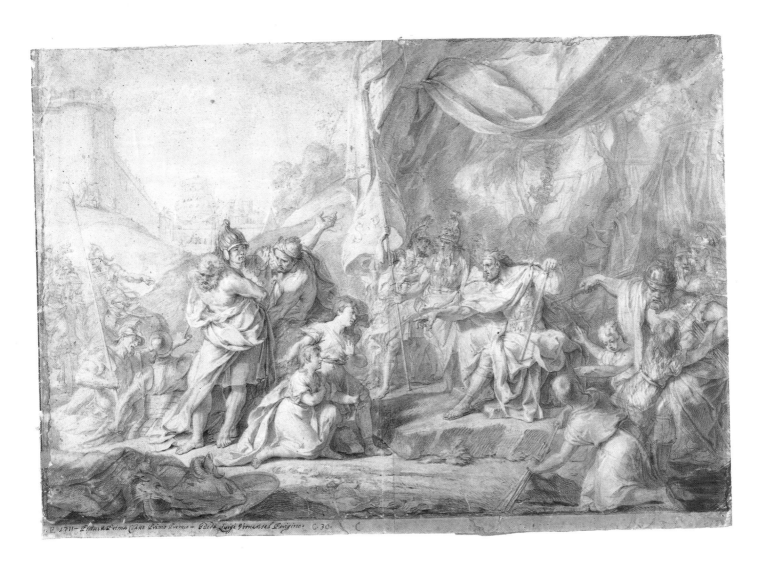

E 1711 - Pictura Prima Classe Primo Premio - Dedo Luigi Fernandes Parigino - C. 30.

41 CRISTOFORO EPIFANIO CREÒ (Gaeta c. 1690 –)

Furius Camillus condemns the Pedagogue of Falerii

1711, First Class of painting, third prize, inv. A. 260.
red chalk, mm. 475(530)×735 (775).
at the bottom: *1711. Pittura Prima Classe Terzo Premio. Christofaro Creb Gaetano. C 29.*

Cristoforo Creò of Gaeta frequented the studio of his fellow countryman Sebastiano Conca in Rome at least from 1710 and 1712 (*Sebastiano Conca 1680-1764*, Gaeta 1981, pp. 41 and 386, cf. the table in which the first names are given without a surname). During this period he participated with relative success in the competitions of the Accademia di San Luca. In 1710 he received the third prize in the second class with a test piece depicting *The Death of Portia* (Disegni, II, A. 253) and in 1711 the third prize in the first class after the Frenchman Vernansal and the Scotsman Trench for the drawing *Furius Camillus condemns the pedagogue of Falerii to be beaten by his own pupils*. His drawing is of very high quality, as can be seen in the delicacy of the outline and the variety of the expressions. He gives special care to the faces of the youths, which even in anger express a lightness and a charm which link the painter to the arcadian tendency of his master. However his composition lacks both the clarity of the drawing awarded first prize as well as the dramatic tension of that which placed second. Creó's work suffers from excess: the gesticulation of the figures shows a Neopolitan exuberance, and the tent of Camillus is the product of too free an imagination. The ancient city too is sketched with little care and the groups of people standing by on the left and right include anecdotal figures, such as the dwarf and his dog, who have no clear connection with the scene. The knight carrying a standard on the right is a textual citation from Francesco Solimena's frescoes in the church of S. Giorgio in Salerno (Bologna, 1958, plate 26) and poses the problem of the training of the artist. Born around 1690, could Creò have spent some part of his earliest period in Naples with Solimena, where he might have met Conca, following or joining him later in Rome?

He established himself in Rome and painted for various noble families, including the Falconieri, who in 1717 displayed two of his works, the *Moses trampling on Pharoah's crown* and a *Madonna and Saints* (De Marchi, 1987, p. 349), and the Sassetti family of Rieti, two of whose paintings, *Venus and Cupid* and *Judith* are now in the Civic Museum of that city (Mortari, 1960, p. 37, plate 43). In 1728 Pope Benedict XIII commissioned from him a *St Phillip in Ecstasy* for the church of San Nicolò da Tolentino, now in the refectory of the Collegio Armeno (Zandri, 1987, pp. 75 and 170; *Memorie del Pontificio Collegio Armeno 1883-1958*, 1958, p. 64). In 1740, on the death of Giuseppe Mattei Orsini, duke of Paganica, the artist made an inventory of his paintings together with Corrado Giaquinto (ASR, 30 Notai Capitolini, office 31, envelope 486, fol. 71 r.). It is probably due to the ties of the Orsini with Spain that Creó's *St Barbara* is found in the cloister of the cathedral of Valencia (Urea Fernandez, 1977, p. 326, plate 104).

His rather nerveless style also explains why his only known pupil, Gaetano Lapis di Cagli, quickly grew to prefer Sebastiano Conca (*Memorie per le Belle Arti*, 3, 1787, p. 1), and suggests that the *Madonna with Child, St Clare of Assisi, St Rose and St Rosalie* in the church of San Paolo alla Regola in Rome (Titi, 1763, p. 100 "Cristofaro Creó"; Vasi, 1791, p. 584 "Mariano Rossi Siciliano"), should be attributed to Mariano Rossi rather than to him. Could the painting by Creó have been replaced by that of Rossi at the end of the century?

O.M.

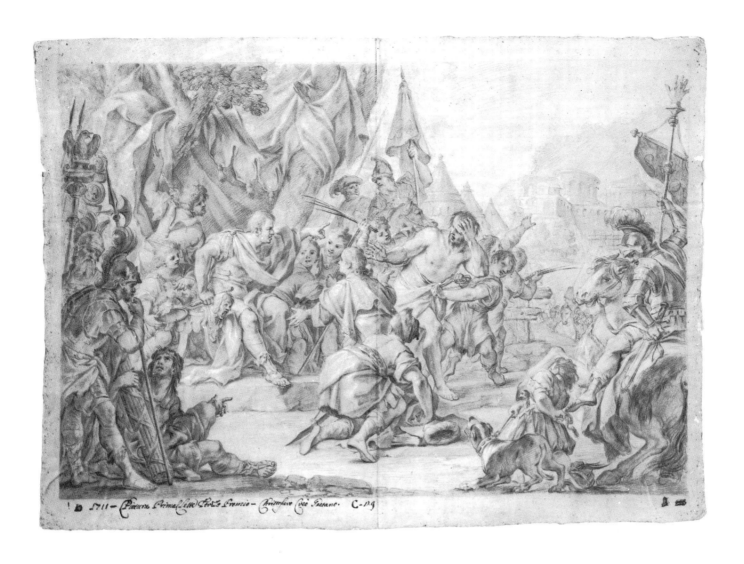

1711 – Pittura Prima detto Prto Brencio – Christofaro dei Passano. C-D.9

95

42 PIETRO BIANCHI (Roma 1694 – 1740)

The Death of Cleopatra

1711, Second Class of painting, first prize, inv. A. 261.
red chalk, mm. 540×680.
on the lower left border of the mount; *Pietro Bianchi romano per Accademico di San Luca 1711 448* (probably a repetition of the inscription originally on the lower left border of the drawing itself, of which faint traces remain); on the reverse: *N. 94 C.*

Bianchi rated a third prize in the Clementine competitions of both 1708 and 1709 (Disegni. II, A. 234, the second *ex aequo* with Isidoro Soler) for his copies in red chalk of the tomb of Paul III and of the allegorical statues placed on that of Alexander VII in St. Peter's. The profit he drew from this type of exercise, customarily allotted to the participants in the third class of painting, as well as from his apprenticeship with Pierre Le Gros, is evidenced by his later involvement with major Roman sculptors such as Filippo della Valle and Pietro Bracci, to whom he supplied drawings for their projects.
This gifted, refined artist is the subject of a brief but valuable article published by A.M. Clark in 1964, that utilizes the biographies compiled by Dézailler d'Argenville (1762) and Ratti (1769) and represents the first modern attempt to redintegrate the status he had attained as a painter within the Roman School during the second quarter of the 18th century. Although a Roman by birth, Bianchi was of Genoese extraction (actually his father was probably from nearby Sarzana: cf. Crelly, 1968, p. 165) and had moreover been introduced by Giacomo Triga into the workshop of Gaulli, where he remained until the latter's death in 1709. After a parenthesis with Giuseppe Ghezzi, which left no appreciable trace in his subsequent work, he found in Benedetto Luti (cf. catalogue entry no. 4) a teacher ideally suited to mould his sensitive talent. The prize-winning drawing of 1711 is a product of this phase of transition between masters, which was already concluded two years later with the full assimilation of Luti's manner he evinced in the drawing awarded a second prize in the first class in 1713 (cf. catalogue entry no. 47). Clark judged this *Death of Cleopatra* a beautiful essay in the sort of Rococo taste purveyed by Trevisani. One might add that the velvety texturing of line and the delicate calligraphy of the drapery edges (for example, on the prone woman) are evidence that he was certainly working under his new master by this date. The Genoese connotation of the drawing is, on the other hand, a rather unexpected element that emerges both in the fluidity of line and in the somewhat boneless morphology of the figure of Alexander. These stylistic traits are not so much derived from Gaulli's repertory, as might be conjectured, as intrinsic to the graphic tradition of Domenico Piola and his son Gerolamo and give leave to suppose that Bianchi had remained in contact with the artistic situation in his father's homeland. A like strain of his Ligurian origin was, in fact, implied by Clark when he remarked on Bianchi's later altarpiece for St. Peter's (now in Santa Maria degli Angeli, Rome) "being as if by a nephew of Piola in Rome" (1970, p. 180).
Bianchi's approach to the assigned subject differs from that of the other participants in this class of the 1711 *concorso* in a manner that permitted him to give free rein to the particularly sentimental, intimistic inflection that would characterize the masterpiece of his maturity, the *Encounter between Philip V of Spain and Cardinal Anton Felice Zondadari* in the Galleria Nazionale d'Arte Antica, Rome (Clark, 1981, pp. 49-50, fig. 52). Pietro Claudio from Norcia (Disegni, III, A. 262: second prize) and Adam Eilauser (cf. catalogue entry no. 43) chose to illustrate the culminating moment of the episode, the Queen's suicide assisted by two ladies-in-waiting, with the declamatory gesticulation usually found in the representation of this dramatically tense scene. Bianchi instead preferred to stage a

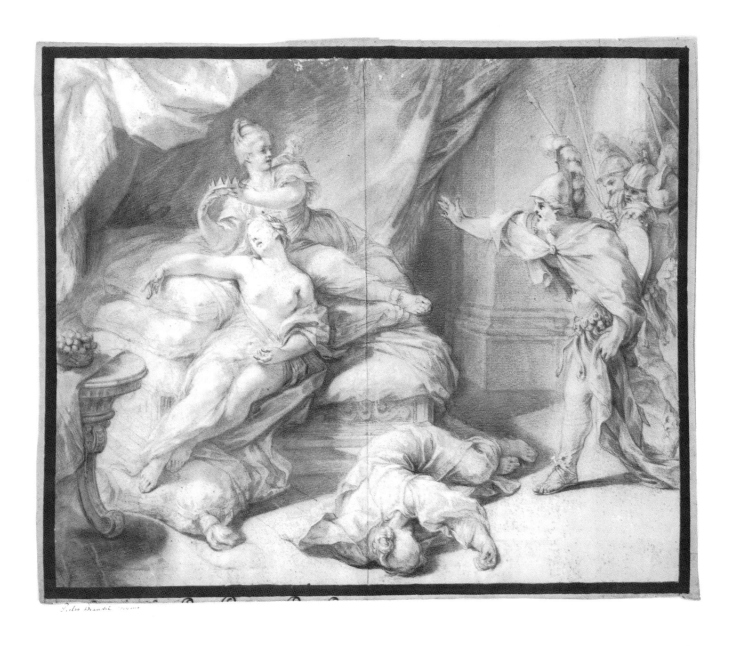

tableau vivant of the aftermath of the tragedy with all passion spent in a sort of still-life of tender female beauties (the Queen and her servant, the latter lifeless in a guise reminiscent of the celebrated statue of St. Cecily by Maderno), depicted as the poignant discovery of the armed men who have broken into the chamber. The entire import of the event is conveyed by the delicate gesture of the maiden who removes the crown from Cleopatra's head, a figure of surpassing grace that alone would suffice to warrant Bianchi a place of prominence in the vangard of Rococo painting in Rome.

Bibliography: A.M. Clark, 1964 (1981, p. 49); L. Salerno, 1974, p. 352.

S.R.

43 ADAM EILAUSER

The Death of Cleopatra

1711, Second Class of painting, third prize, inv. A. 264.
red and white chalk on paper prepared in grey, mm. 355(505)×355(420).
at the bottom: *N. 1711. Pittura Seconda Classe Terzo Premio. Adamo Eilauser Tedesco C 39.*

Adam Eilauser (the German name is probably Eilhauser) has left no traces of himself in the history of art apart from his participation in the Clementine competition of 1711. With this "academic" composition, certainly rich in color but somewhat awkward in its overall result, he won the third prize.

Eilauser's extempore piece demonstrates, however, that this German artist was certainly a very able draftsman. The theme was *The Sacrifice of Manoah* (Disegni, II, A. 265) and Eilauser passed the test brilliantly. In the freedom, spontaneity and assurance with which he creates both figures and in the spatial relationship which links them, this drawing shares nothing of the overworked tiredness that characterizes, in contrast, the winning drawing. Black pencil, chalk and watercolor are used with full mastery in this sketch of excellent quality, showing that the artist certainly could perform as an accomplished draftsman.

D.G.

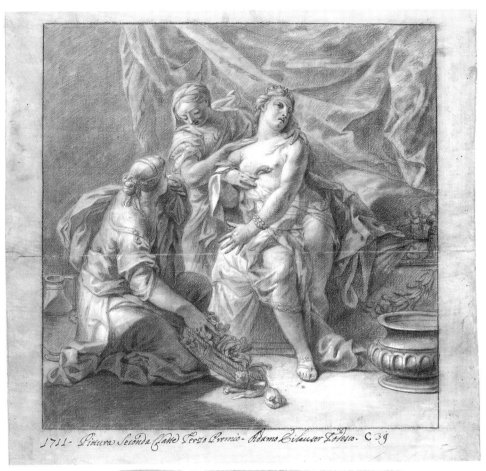

1711 - Pittura Seconda Classe Terzo Premio - Adamo Bilauer Boseno. C 39

Prova di Adamo Bilauer Boseno 12

99

44 VINCENZO FRANCESCHINI (Roma 1680 – Firenze 1740)

Drawing from the Nude

1711, Third Class of painting, first prize, inv. A. 266 a-e.
red and chalk, mm. 575×425; 480×275; 565×425; 415×580; 560×430.

This study of a seated male figure forms part of a series of five studies of the nude with which Vincenzo Franceschini won, in 1711, the first prize in the third class (Disegni, II, A.265 a-e). It is clear that the whole series draws upon the same model. In three studies the figure is seated in various poses and is drawn from different viewpoints (A.266 a, c, e), but the group also includes the reclining figure seen from behind (A. 266 d) and a study of the figure in three quarter profile, with one leg bent (A. 266 b). The movement of the man in this last sheet, who is shown with the arm raised to strike, is motivated by the presence of hammer and anvil. However, in reality the model is not leaning on the block of stone, shown in the drawing, but on a podium of wood and, as in drawing A. 266 c, is holding onto a rope with both arms, which would have enabled him to maintain such a complicated physical position for a longer period. Equally complicated is the pose in drawing A. 266 e, where the model is seen in profile, with the right foot resting on a higher level and the left hand grasping the right knee, while the right arm is half hidden behind the back with the palm of the hand facing outwards. The head, depicted almost frontally, is bent forward. This pose, to all appearances simple, is in fact very contrived, with frequent intersections and foreshortenings, and was produced by Franceschini with especial precision and sensitivity to the plasticity of the body. The shaft of light which falls from the above left, molds the forms delicately, leaving them without sharp outlines. The red chalk becomes more intense in the shaded areas, for example the left leg and the back, while remaining delicately diffused in the depiction of the face, the hair, and the lighted areas.

In such drawings the individual traits of the artist disappear almost completely. The great collections of Italian Baroque drawings such as those of the Louvre, of Windsor Castle and of the Kunstmuseum in Düsseldorf, preserve a large number of drawings such as this where, written in ink, one finds old attributions to specific artists. It should not be forgotten that during their apprenticeships, all artists produced exercises of this type. But in many cases it is difficult to confirm or refute the traditional attribution, given the lack of recognizable personal traits. However, only a glance at the drawings of Francesco Giardoni and of Leonardo Siccardo (respectively the second and third prizewinners; Disegni, II, no. 267 a-d; 268 a-e) is needed to understand with what superiority Franceschini was able to portray the same model.

D.G.

d

c

1711 Licence Preto Celli Primo Benio Joan Schimmitim Romano Cui f Congre concedi.

a

b

e

45 COSMAS DAMIAN ASAM (Benediktbeuren 1686 – München 1739)

The Miracle of St Pius V, who heals an obsessed woman by the touch of his stole in the Church of Santa Maria d'Aracoeli

1713, First Class of painting, first prize, inv. A. 269.
pencil, pen, watercolor and white chalk, mm. 520(540)755(775).
at the bottom: *1713. Pittura P.a Classe Primo Premio Cosimo Damiano Asam Bavaro C = 38.*

Son of the painter Georg and brother of Egid Quirin, Cosmas Damian Asam, remembered above all as a sculptor and stucco decorator but also working as an architect and painter, had his first apprenticeship in the studio of his father. Between 1711 and 1713 he was in Italy, primarily in Rome but also perhaps in Naples. He participated in the Clementine competition of 1713 and at the end of the same year returned to Bavaria.

No other class of painting in the Clementine competition has ever received so much attention on the part of art historians as that of 1713, in which not only Italian artists but also the English painter William Kent (cf. catalogue entry no. 50) and two German painters, Cosmas Damian Asam and Franz Georg Herman (cf. catalogue entry no. 49) participated and took prizes. It is true that foreign artists, and in particular the French, had participated and won in previous competitions, but it is clear that the later fame of Kent and of Asam has focused the attention of English and German scholars on this competition in particular. From 1911 Friedrich Noack (Noack, 1911-12), using the publication of Giuseppe Ghezzi *Trionfo della Fede solennizzato nel Campidoglio dall'accademia del Disegno al di 23 Maggio 1713* as a starting point, made note of the drawings of Cosmas Damian Asam and Franz Georg Hermann, without, however, publishing them. In 1967 Eckhard Schaar, curating the catalogue of the exhibition "Meisterzeichnungen der Sammlung Lambert Krahe", showed a preliminary study by Vincenzo Franceschini for the drawing which won a prize in the competition (Disegni, II, no. 48), dedicated a careful study to these two works by foreign artists and cited them in the exhibition catalogue (op. cit., cat. no 100) as still present at the Accademia di San Luca. Contemporaneously Gerhard Hojer, who was studying the Asam brothers, was attracted by the works of the competition of 1713 and had photographs made. But the publication did not occur until 1980, the same year in which Helene Trottmann, who had written a dissertation on Cosmas Damian Asam, published the drawing in question.

Cosmas Damian Asam won the first prize of the first class. His work differs from those of the other four contestants, Pietro Bianchi (cf. catalogue entry no. 46), Domenico Maria Sani (cf. catalogue entry no. 47), Vincenzo Franceschini (cf. catalogue entry no. 48) and Giovanni Battista Puccetti (Disegni, II, A. 273) for two reasons. First, the artist did not draw the scene in red chalk as did the other four, but with a brush as a grisaille, and second, he did not place it in an imaginary space but within S. Maria in Aracoeli itself, where the miracle is known to have occurred.

The scene takes place between the transept and the choir. Pope Pius V arrives from the left, followed by cardinals and clergy. Detaching himself from the crowd, a common man goes to meet him, supporting the possessed woman and checking her disjointed movements while she kneels before the Pope without recognizing him. The Pope blesses her and touches her with his stole, and the evil spirits fleeing from the mouth of the woman take the form of three small devils with tails who fly away across the space of the church. On the right the observers react with astonishment and emotion before the miracle. On the left the curious who had gathered are held back by a soldier of the pontifical guard. Soldiers are also present on the right behind the group of awe-struck spectators; one of these is clearly visible between the crowd, while the others are suggested by their spears. In

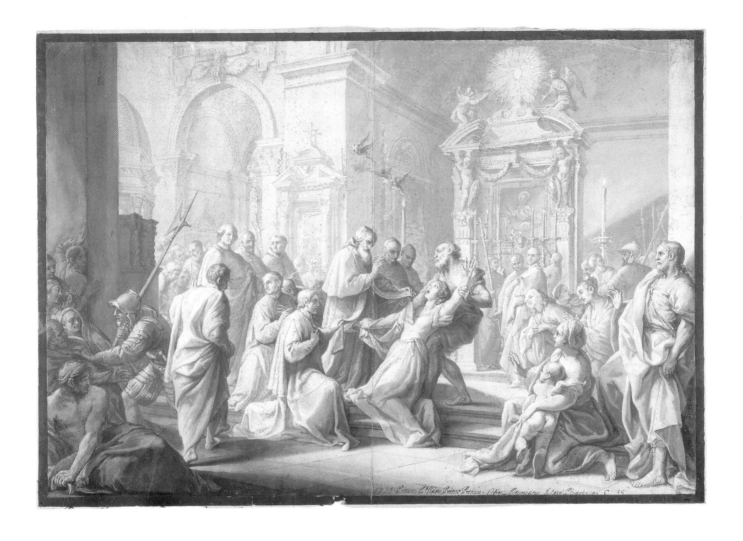

front of the altar is a group of clergy, one of whom (who had preceded the papal procession) holds the cross. The candles on the altar and at its sides are lit. Each detail of the interior is reproduced with great precision, especially the principal and side altars, the foreshortened left side chapel with the epitaph at the entrance and the capitals and cornices. It is therefore not surprising to find the figure of the Pope (d. 1577) well characterized as is also true of the clergy in the procession, (especially the one standing on the left, with a typically 18th century hairstyle), even though these latter do not represent historically known people. Corresponding with this precision in details is a similar precision in the control of the light. It is the light, in fact, which gives veracity to the representation of the figures and objects in this masterly composition.

Concerning a possible source of inspiration, Helene Trottmann (Trottmann, 1980, p. 162) has rightly recognized that the central group with the woman is a paraphrase of the same motif in the *Transfiguration* of Raphael. However the author does not limit herself to citing the frescoes of Raphael in the Vatican as well as his tapestries for the Sistine Chapel as sources, but also emphasizes Asam's evident study of the Roman works of Annibale

Carracci and Domenichino. As additional confirmation, Trottmann recalls that in section 37 "De Concorsi" of the Statutes of the Accademia di San Luca it is stated "That the beginning students of painting should produce a drawing copied from the work of famous Masters, such as Raphael, Carracci, Domenichino and others, as has been required by the Congregation...". In fact the woman with the child in the foreground right is taken from the "Martyrdom of St Sebastian" by Domenichino.

We do not know with whom Asam worked and studied during his stay in Rome, but the pictorial technique of this composition seems to come from Benedetto Luti. In this connection a drawing by Luti, *The Finding of the Baby Moses* (London, British Museum, inv. 1874-8-39) and *The Madonna blesses a Church* (Holkham Hall, coll. Earl of Leicester, Portfolio II; see G. Sestieri, 1983, fig. 136) may be mentioned. A closeness to Luti is also recognizable in Asam's extempore piece (Disegni, A. 270; cf. Trottmann, 1980, fig. 2). In addition, the figures of Pope Pius V and the woman are so similar to those of Pietro Bianchi, also a pupil of Luti, (cf. catalogue entry no. 46) that it is impossible that they were conceived of independently; this seems further to confirm the existence of a common master who would have to be Benedetto Luti. A design by Luti for a now-lost painting, presently in the Metropolitan Museum of New York (inv. 69.169 must be cited; cf. Bean, 1979, no. 267, reproduced here). It appears that Luti painted the picture as a commission from the General of the Dominicans for Pope Clement XI on the occasion of the canonization of Pius V in 1712. The work would therefore slightly predate Asam's drawing. (It should be recalled that the whole competition of this year was centred upon the continued celebration of the canonization of the previous year (A.S.L. vol. 46a, 147 ff.). In the drawing Luti represents Pius V and the envoy of the king of Poland in St Peter's Square, and both Asam and Pietro Bianchi seem to have known this composition. Bianchi used, in reverse, the figure of the papal litter which, in the sketch of Luti is found on the right. In Asam, however, more than anything else, is notable a general affinity in the arrangement of the composition. It is surprising that Luti, in his model, did not simply set the scene in St Peter's Square, where the event in fact occurred in 1560, but actually recreated the square as it would have been in that year.

This significant archaeological accuracy seems to confirm the hypothesis that it was Luti who persuaded Asam to reproduce the interior of S. Maria in Aracoeli with such precision.

Bibliography: F. Noack, 1911, pp. 129-131; E. Schaar, 1969, cat. no. 100; L. Salerno, 1974, p. 382; G. Hojer, 1980, pp. 114-118 and pp. 214-218, fig. 1; H. Trottmann, 1980, pp. 158-164, fig. 6; B. Rupprecht, 1980, p. 58 and color plate; B. Beeshart, 1986, pp. 51-61; B. Hamacher, 1986, p. 310, fig. Z 2; H. Trottmann, 1986, p. 30, fig. 35.

D.G.

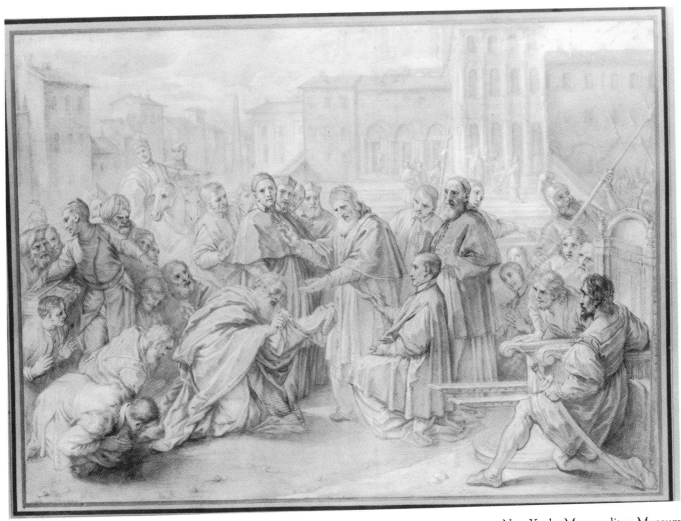

New York - Metropolitan Museum

105

46 PIETRO BIANCHI (Roma 1694 – 1740)

The Miracle of St Pius V, who heals an obsessed woman by the touch of his stole, in the Church of Santa Maria d'Aracoeli

1713, First Class of painting, second prize, inv. A. 270.
red chalk, mm. 515×750 (drawing cut down on the margins with traces of the original inscription on the lower border).
on the reverse: *Ia Classe 2.o Premio Pietro Bianchi Romano N 17 B.*

Of all the Clementine *concorsi* held during the 18th century only that of 1713 has been fully illustrated, indeed twice, in articles by G. Hojer and H. Trottmann published in 1980. The competition is certainly of particular historical interest, since two aspiring artists participated, Cosmas Damian Asam and William Kent (cf. catalogue entries ns. 45, 50), who were destined to celebrity in their own countries, one as the major exponent of decorative fresco painting in Bavaria and the other as the versatile innovator of architectural design, interior decorations and the English garden. But apart from the talents convened on this occasion (D.M. Sani and V Franceschini, cf. catalogue entries ns. 47, 48), the competitive context might have seemed arduous to Bianchi because of the chosen subject, in that it implicated the representation of a crowded scene inside a church. At least the other contenders took it as such, for they dealt literally with the requirement of inventing an ecclesiastical setting, more or less faithful to the actual interior of the Roman basilica, and a press of witnesses to the miracle wrought by the pope. This was, however, a type of narrative hardly congenial to Bianchi's figurative propensities, for his paintings almost never accommodate scenographic or architectural features.

Nonetheless he gamely tried his hand at this sort of historical depiction in a black chalk drawing of the subject in Düsseldorf (Kunstmuseum, Inv. FP 10868) reproduced in 1981 by G. Sestieri (Roli-Sestieri, no. 169), who did not attempt to draw conclusions about the nature of its relationship to the prize-winning sheet of 1713 because, as he remarks, of their notable diversity. Yet the Düsseldorf version appears to be none other than the artist's first idea for the 1713 *concorso*, set forth according to the terms implied by the designated episode, that is, with numerous figures in a church interior (rather than outside the entry, as indicated by Sestieri, op. cit., p. 100). Its similar measurements (mm. 536×744) support the hypothesis that Bianchi produced the drawing for precisely this competition, whereas its preliminary nature is underscored by the fact that he eventually submitted the very different compositional solution that won the second prize. The substitution was a courageous choice, indeed a sign of his achieved maturity as an artist, for Bianchi decided to propose a visualization of the scene that runs countercurrent to the pattern followed by all the other candidates. In brief, he reduced the event to an enlarged detail of the exorcism, concentrating its considerable expressive intensity in the heads of the bystanders and limiting the interference of scenery to the base of a gigantic altar with candles that suffices to identify the ambient. Thus brought up close, the beholder is further piloted into the scene by the theatrical gesture of the kneeling man to the left: the efficacy of these devices makes the solutions of the other competitors appear, in comparison, at once dispersive and congested. Otherwise only Asam, who took the first prize, succeeded in dominating the outsized architecture by the terseness of the narrative action it embraces.

The similarity of the poses of the obsessed woman in the drawings by the two artists raises the question of whether they might have consulted one another during the phase of elaboration, something to be expected if one considers the lapse of time between the notification of the subject and the presentation of the entries. This is an aspect of the

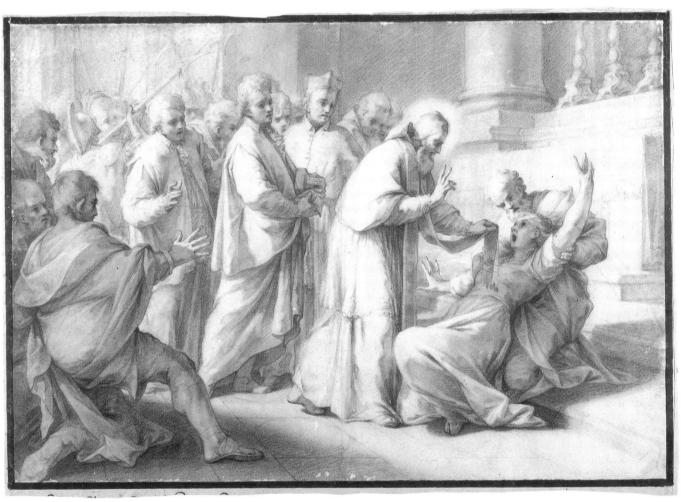

Düsseldorf - Kunstmuseum

107

competition that needs to be clarified, for in more than a few instances (see the sheets from the 1739 *concorso* in this exhibition) the drawings submitted in a given class seem calibrated in their subtle variants as the result of tacit contrivances or indiscretions within the *milieu* of the Academy and the principal studios represented.

If the style displayed by Bianchi in this drawing identifies him as the major interpreter of the pastel-like suavity that distinguishes Luti's graphic technique, the emotive sensitivity of the expressions of the youthful prelates (especially the last to the left) is of an uniquely rarefied psychological penetration. He remained for years in his master's workshop, to the point that his career got underway only after the latter's death in 1724, thanks to several prestigious commissions from Spain and Portugal. When Bianchi was at last elected member of the Academy of St. Luke, in 1735, his activities had extended to dealing and to landscape painting in the Arcadian mode, a genre in which a few drawings, albeit in the more picturesque taste of Magnasco, have recently been attributed to him (Newcome-Schleier, 1989, cat. 105).

Bibliography: A.M. Clark, 1964 (ed. 1981), p. 49; L. Salerno, 1974, p. 352, fig. 28; G. Hojer, 1980, pp. 114-118 and 214-218, fig. 3; H. Trottmann, 1980, pp. 158-164, fig. 3; R. Roli-G. Sestieri, 1981, p. 100, fig. 170

S.R.

47 DOMENICO MARIA SANI (Cesena 1690 – 1772 ca.)

The Miracle of St Pius V, who heals an obsessed woman by the touch of his stole in the Church of Santa Maria d'Aracoeli

1713, First Class of painting, third prize, inv. A. 272.
pencil, red and white chalk, mm. 505(545)×675(740).
at the bottom: *1713. Pittura Prima Classe Terzo Premio. Domenico Maria Sanni da Cesena C 36*; on the reverse: *N 55 B.*

Sani obtained the third prize sharing the merit with Giovan Battista Puccetti and Vincenzo Franceschini. Their three drawings are not on the whole dissimilar in architectural setting, but differ both in the placing of the figures as well as in the overall stylistic results.

In 1713 Sani was 23 years old and already "an old man" with respect to the average student in the academic courses; in fact he had already had a three year apprenticeship in his native Romagna with Marco Maria Laschi. He then came to continue his studies in Rome where it was necessary, at that time, to attend the school of Maratti. His teacher was Andrea Procaccini who in 1721 called him to Spain as a collaborator (Pio, 1977, ff. 198-199), where he was to produce all his work (cf. Thieme-Becker, and Y. Bottineau, 1960, passim). Employed as a draftsman of designs for carpet making, painter and decorator in various palaces, but also as architect, he gained a certain renoun, officialized by his nomination as private painter to Philip V (1734) and as honorary director of the Academy of San Fernando in Madrid (1759). The drawing at the Accademia di San Luca, together with numerous portraits for the *Vite* of Pio (now in Stockholm, cf. Clark, 1967, pp. 14, 20-21) are at present the only testimony of the work which he produced in Italy (those produced in Cesena prior to his departure for Spain are unknown).

The evidence which remains allows us to make some observations on Sani's cultural choices and his expressive tendency which grafted a Bolognese stylistic language onto the

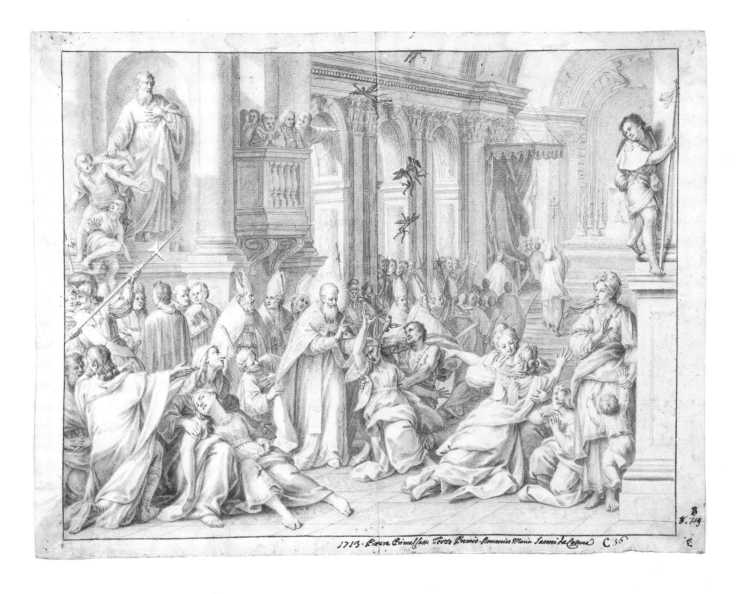

1713 · Pietra Criwalfatti Terso Premio Romenico Maria Sanni da Cesena C 36

manner of Maratti. The typologies and poses in the style of Caracci an Reni notable especially in the group of female figures on the right, together with the general formal stamp, argue for a far more incisive Emilian source than the unknown Laschi. Contact with the work of Lorenzo Pasinelli (1629-1700), whose value can be estimated through his most faithful disciple Giampietro Zanotti (1674-1765) is possible. Once in Rome, Sani was able to ascertain its validity through the work of a pupil of Pasinelli, Domenico Maria Muratori (*c.* 1655-1742). An academician of the Accademia di San Luca from 1705, Muratori became an interpreter of a taste in which the styles of Bologna and Maratti were fused in a synthesis constrained within rigidly academic definitions.

The lack of expressive autonomy on Sani's part may be observed in the scene's composition where several citations of Pasinelli's works such as *The Adoration of the Shepherds* and especially the *Martyrdom of St Ursula* (both in Bologna, Pinacoteca Nazionale) may be noted. These models explain the curious figures who rise up to the cornices, the

affectations of the groups of women in the foreground, the preference for a frontal view of the scene, which is disturbed by the obliquely-set architectural setting. Also of interest is the revival of these expressive forms in the later work of Muratori (for instance, a similar placement of the groups, with the women on the right, is found in *The pyre of luxury objects during the sermon of St John of Capistrano*, Rome, San Francesco a Ripa; while his motif of two fainting females is found in *San Francesco Regis who helps the plague-stricken*, Rome, Galleria Nazionale d'Arte Antica, dep. Acc. Naz. Lincei). This figurative continuity, it may be said, defends the prestige of the tradition itself.

Sani was actually present in 1713 at the death of Carlo Maratti. Sani's theoretical position cannot have displeased the Accademia di San Luca, especially since he knew to look with fresh sensibility at the Marattesque context. This ability is shown in the entry drawing by some secondary, but extremely significant, details. The numerous observers who populate the scene and the careful way in which the faces are drawn give weight to the idea of the strong influence of Pier Leone Ghezzi, whose artistic methods reconcile innovative solutions with academic directions. (Lo Bianco, 1985, ns. 10, 15). A textual homage (with a reversal of pose), is found in the typology of the woman who supports her fainting neighbor, while it may be possible to recognize the features of Ghezzi himself in the man in a wig behind the warrior talking with a young man at his shoulder, perhaps Sani.

Venturing into supposition, it may be inferred that Sani participated in the execution of one of the six pictures with episodes from the life of Clement XI, that which shows the Pope celebrating a service in the Vatican (Urbino, Galleria Nazionale). Lo Bianco (Lo Bianco, 1985, n. 81) suggests that the involvement of an assistant is perceptible, noting a certain stiffness in the execution and uncertainty of perspective which are not possible for Ghezzi. The cycle of paintings was undertaken around 1715 and certainly not later than 1718, a date which does not create problems for the hypothesis that Sani was employed in executing the drawings for the portraits illustrating the "Vite" of Pio, which demonstrate his ability at physionomic characterization.

A.P.

48 VINCENZO FRANCESCHINI (Roma 1680 – Firenze 1740)

The Miracle of St Pius V, who heals an obsessed woman by the touch of his stole in the Church of Santa Maria d'Aracoeli

1713, First Class of painting, third prize, inv. A. 274.
red and white chalk, mm. 530(550)×740(770).
at the bottom: *1713. Pittura Prima Classe Terzo Premio. Vincenzo Franceschini Romano C32*; on the reverse: *91 C.*

While in Cosmas Damian Asam's drawing (cf. catalogue entry no. 45) the miracle of Pope Pius V is set obviously within S. Maria in Aracoeli, the artists who took third prize, that is, Domenico Maria Sani (cf. catalogue entry no. 47), Giovanni Battista Puccetti (Disegni, II, A. 273) and Vincenzo Franceschini, all place the scene in interiors of uncertain identity. Although S. Maria in Aracoeli may be intended, they do not reproduce it faithfully. In Franceschini's drawing, the figure of the Pope, whose face is well characterized, is placed on the central axis of the composition. Followed by ecclesiastical

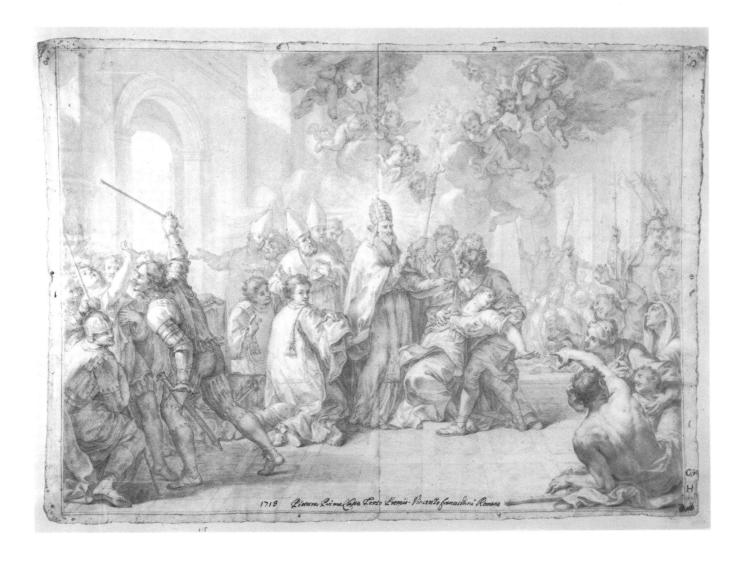

dignitaries and attended by deacons, he is shown with the benedictory gesture whereby he accomplishes the exorcism of the unfortunate woman. At the invocation of God the heavens open and the angelic host descend, hovering in the vast space of the church to bring credibility to the miraculous event. At the sides of the principal scene, groups of onlookers observe the miracle with great expressions of astonishment. The refinement of the shading and the geometric motif of the pavement whose orthogonals accentuate the depth give the composition a convincing sense of space.

The quality of this red chalk drawing is so high that it is difficult to believe that this artist did not go on to produce something more significant than engravings based on the works of others. A possible explanation may be found in the evidently crucial collaboration of the master with an artist whose name has never been disclosed, but now seems certain to have been that of Giovanni Odazzi. Franceschini's figures and drapery are so similar to Odazzi's that they confirm the hypothesis of a meaningful collaboration between the two.

111

Observing the drawing from close by one sees that numerous figures come from Odazzi's fresco, *The Funeral of St Clement* (Rome, S. Clemente) or from the preparatory studies for this same fresco (cf. Gilmartin, 1974, pp. 305-312, figg. 19 and 20). From Odazzi's composition come the figure of the father and the two others on the right as well who, taken in reverse by Franceschini, now become the deacons on the left of Pius V. Also copied in reverse is the *repoussoir* figure of the man lying on his back who is claiming the attention of the others in the central scene. Finally, in both compositions the motif of the glory of the angels is present which Odazzi, in turn had taken in this same form from his master Giovanni Battista Gaulli. In comparison with Odazzi's fresco, the drawing by Franceschini is artistically more convincing, but this may be due to the complicated dimensions of the fresco. A preliminary drawing by Franceschini, almost identical in size, is preserved in Düsseldorf (cf. E. Schaar, 1969, cat. no. 100, fig. 48, reproduced here); it is drawn with pen and brown ink and shaded in grey in contrast to the final entry piece in the Accademia di San Luca which is executed in red chalk. The combination of brown ink and grey watercolor, typical of Gaulli, was taken up by Odazzi who passed it on to Franceschini. The example in Düsseldorf betrays the hand of Odazzi to a higher extent than does the final version submitted to the competition. This brings to mind the letter cited by Helene Trottman (Trottmann 1986, p. 30), dated 27 May 1713 (that is a few days after the award ceremony), in which the vice-president of the Accademia writes to Duke d'Antin: "La plupart des Italiens, pour remédier à ces inconvéniens, on été puissant aydés de leurs Maîtres, en sorte que le Concours a plutôt été une dispute de Professeurs que d'ecoliers".

Bibliography: E. Schaar, 1969, cat. no. 100. G. Hojer, 1980, pp. 114-118 and pp. 214-218, fig. 6; H. Trottmann, 1980, pp. 158-164, fig. 6.

D.G.

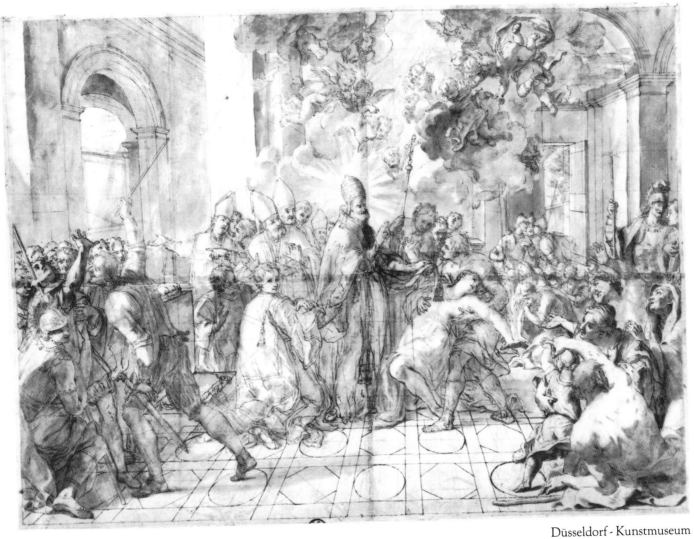

Düsseldorf - Kunstmuseum

113

49 FRANZ GEORG HERMANN (Kempten 1692 – 1768)

The Miracle of St Andrew Avellino, who resuscitates a child at the supplication of the mother who crawled, face down, from the church entrance to the Saint's altar

1713, Second Class of painting, first prize, inv. A. 275.
black pencil, pen, watercolor and chalk on brown-violet, prepared paper, mm. 520(610)×780(870).
at the bottom: *1713. Pittura. Seconda Classe. Primo Premio. Francesco Herman da Svevia A 32 L*; on the reverse: *N 32 A*.

Franz Georg Hermann, who came from a family of painters originally from Kempten in the Allgäu, learned to paint in the studio of his father Franz Benedikt Hermann. Following an almost ten-year residence in Italy, the now mature artist returned to Kempten where the title of "Hochfürstlich Kemptischen Hofmalers" (Court Painter of the Princes of Kempten) was conferred upon him. He proceded to work in numerous churches in Upper Bavaria and in Swabia. The success obtained in the Clementine competition of 1713 must have represented a crucial achievement in the life of this artist. In fact, in his *Self-portrait* of 1767, a year before his death (a work which is now to be found in a private collection in Ulm), Franz Georg Hermann includes the certificate of the prize of 1713 as well as the medal that was awarded to him for the portrait of Pope Clement XI Albani. In this drawing the miracle takes place within a church. The fallen child, dead from the impact and lamented by his family, lies on the altar of the church whose interior is very clearly drawn. The stricken mother is crawling from the entrance to the altar, touching the floor with her tongue. Attended by angels above the altar, St Andrew Avellino hovers above the clouds, giving blessings. Groups of onlookers placed to the left and right of the composition as *repoussoir* figures, react gesturally to the event. The story is varied, and sub-divided into many parts. One may note, for example, the richness of movements in the family group to the right of the altar. Behind, children clamber on the base of one of the columns, a motif used since the period of Veronese. Next to the entrance which leads the eye to the exterior is a scene with a monk who gives alms to a cripple crouching on the ground, almost a small genre scene. The group in the right foreground, is also highly varied. It includes not only the knight with the sword seen from behind, but also the cripple seated on the ground and the boy with his dog.
The artist depicts the architecture and furnishings of this possibly imaginary interior with the same precision used for the figures. An altarpiece, only in part hidden by the clouds can be recognized, for instance, and to the right of the altar in a niche there is a statue of St Paul. The coat of arms above the portal accompanied by the figure of *Fama*, alludes to Pope Clement XI as do the mountains crowned with stars visible on the balustrades of the side chapels. Here, as in the composition by Asam, the general effect is created through a well calculated control of the light which, accompanied by the precise drafting of architectural elements, gives an accurate definition to the space inhabited by numerous groups of figures. Franz Georg Hermann's technique is as remarkable as that of Cosmas Damian Asam when compared to the other red chalk drawings in the competition. Hermann covers the board with a brown-violet background, and then places a "sfumato" in grey and brown for parts in shadow, finally making abundant use of white chalk for the lighted areas; as a result, the composition gains great pictorial richness.
At the time of the Clementine competition Franz Georg Hermann was 21 years old and had already spent five or six years in Italy. He may have also spent the following years in Italy, since he is not traceable in Germany until 1717. According to the biography of the artist by Felix Freiherr von Oefele, Hermann worked in the studio of Sebastiano Conca (1680-1764).

114

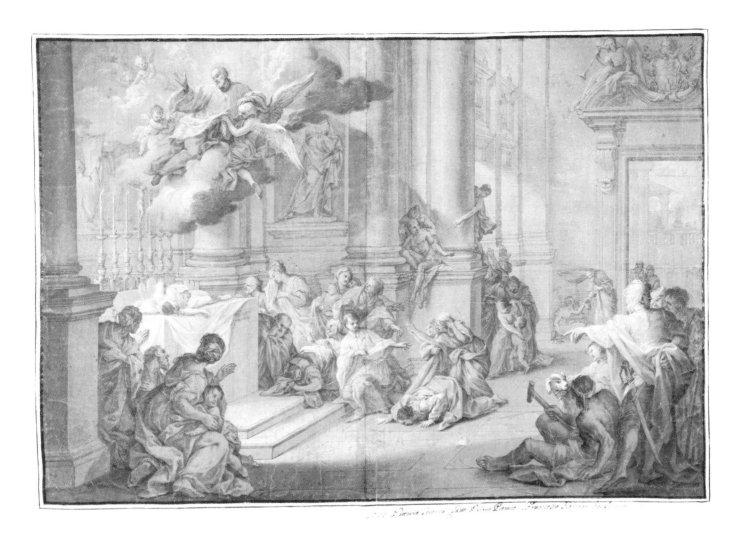

In fact Conca was in Rome from 1707, and in 1710 "he opened in his own house an Academy of the nude for a period of seven years" (Orlandi 1719, Stato delle anime di S. Lorenzo in Damaso; cited in *Sebastiano Conca*, 1981).

The influence of Sebastiano Conca, who brought late Baroque Neapolitan painting to Rome, especially the idiom of his master Francesco Solimena, is visible in the accurate relationship between the architecture and figures, in the uninhibited grouping of the figures within the spacious interior and, finally, in the rich drapery where the influence of Solimena, in addition to that of Conca, can be detected.

Bibliography: F. Noack, 1911, pp. 129-131; C. Böhm, 1968, p. 5; Schaar, 1969, cat. no. 100; G. Hojer, 1980, pp. 114-118 and pp. 214-218, fig. 7; H. Trottmann, 1980, pp. 158-164, fig. 7.

D.G.

50 WILLIAM KENT (Bridlington 1685 – London 1748).

The Miracle of St Andrea Avellino, who resuscitates a child at the supplication of the mother who crawled, face down, from the church entrance to the Saint's altar

1713, Second Class of painting, second prize, inv. A. 277
red chalk, mm. 660×545.
on the lower left border, "N", and further to the right, *1713. Pittura Seconda Classe Secondo Premio Guglielmo Kent Inglese C 34* (the two following numbers have been cancelled).

After training with a carriage painter, William Kent settled in London, whence he set off for Italy in June of 1709, together with John Talman, and the following winter arrived in Rome for a sojourn that was to last many years. From the letters he wrote at this time we learn that Kent pursued his studies in painting under Giuseppe Chiari, rather than with Luti as is usually stated (Wilson, 1984, p. 252, note 12). On June 3rd, 1713, he apprised Burrell Massingbird of his recent success in the Clementine *concorso*: "I made a drawing of my invention, about 200 figures, and have won now the prize" (ibid., p. 9). This is patently an exaggeration, since his drawing contains some twenty figures instead of two-hundred; moreover he implies that he came away with "the" one and only prize, whereas he was only a candidate in the second class of painting in which F. Hermann, as a matter of fact, surpassed him to win the first prize (cf. catalogue entry no. 49). Although he had read the correct version of the affair in a French newspaper, the loyal Massingham took Kent's assertions at face value and even hastened to have the news published in the August 5th number of the *British Mercury* (Middeldorf, 1957, p. 125). This minor incident is of interest insofar as it reveals something of Kent's character, for he emerges as an ambitious and sometimes unscrupulous individual when it came to manipulating facts and persons to his advantage: a type of behaviour that, coupled with his conspicuous artistic gifts, assured him a brilliant career under the auspices of his patron, the omnipotent Lord Burlington (see also Trench, cf. catalogue entry no. 30).
The drawing in question is an exercise in the manner of his master Chiari, undoubtedly better than the one with which Francesco Marzi from Acquapendente (Disegni, II, A. 278) won the third prize, although inferior to the representation of the subject by Hermann, due to certain deficiencies of an expressive and syntactic order. Apart from a few noteworthy passages (the head of the standing youth to the left and the woman with a child at the foot of the altar, as well as the kneeling mother), the figures come across as woolly in their modelling and with incongruities in their proportions. Flaws notwithstanding, Kent coped rather effectively with the task of staging the visionary apparatus required by a miracle whose iconography had not yet been firmly established after the recent canonization of Pius V (1712). The perspective view of the nave offers the glimpse of an academic-classical vocabulary that adherent to the taste of contemporary architecture designed by Carlo Fontana, whose varied decorative repertory extended also to the type of late Baroque idiom that characterizes the supple outlines of the altar. These details merit attention, because they are probably indicative of Kent's preferences in architecture during a formative period, many years prior to the work he undertook in this field after returning to England.
Towards the end of his prolonged stay in Rome, Kent debuted as a fresco painter with a public commission, the 1717 *Glory of St. Julian* in San Giuliano, the church of the Belgian residents in the city (Rudolph, 1983, fig. 354). In the wholly conventional imagery, patterned on Chiari's bland illusionism, Kent displayed neither a particular gift for painting nor even, it would seem, the corrective of an earnest application in its execution. His protean talent lay elsewhere and was rightly perceived by Burlington, who oriented

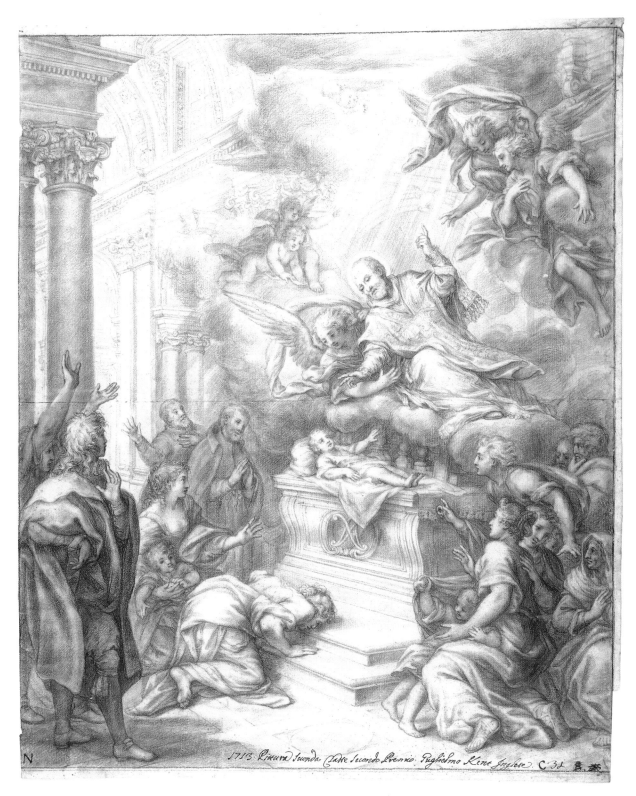

1713. Pittura Secondo Parte Secondo Premio. Puglielmo Kent Inglese. C 31

him to the sort of jobs that released his creativity in the inspired, eclectic designs for furnishings of every sort (interiors of Houghton Hall, etc.), architecture (Holkham Hall), engravings (illustrating Grey's *Fables* in the first edition of 1727, etc.) and, above all, for the landscaping of the emminently English garden (Carlton House in London; Rousham, etc.). The ease with which he juggled a heterogeneous repertory of archeological-Gothic-Chinese-Baroque styles rendered him a controversial personality in certain quarters (see, for example, the quarrel with Hogarth), yet at the same time placed him at the very forefront of contemporary English art. It must be remembered, in this sense, that no compatriot of his generation had merged himself for so long in the Roman *milieu*, a unique experience, documented by the prize-winning drawing of 1713, that gave him license to express his innate originality and facilitated his quest for an identity that could finally counter the dominence of European artists in his country.

Bibliography: U. Middeldorf, 1957, p. 125; L. Salerno, 1974, p. 352, fig. 29; G. Hojer, 1980, pp. 114-118 and 2314-218, fig. 9; H. Trottmann, 1980, pp. 158-164, fig. 9; M. Wilson, 1984, pp. 9ff (with further bibliography on Kent's Roman period).

S.R.

51 DOMENICO FREZZA

Triumphal Chariot laden with Trophies

1716, Second Class of painting, second prize, inv. A. 286.
pencil and red chalk, mm. 420(470)×585(720).
at the bottom: *1716 Pittura Seconda Classe Secondo Premio. Domenico Frezza Romano C 35 461*: on the reverse: *N 9 C.*

Our present knowledge of this artist, who is never mentioned in the specialist studies, is based only on the drawings preserved in the Accademia di San Luca. These show that he participated in the Clementine competitions of 1713, when he was awarded the first prize in the third class (Disegni, II, A. 279), of 1716 when he entered the present drawing, and, after many years, in that of 1732 (Disegni, II, A. 336). The 1716 competition theme assigned in the second class, "A chariot laden with spoils and trophies with some Ottoman slaves behind, tied to the chariot" did not give many possibilities for spatial interpretation, limiting the creativity of the individual competitors to the invention of the compositional setting and the distribution of the figures. Leonardo Siccardi, winner of the first prize, succeeded in dignifying the subject by placing the triumphal chariot in the centre of a scenographic structure, which in the modular scansion of the niches, emulates the nympheum of the Aldobrandini villa in Frascati, echo, as it were, the celebratory sound of the trumpeters who anticipate the chariot. Frezza, in contrast, does not aim for such epic tones but at a factual description which takes advantage of a large quantity of observers to exalt the episode which unfolds in everyday reality. The artist does not create a symbol of victory, but describes a parade of the booty of war witnessed by a crowd of people who marvel at the sight. Because of the exigencies of such a narrative, the crowded scene is set in an abbreviated landscape, but one which breathes the air of the mythic and fantastic. The episode's mythic nature is confirmed by the broken columns on high plinths which fancifully lean against a barely perceptible rock sprouting leafy trees. The story transforms itself into a fable recounted with the choral participation of the principal

1716 - *Pittura Seconda Classe Secondo Premio. Domenico frezza Romano.* C. 35

observer, Frezza himself who, to achieve the proper expository objectivity, sets the scene at a distance. The possibility of an arcadian interpretation of the subject is fascinating, and it would redeem the drawing from the overly academic style of its execution. There is a certain uneasiness in the banal style of the chariot (such a distant relative of the "currus triumphalis"!), in the definition of the faces and drawing of the bodies, whose distorted poses are vaguely grotesque and puppet-like. Nevertheless, his stroke is uninhibited, suggesting a long experience with pencil drawing. The linear *ductus* is clean and precise, the mellow *chiaroscuro* obtained by the red chalk is soft in the landscape and luminous on the columns, and these qualities recall the descriptive particularism and interpretations of light usual in prints. This latter suggestion supports the idea that Domenico was a relative of the better known Girolamo Frezza (1659-1741), an important engraver, and a pupil of Westerhout.

A.P.

52 SZYMON CZECHOWICZ (Cracow 1689 – Warsaw 1775)

Triumphal Chariot laden with Trophies

1716, Second Class of Painting, third prize, inv. A. 287
black pencil and chalk, mm. 405(465)×505(550).
at the bottom: *1716. Pittura Seconda Classe Terzo Premio. Simone Conowiz Polacco. C=37*; on the reverse: *N 90 C.*

In Italy by 1711, this Polish artist had been sent to Rome by his protector and patron F.M. Ossolinski to perfect the study of painting. He followed the courses of the Accademia di San Luca and won the third prize in the second class in 1716; proving himself quite successful in the Roman artistic environment, he concentrated on religious subject matter and earned justified credit for himself upon his return to Poland in 1731. He worked in Warsaw and Poznan producing portraits and sacred works both for great families and for churches, and founded a flourishing school of painting from which emerged Franciszch Smuglewicz (Warsaw 1745 – Wilno 1807); the latter came to Rome in 1763 and became a pupil of Anton von Maron, making a name for himself as a neoclassical artist.

Czechowicz's personal culture is characterized by a combination of figurative tastes which can only in generic terms be captured under the label "Marattism". Both the extempore work (Disegni, II, A. 288) and the prize winning drawing reflect the influence of the Cortonesque G.B. Lenardi and of S. Conca for certain characteristics of composition of the group in the foreground. However, the woodenness of the figures is reminiscent of the style of G. Triga who, together with Conca, worked in those years on the pictorial decoration of San Clemente in Rome. The drawing, very similar in its structural setting to that of L. Sicardi, first prize winner, is a true academic exercise, composed in a flat and schematic way and presents faithful to classical formulae not only in the citation of a temple on the right and the Pyramid of Gaius Cestius beyond the city walls of ancient Rome, but also in the extremely rigorous alignment of the four horses, copied from a *bas-relief* or from an Imperial coin. Stylistically the drawing tends to a taste for the picturesque, a quality however not sustained throughout due to graphic weaknesses such as the almost sculptural and rigid volumes of the horses, and the treatment of the edges with the hard, thick line. The artist's uncertainty in his execution of the background architectural elements results in a failure to capture the idea of a broad landscape ennobled by the presence of a fine group of small figures seen against wall, which aspires to recall Poussin. This hoped-for effect may represent an implicit homage to the Principal of the Accademia, the Frenchman Charles François Poerson.

Bibliography: M. Loret, 1929, pp. 18-22; J. Oranska, 1948, pp. 24-29, figg. 2, 3; J. Malinowska, *Polonia: arte e cultura dal medioevo all'illuminismo*, 1975, pp. 232-233, fig. 218 and fig. 217 for the extempore drawing.

A.P.

1716. Pittura Seconda Classe Terzo Premio. Simone Conoui? Polacco C.33

53 LUIGI VANVITELLI (Napoli 1700 – Caserta 1773)

Copy of the so-called "Urania" in the Capitoline Museum

1716, Third Class of painting, third prize, inv. A. 291.
pencil, red and white chalk, mm 535×350.
on the pedestal: "Urania"; on the square plinth: *1716. Pittura 3ª Classe 3° Premio Luigi Vanvitelli Romano.*

This competition drawing which, as far as the present author knows, is unpublished, earned for the sixteen year old Vanvitelli the third prize in the third class of painting, the course reserved for students of the Accademia who competed in the exercise of copies. This skill was important for professional, intermediary level, artists, required in editorial production and in the "service" work, very common in Rome and throughout Italy at the beginning of the 18th centry. For Vanvitelli, evidently a pupil at the Accademia di San Luca of his father Gaspar (who was already an academician in the years when his son studied at the Accademia), the decision to compete in a class of lesser rank was probably dictated by the possibility of lucrative professional markets it offered through its relations with a very active client market.

The copy of the Urania at the Campidoglio was the assignment for the competition of the third class of sculpture. From the publications relating to the competition of this year a relationship does seem not to emerge between this choice and that of *The Three Fine Arts in League with the Weapons for the Defense of Religion* which would emphasize the support of the Accademia di San Luca, so that the *Desired Triumph of the Christian Forces against the Turks* (in the conflict which in this period engaged the European powers) would come about.

Probably the connection, explicit in the themes assigned to the higher classes, was not pressed for in the sector where the fundamental object was to evaluate the technical skills of the copyists. The Capitoline *Urania*, standing on its present pedestal since 1639, was one of the most popular ancient objects, a popularity which originated with the masterly reinterpretation by François Duquesnoy in the *St. Susanna* of Santa Maria di Loreto (1629?-1633?). Without getting involved in the archaeological problem of the *Urania* (but cf. at least Stuart Jones, 1926, 1968, vol. I, pp. 20-21, vol. II, plate 10), it may be noted that the sculpture had been restored by reintegrating the arm and nose, that she holds a flute in her right hand but is missing the globe from her left, attribute of the Muse, and in the 18th century was also known as "Music".

Vanvitelli's entry drawing varies in many respects from those of the winners of the first and second prizes, respectively the Roman Stefano Pozzi and the Neapolitan Giuseppe Quercia (here reproduced on a smaller scales). In Pozzi's work (Disegni, II, A. 289) the refined virtuoso stroke of the red chalk is sustained by the minute graphic quality of the pencil and white chalk on the right arm. The division of the sheet by horizontal and verticle lines implies a drawing conceived in a form suitable for transference to an engraving. This is also implicit in the total absence of a back-drop, the almost frontal position of the sculpture (slightly oriented towards the left of the sheet) and the double rectangular border which frames the design, which is a purely graphic solution, as in the plate of a text. In Giuseppe Quercia's drawing (Disegni, II, A. 290) the more compact and summary stroke on paper with chain wires and laid lines with a quite large weft, expresses the plastic peculiarity of the drapery and the slight *hanchement* of the *Urania*, who in the drawing is implied as an object unto itself. In Quercia's work the suggestion of shadow on the right of the sheet alludes to the spatial location of the sculpture which is orientated in a somewhat oblique position towards the right hand side of the sheet.

Vanvitelli solved the problem by totally different means. The paper was probably

VRANIA

1716. Pittura 3:ª Case 3:º Premio
Luigi Vanvitelli Romano

123

prepared by passing a very light layer of pulverised red chalk with a brush which gives relief to the subtle weft with laid lines only. A *passe-partout* was used to define the margins of the sheet (which is probably the original, since the fixing holes on the table of the easel appear on the inside). His graphic technique which, as in the other two sheets, employs strokes of pencil, red chalk and highlighting with white chalk (here more marked), is more varied in dimensions the range of its: broader in the drapery on the right but very fine in the details of the hairs on the neck. The heightened use of white chalk and the red chalk line articulate a *chiaroscuro* that is much more varied than in the drawings by Pozzi and Quercia, emphacized by Vanvitelli's decision to place the sculpture within its spatial context, the rectangular niche where it is still today located. Vanvitelli placed himself in front of the *Urania* like a visitor in a museum, where the sculpture is affected by all the physical "mishaps" created by the light as it spreads over the rounded surfaces: hence the strong highlighting on the right part of the face. The molded rectangular niche gives direction to the expertly drawn shadows, on the vertical element behind the flute supported by the right arm. Similarly, the inclusion of the inscription on the pedestal (absent in the other two drawings) is intended to reinforce the presence of the sculpture as an object, in which the architectural space is inseparable from its primary function. The drawings for the academic competitions were notorious for being elaborated in minute detail up until the very day of their presentation to the academic commission. We do not know much of the lenticular precision of Vanvitelli's copy of the *Urania* was due to the advice of Gaspar Van Wittel, to whose culture and technical 'baggage' all the above graphic solutions clearly refer. But it is certain that when the artist appeared as a formed painter, perhaps already torn between the professions of architecture and painting, the learned classicism of the *St. Cecilia in ecstasy surprised by Valerianus* in Santa Cecilia in Trastevere, (its Marattesque character filtered through Sebastiano Conca), reveals a complete artistic personality, with the capacity to achieve a purified academism. (Cf. the incisive and dynamic preparatory drawing now conserved in Caserta; for Vanvitelli's pictorial production, cf. Chierici, 1937, pp. 513-517).

Is it possible to harmonize so evidently bitter an experience with his subsequent developments, which were of such complexity as to make his appearance as a painter, in hindsight only a brief interval of his career?

Without wanting here to tackle the complex and much discussed problem of the qualification, in late Baroque and neoclassic terms, of his classicism, I should like at least to note that he assumed an exceptionally complex creative physiognomy, both from the point of view of architectural decoration and that of the use of sculpture in architectural contexts. The great variety of Vanvitelli's approaches to the classicist vocabulary proves that it is impossible to label him as simply late Baroque or neoclassical. As is clearly documented in his student copy of the *Urania*, his relationship with antiquity began very early within his activity as an artist, and was almost never absent from his work again.

R.L.

C.

1716. Pittura Terza Classe Primo Premio. Stefano Pozzi Romano.

1716. Pittura Terza Classe Secondo Premio. Giuseppe Guerra Napolitano

125

54 CHARLES NATOIRE (Nîmes 1700 – Castel Gandolfo 1777)

Moses descending from Mount Sinai

1725, First Class of painting, first prize, inv. A. 292.
pencil, pen, watercolor, white chalk, mm. 485(525)×740(760).
at the bottom: *1725. pittura Prima Classe primo Premio Carlo Natoire de Nîmes C. 37 a.o. trentasette*; on the reverse: *N. 36 A.*

The theme assigned in this year for the first class is the moment when Moses, descending from Mount Sinai, stops within sight of the people of Israel. With the Tables of the Law in his hand, he shows the will of God to his people camped at the foot of the holy mountain, referring also to the dramatic event of the breaking of the Tables as parallel to the breaking of the covenant between God and his people.

Here Natoire shows that he has taken much from Michelangelo, as is equally true of the drawing which shared the first prize, by Domenico Scaramucci.

However, Bernini also must have strongly influenced Natoire, for in his *Moses* he reiterates both the gesture and the overall pattern of the *River Plate* from Bernini's *Fountain of the Four Rivers*. Nor can Raphael have been missing from the young artist's Roman training to judge from the fact that a parallel can be inferred between the drawing in question and the Vatican *Disputa* in the two figures, one kneeling and the other moving away towards the back, which appear on the left side of the composition of Natoire.

Charles Natoire, born in Nîmes in 1700, worked with his father, a sculptor, until he reached the age of seventeen. He then went to Paris to study under François Lemoine for four years. In 1721 he won the Grand Prix of the Académie Royale with *The Sacrifice of Manoah* (*Charles-Joseph Natoire*, 1977, pp. 39-41). In this year he began to develop a more personal style in which it is possible to detect, especially in the principal figures, echoes of Poussin. The drawing for the Accademia di San Luca is stylistically close to his earliest paintings, portraits of noble ladies with their children. Undoubtedly the influence of Lemoine is clearly visible in the style of Natoire's first works up until his Accademia drawing of 1725. Parallels may easily be traced with the *Juno, Iris and Flora* by Lemoine, now in the Louvre, especially in the faces of the women and men which repeat themselves over and over in Natoire's entry drawing, directing the eyes towards the central fulcrum of the figure of Moses.

The influence of the *Heracles and Omphale*, the only painting executed by Lemoine in Rome, during his brief six-month stay in the Académie de France in 1724 (L. Dimier, 1928, pp. 61-92) on Natoire's present work is also clear, especially in the two figures in the foreground with a child, whose profiles together with the child's anatomy faithfully repeat the gracefulness of the painting by Lemoine.

Other artists who may also have influenced Natoire are Nicolas Vleughels, director of the Académie de France (L. Dimier, 1928, pp. 245-260), and Giuseppe Chiari, Principal of the Accademia di San Luca.

However, Natoire's drawing reveals a noteworthy enthusiasm for developments in Roman art at the beginning of the 18th century. Thus one finds echoes of the *St Peter* by Pierre-Etienne Monnot in St John Lateran executed between 1708 and 1713 (Enggass, 1976, pp. 77-89) in the overall design, the drapery, the gesture of the hand, even in the angle of Moses's face, resulting in a sort of copy of the sculpture in a graphic technique.

Charles Natoire, later one of the most important artists of the French Rococo, returned to France in 1730, and became the principal painter to the king. In 1735 he obtained the post of professor at the Paris Academy. However his fame remains primarily linked with the

126

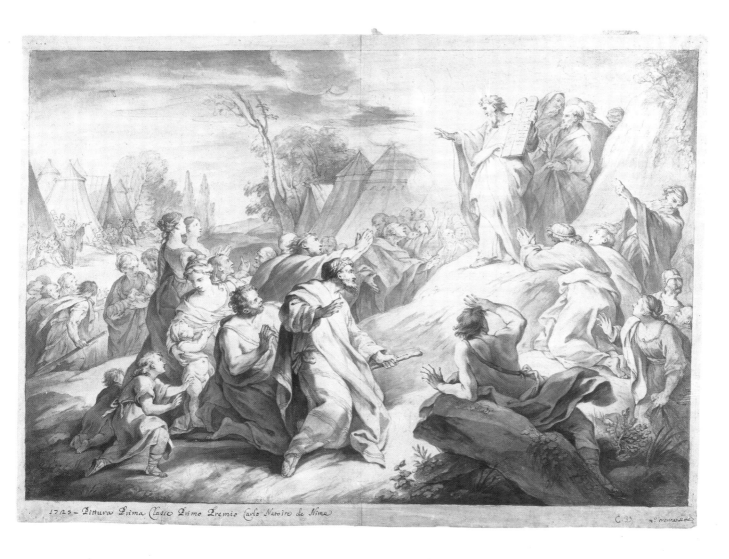

1725 - Pittura Prima Classe Primo Premio Carlo Natoire de Nîme

decoration of the Oval Hall of the Hotel de Soubise and of the Royal Residences of Versailles and Marly.

He returned to Italy in 1751 as Director of the Académie de France and remained in Rome until 1774, working, among other things, on the decoration of the vault of S. Luigi dei Francesi. He spent the last three years of his life in retirement at Castel Gandolfo (Rubin, 1977, pp. 14 and 84; P. Rosenberg, 1984, pp.185-187).

It is probable that the Accademia di San Luca instructed its students to use the works of already estabilished artists as models, without however destroying the original beauty. It may be supposed that creativity and originality were encouraged in a just balance with the classical tradition. However, both the talent and the professionalism of the artists in the first decades of the 18th century in Rome are quite high and in like manner the qualitative standard of the competition entry drawings for which the Accademia awarded prizes in its competitions was elevated.

M.T.

55 DOMENICO SCARAMUCCI

Moses descending from Mount Sinai

1725, First Class of painting, first prize, inv. A. 293.
red chalk and black pencil, mm. 580(610)×470(545).
at the bottom: *1725 Pittura prima Classe Primo Premio. Domenico Scaramucci Senese. C=45 464.*

Here once again the decision of the judges seem to be directed towards rewarding in the competitors the ability to re-work or actually quote wholesale from well known models, while maintaining throughout the drawing a good stylistic quality and a fair compositional balance. The similarities between the drawings in the same class suggest that the interpretation of the passage from Exodus assigned was guided by precise instructions, if not directly by a common model which is more or less silently present. As in Natoire's drawing which shared the first prize, this drawing shows the Israelites who are characterized by imploring and fearful gestures in a circular arangement around Moses who has just come down from Mount Sinai. In the distance the camp is suggested by the groups of tents while in the foreground Moses holds up the Tables of the Law.

The present drawing is by "Domenico Scaramucci senese", an artist whom we know very little about but who must have been well informed with regard to Roman painting and sculpture of the period.

It is also possible to discern the echo of a detailed study of Michelangelo's frescoes in the Sistine Chapel, especially in the figure of the youth on his knees who turns his face to protect himself from the strong light emanating from Moses. The relatively small head and neck compared with the strong and broad thorax and the accentuated muscles of the shoulders and arms, have direct parallels in the fresco by Michelangelo. Another convincing relationship may be established between the female figure on the left side of the *Last Judgement* and the woman in the foreground in Scaramucci's drawing emphatically twisted into an unnatural position with a long braid which counterbalances her disproportionately small back and a terrified child at her side. However another possible source for these figures which cannot be discarded, is the authority, Maratti, Principal of the Accademia between 1699 and 1713. He uses the same figure in the foreground on the right of his *Visitation*, in the drawing of *Prudence* now in the Metropolitan Museum of Art, and in the engraving, *The Birth of the Virgin* in the Museum of Düsseldorf (Graf, 1973, nn. 80-101). Again following these classical examples, one may establish a direct relationship between the figures of Scaramucci and the *Stanza della Segnatura* of Raphael, which reveals that the Moses is directly modelled upon the Aristotle of Raphael while the gestures and position of the priest in the drawing replicate the characteristics of his Plato. There is sculpture as well to be found in the 'bagage' of images from which Scaramucci drew inspiration: Bernini's *The Rape of Persephone*, is faithfully cited in the figure in the foreground on the right, especially in the counterpuntal turning of the head and the shoulders. Hence the Accademia, in this case as well, seems to have rewarded not so much the originality of the drawing, but the artist's capacity to add up obligatory citations into a coherent illustration.

Domenico Scaramucci went on to become an established artist in Rome in that period and the prize of the Accademia di San Luca probably helped him to obtain commissions such as *St John the Evangelist* for the new facade of the basilica of St John Lateran and the bas-relief of *The Beheading of John the Baptist* for S. Giovanni dei Fiorentini, both in 1735, ten years after his competition victory.

M.T.

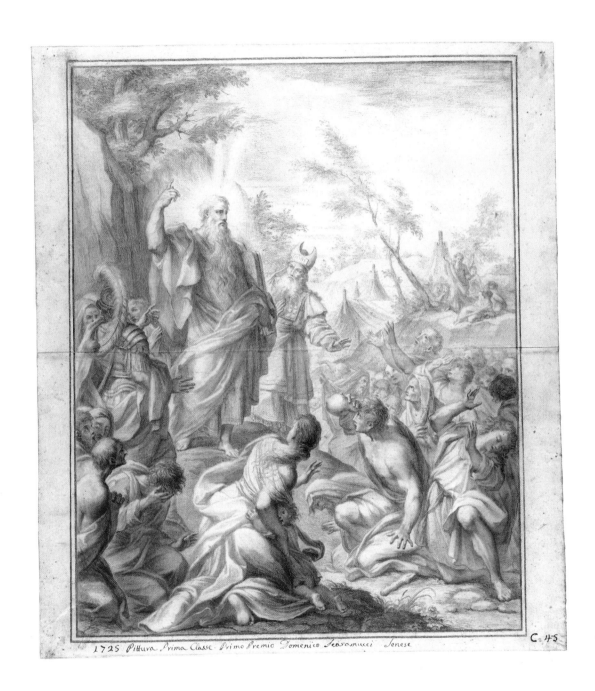

1725 Pittura Prima Classe. Primo Premio Domenico Scaramucci Senese

56 CHARLES VAN LOO (Nice 1705 – Paris 1765)

The Feast of Belshazzar

1728, First Class of painting, first prize, inv. A.312.
pencil and red chalk, mm. 505(525)×745(780).
at the bottom: *Carlo Vanlò Provenzale 1728*: on the reverse: *N.48A*

Charles Van Loo was born in Nice in 1705 and came to Rome while still very young. Here he became a pupil of Benedetto Luti and the sculptor Le Gros. In 1719 he went to Paris, where in 1724 he won the Grand Prix, returning to Italy in 1727 together with his father Louis, his uncle François and François Boucher, travelling throughout the peninsula before arriving in Rome (Rubib, 1977, pp. 94-96; Rosenberg, 1983, pp. 210-211; id, 1984, pp. 216-218). This proves that Charles Van Loo knew many works of the great artists directly and that the most apt parallels with his drawing are really to be sought outside Rome. This leads one to suppose that Van Loo's brief stay in the Eternal City was useful for developing a basic visual vocabulary.

Van Loo's composition is broad and spacious and the architectural elements in the background seem to suggest that the scene took place in an open, internal courtyard.

Stylistically the drawing submitted to the competition is similar to early works by Boucher, in particular to *Evilmeradoch who liberates Joachim from Prison*, winner in 1723 of the Grand Prix, in its depiction of the draping tapestry folds (Sutton, 1982, pp. 23-31 and 257-267).

Perhaps Van Loo was recalling the works of Leonardo, especially *The Annunciation of the Virgin* in the Uffizi and *The Virgin, the Child and St Anne* now in the Louvre, in the delicacy of profiles of his female figures, especially those who look towards the king from the centre of the table, and for the play of the hands of the two women. There is also his *Last Supper* to consider, as the most obvious model given the similarity of the scenes. Among the many parallels with the latter, the most specific is the similarity of Van Loo's figures with the physical types and gestures of the Apostles. Van Loo's adaptation of the two grottesque heads from the sketches of Leonardo however is exact, and to be compared with the head of the warrior now in the British Museum and to the other grottesque profile of a man with a hat now in the Royal Library in Windsor Castle. Nevertheless it seems that strong debts to Rubens or Van Dyck are recognizable in the delicate modelling of the figures and in the quiet movement of the drapery which represents a further return to French and Flemish baroque art.

These comparisons are useful for understanding the training of Charles Van Loo, who matured both in Rome and outside its environment. In his drawing are reflected the echos of other masters beyond Raphael and Michelangelo (who dominated the Roman 'training school' of the 16th, 17th and 18th centuries) and he suggests a different way of putting to good use the famous 'copying from the masters' in contrast to current use.

Charles Van Loo remained in Rome until 1734 where, among other things, he painted the ceiling of San Isidoro. In Turin he painted in the Palazzo Reale and in the Stupinigi. In addition to this he produced numerous canvases, including the *Aeneas Carrying Anchises*, now in the Louvre. Upon his return to Paris he was offered prestigious commissions, became an academic in 1735, professor in 1737 and director of the Ecole Royale des Elèves Protégés in 1749. Finally he was appointed director of the Académie.

M.T.

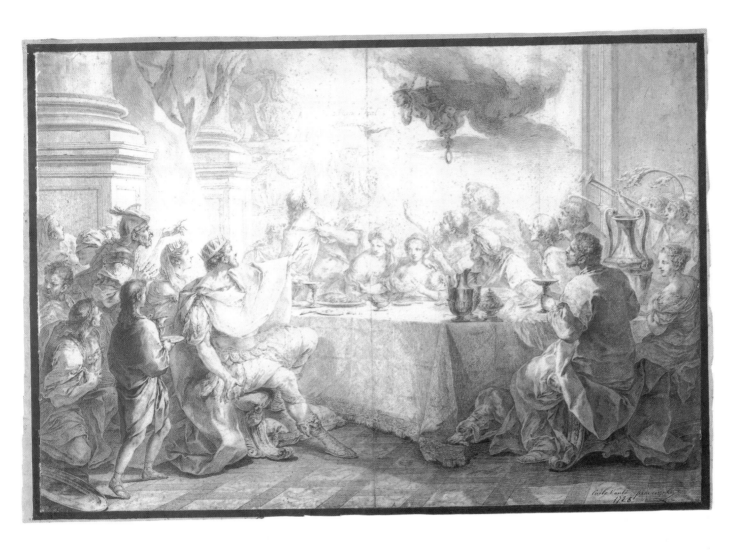

131

57 FRANCESCO CACCIANIGA (Milano 1700 – Roma 1781)

The Feast of Belshazzar.

1728, First Class of painting, first prize, inv. A. 313.
red chalk, mm. 744×550.
in the lower left corner *C.412.*

After Carlo Maratti's death in 1713 the Clementine *concorsi*, held quite regularly up to then, became less frequent under the waning authority of his followers, which lapsed altogether during the years between the end of the papacy of Clement XI in 1721 and that of Giuseppe Chiari's tenure as *Principe* of the Accademia di San Luca in 1727. The only two competitions dating from the reign of Benedict XIII (1723-30) reflect both his phase of reorientation and the increasing prestige of French masters. Sent to Italy on the strength of the *Prix de Rome* awarded in Paris, such as Natoire (cf. catalogue entry no. 54) and Charles Van Loo (cf. catalogue entry no. 56). It is known that the Orsini Pope preferred the architectural enterprises of the "gotico beneventano" Raguzzini (the epithet is Milizia's) to painting; indeed the latter was briefly a less prominent factor in Roman art until a new generation of talents, headed by Batoni, came to in the early 1730s. Therefore the results of the 1728 *concorso* offer a cross-section of trends that is useful for the identification of the type of Rococo taste then in fashion, before it underwent the modifications during the period of Clement XIII (1730-40) that ultimately led to the classicizing deflection evidenced in the 1739 competition (cf. catalogue entries ns. 62, 63 and 64).

All the prize-winning drawings in the first class are distinguished by the scenographic nature of the settings devised for the banquet and by the opulence of furnishings and costume, this inherent in the designated subject. Francesco Caccianiga had lately reached Rome well prepared to meet the challenge posed by this sort of representation: as a youth he had studied perspective with Ferdinando Galli Bibiena in Bologna (1717-19) and then returned to his native Milan, where he produced frescoes and canvases for some churches (Santa Maria in Beltrade, etc.) and a series of Biblical stories for his patron, Conte Calderari. His *Feast of Belshazzar*, which won him a first prize *ex aequo* with Van Loo, probably gives an idea of the tenor of those lost paintings and at least clearly reveals in its staginess the hallmark of his Bolognese formation. Caccianiga's interpretation draws its strength from the vertical format he chose, emphasised by the shaft of an outsized column in the foreground whose shadowy silhouette accentuates the resplendency of the company beyond. The intromission of this element constitutes an efficacious theatrical note and is also a device that clarifies the narrative, in that it frames the distant display of the plate taken from the Temple and, at the same time, isolates in the supper right the hand writing the prophecy deriving from that profanation.

Apart from the very obvious citation from Michelangelo in the servant hoisting an urn (modelled on *Amman* in the Sistine pendentive, but in the manner of Ludovico Carracci), it is the reminiscences of Bolognese art that predominate here, even in details like the balcony with musicians (frequent in Emilian painting from the time of Niccolò dell'Abate) and the charming visage of the Queen (akin to figures in V. Bigari's contemporary frescoes in the Palazzo Ranuzzi in Bologna). The historical costume worn by the boy to the left and the play of light over the face of the one against the column suffice to underline Caccianiga's tendency to translate prototypes found in Creti's work in an imagery strikingly similar to what Sebastiano Ricci and the young Tiepolo were evolving in the Veneto on the basis of the tradition established by Paolo Veronese. Indeed it was precisely in 1728 that this Venetian School emerged in the Clementine *concorsi* with the debut of

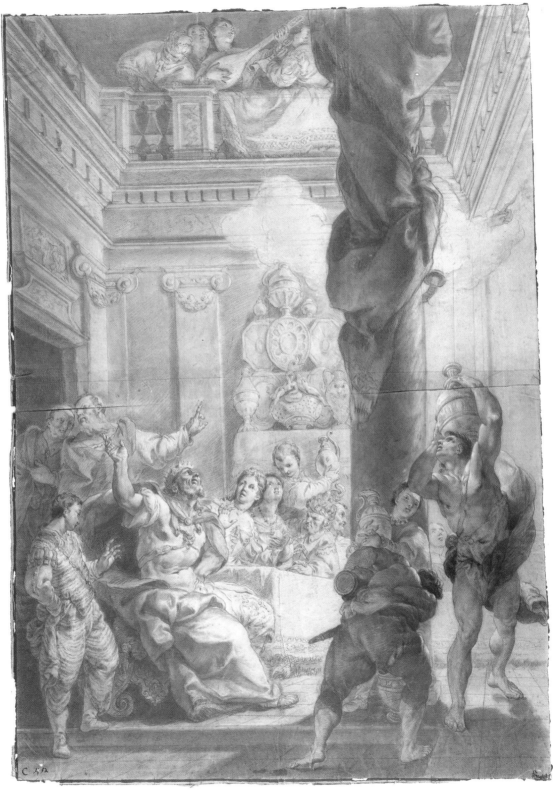

133

Francesco Fontebasso, who took at third prize (Disegni, II, A. 314: *ex aequo* with Giovanni Sorbi from Siena) for a drawing excessively cluttered with actors in fancy dress and flimsy architecture.

It transpires that this Venetian mode did not secure a foothold in Rome: Caccianiga had already abandoned it when he unveiled his first public work there, *St. Celsus vanquishes the Pagan Priests* of 1736-38 (in Santi Celso e Giuliano: Rudolph, 1983, fig. 109), which signals an almost Purist return to his Lombard origins. His lengthy quarrel with the prelate who commissioned that painting compromised his career, of which the successive chapters have been reconstructed by A.M. Clark (1973, pp. 3-4). Caccianiga involved himself with the administration of the Accademia di San Luca, to which he was elected in 1740, and sent paintings (many now lost) to Ancona, Forlí, Turin, Florence (the fine *Self-Portrait* in the Uffizi Gallery), as well as to Spain and Portugal. At intervals he came forth with pictures of real distinction, such as the sober *Confirmation of the Dogma of the Immaculate Conception* in Salamanca (Capilla de la Universidad: Urrea Fernández, 1977, pp. 251-252, pl. LXVI, 2) and the late but still Baroque *Fall of Phaeton* for a ceiling in the Villa Borghese (Rudolph, op.cit., fig. 110), that confirm his rank within the Roman School of the 8th century as a subject that merits further investigation.

Bibliography: L. Salerno, 1974, p. 352, fig. 33

S.R.

58 PLACIDO CAMPOLO (Messina 1693 – 1743)

Daniel interprets the Dream of Nebuchadnezzar

1728, Second Class of painting, first prize, inv. A. 319.
red chalk, mm. 490(540)×740(770).
at the bottom: *1728 Seconda Classe Primo Premio. Placido Campolo Messinese.*

Classical references to Michelangelo and Raphael, from the frescoes of the Sistine chapel and the Stanza della Segnatura are irregularly gathered together in this composition making a qualitative evaluation of the style difficult, for Campolo does not succeed in giving unity to the whole. The citations remain as such, telling of his ability to copy but not of his capacity for original creation.

Placido Campolo studied with Filocamo in Messina (Thieme-Becker, pers. comm.) and came to Rome in 1713 at the latest, working in the studio of Sebastiano Conca. After having won the first prize in the second class of the Accademia di San Luca, he remained in Rome where he became a priest (in 1732 he won the first prize in the first class of the same Accademia and he is already called 'priest' in the printed program of the celebration of that competition; cf. the following entry). In 1735 he received an assignment for several paintings in the Palazzo Pubblico from the Senate of Messina. He then remained in his native city where he worked on *The Fall of the Rebel Angels* in the chapel of the Monte della Pietà in S. Angelo dei Rossi (1738), and other frescoes and paintings, such as the *Madonna of the Letter* now in the church below the cathedral. His career also included some experience as an engraver, such that he created the dedicatory allegory for the *History of the Famous Archconfraternity of the Azzurri*; he also practiced as an architect, designing the flight of steps for the chapel of the Monte di Pietà degli Azzurri.

M.T.

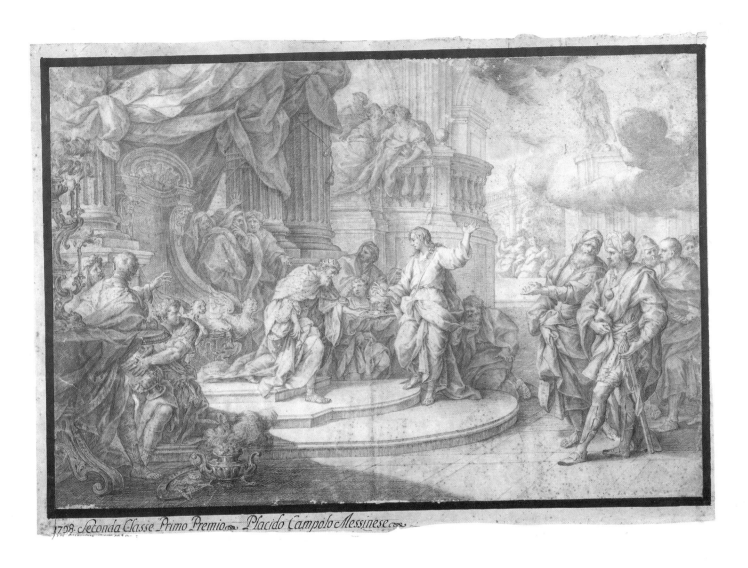

1798. Seconda Classe Primo Premio. Placido Campolo Messinese

135

59 PLACIDO CAMPOLO (Messina 1693 – 1743)

Mattathias destroys the Altar of the Idols

1732, First Class of painting, first prize, inv. A. 333.
red and white chalk, mm. 530(640)×600(770).
at the bottom: *Anno 1732, Prima Classe Pittura, Primo Premio D. Placido Campolo Messinese. C=56 111 477.*

Placido Campolo partecipated in the Clementine competitions of 1713, 1728 and 1732. He must therefore have been in Rome at least from 1713, as a collaborator in the studio of Sebastiano Conca who had returned to Rome from Naples in 1707. In 1732 Placido Campolo won the first prize in the first class.

The theme is taken from the first book of the Maccabees where, in chapter 2, is recounted the story of Mattathias, priest of Modin, who refused to offer pagan sacrifices though the envoy of King Antiouchus had promised him gold, silver and rich gifts in return. Heedless of Mattathias's call to ignore the decree of the king, a Jew declared himself willing to offer the sacrifice in front of all the people, and the priest of Modin did not hesitate in killing both him and the king's representative and in destroying the altar. After this, in order to save his life, he and his five sons fled into the mountains.

At the time of the Clementine competition of 1732, Placido Campolo was 39 years old, a man who for some time had been a mature artist. Thus it is not surprising that he knew how to develop the theme with skill, even if the general overcrowding of figures and groups makes the action difficult to identify. In addition as he was dealing with a passage rarely represented, the artist lacked the support of iconographic tradition. On the left in the middle ground is the figure of Mattathias, with his sword drawn as he exhorts the people to look towards heaven. Against him press the King's soldiers. In the center of the composition at the foot of the altar lie the figures of the two men killed by Mattathias, while on the altar burns the Book of the Law. A pagan priest reacts to the event with an attitude of defensiveness and fear. Behind him, another pagan priest kneels in adoration of the idol placed on a high pedestal between the columns; behind the idol is one of Mattathias' sons who is about to strike down the pagan image and reduce it to fragments. The whole is orchestrated in a way which recalls Campolo's drawing of 1728 (cf. catalogue entry no. 58), with which he won first prize in the second class. On that occasion as well, he placed the principal figures on a stepped podium, while the columns wrapped in grandiose drapery above the throne of Nebuchadnezzar (here above the pagan idol) are a typical motif of the artist, skillfully used in both drawings.

In its richness and variety, the composition recalls the works of Sebastiano Conca around 1720 such as the painting, *The Arts and the Sciences*, in Pommersfelden. However the figures of Campolo do not have the lightness of movement of Conca's. They are "more classical", each: independantly positioned being Mattathias, the priest near the altar of the youth who is running towards the right, the kneeling woman with the dove in the foreground, of the soldier lying dead at the food of the altar. The artist cites, or develops complicated and interesting poses, linking each into the compositive whole. But because of the stiffness of many figures and the antiquarian precision with which the altar, utensil and vessels are shown, the scene recalls more than anything elese, a collection of tracings in chalk.

Placido Campolo returned to Messina by 1735 at the latest, since the city senate's commission for paintings in the civic galleries dates to that year. The artist died of the plague in Messina in 1743.

D.G.

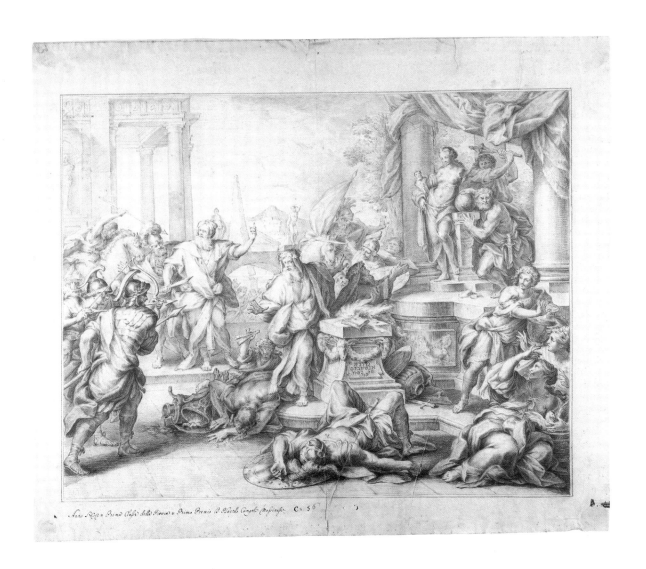

Anno 1612 = Prima Classe della Pittura = Primo Premio P. Piccola Cangelo Orefisiense. C. 56

60 PAOLO ANTONIO MATTEI OF CASCIA

Mattathias destroys the Altar of the Idols.

1732, First Class of painting, second prize, inv. A. 334.
red chalk, mm. 500(545)×745(780).
at the bottom: *Anno 1732, Prima Classe Pittura, secondo premio Paolo Antonio Mattei da Cascia C 43 112.*

Paolo Antonio Mattei, of whose life we know nothing, had already participated in the Clementine competition of 1728, winning the second prize in the third class (Disegni, II, A. 326). In the following competition (1732) he moved directly from the third class to the first class and won the second prize with the drawing shown here (for the theme cf. catalogue entry no. 59).

In comparison with Placido Campolo's drawing (cf. catalogue entry no. 59), the composition of Mattei is much clearer, more comprehensive and academic; two groups of *repoussoir*-figures, to the right and left direct their gaze towards the courtyard of the temple, at whose center are the altar and the idol. Standing beside the partially destroyed pagan image, one immediately recognizes the figure of Mattathias by his ritual priestly dress, as he holds the sword aloft. Nearby are four youths, his sons, who complete the task of destroying the idol. In the background the king's soldiers rush in from the portico which encloses the temple to capture the priest and his sons. In front of the altar lies the body of the Jew killed by Mattathias while the body of the envoy of the king is located in the foreground on the left, quite close to the observer. He lies at the feet of a group of Jews who, together with the woman kneeling on the right, are present on behalf of the observer at the unexpected event, commenting upon it with lively gestures. The conception evidently follows the manual. In the foreground are placed the *repoussoir*-figures in shadow, while at the center is the principal event, while much diminished to give the idea of depth are the figures of the soldiers who rush into the courtyard. Finally there are the various architectural elements: on the left three fluted columns, on the right the temple pediment with smooth columns, behind it a circular temple with the statue of a god and then the enclosing portico. The figures still follow the formal canons of Carlo Maratti, as acquired indirectly through the youngest representatives of his school such as Giuseppe Chiari and, especially Agostino Masucci. They endowed the early and "classical" formal language of the master with lighter, more animated and delicate expressions.

D.G.

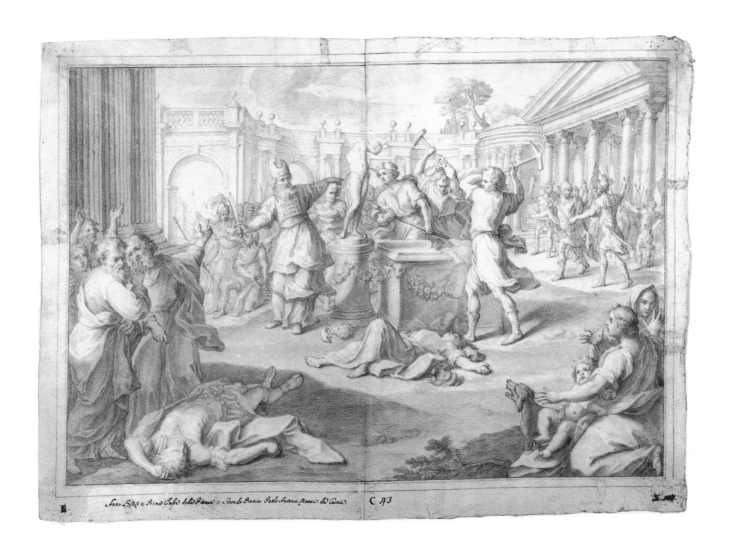

Anno 530 = Primo Caso della Peste = Secondo Premio Paolo Antonio Mauri da Caccia. C 143

139

61 GIUSEPPE PERONI (Parma 1710 – 1776)

The Martyrdom of the seven Maccabean Brothers

1739, First Class of painting, first prize, inv. A. 343.
red and white chalk, mm. 540×755.
on the lower left border, *1739 Pittura Prima Classe Primo Premio Giuseppe Peroni Parmigiano n. 44, n. 6.*

From an art historical point of view the drawings awarded prizes in the first class of painting, three of which present in the exhibition, render the Clementine competition of 1739 one of the most interesting of those held before the middle of the 18th century. Although circumscribed within the limits of the graphic medium, the entries submitted by Peroni, Preciado and Nessi (cf. catalogue entry no. 62, 63) coincide in their articulation of a taste that was emerging in Roman painting in a moment of transition at the end of the papacy of Clement XII (†1740). Thus it was the Academy institution that now corroborated the brand of classicism lately evolved by Agostino Masucci (cf. catalogue entry no. 32): this stately yet opulent vision, akin to the pomp of Metastasian theatre, would become increasingly fashionable during the next twenty years as it was gradually purged of its late-Baroque sediment, so as to merge with the new archeological vogue that rendered Giaquinto's colourful Rococo imagery obsolete in the 1760s. The cosmopolitan aggregation of this *concorso* is particularly indicative, since it was the proving stage for two rising talents, Peroni and Preciado, destined to officially represent the Bourbon style in its Franco-Italian (in Parma, "l'abrégé de la cour de Versailles") and Hispanic-Italian (in the Roman *pensionato* of the Academia de San Fernando) ramifications during the hegemony of the sons of Philip V and Elisabetta Farnese.

Peroni arrived in Rome in 1734 armed with an impeccable curriculum. After studying with Spolverini and Bolla in Parma, he had spent two years in Bologna under Ercole Lelli (anatomy), Ferdinando Galli Bibiena (perspective and architecture), Creti and Torelli (painting), to round out these varied apprenticeships in 1733 by taking a prize in the second class of *figure* in the Clementine Academy there (see Rota Jemmi, 1979, pp. 70-71). Five more years in Masucci's workshop confirmed the conservative bent of this Parmesan and left a conspicuous mark on his graphic manner, as evidenced by the firm, scrupulous execution of the 1739 drawing, which ranks as the most beautiful in his early production. It also shows a degree of approximation to his master that Peroni never attained thereafter: in fact the composition derives from Masucci, its basic frieze-like structure following the layout of *Veturia and Volumnia interceding with Coriolanus* in the Mead Art Museum of Amherst, a picture that A.M. Clark identified as a possible studio replica by that artist (1967, in the 1981 ed., p. 94, fig. 110). Peroni here transposed the nucleus of the confrontation between the mother and son in the center and the hero to the left in that scene, as well as details like the crisp, sculptural folds of drapery and, above all, an accent of Roman gravity that predominates over the marginal episodes of torture. The scenographic *décor* is, however, of a new sumptuousness in the introduction of an imposing backdrop, replete with draped columns, a curved portico and the statue of *Jupiter Fulgor*. If certain aspects of this pseudo-archeological repertory anticipate the Louis XVI taste in ornamentation (the tyrant's throne and the base of the statue), the broad perspective sweep of the ensemble owes much to the airy concoctions of Bibiena.

This drawing constitutes a valuable, if isolated, testimonial to what Peroni might have produced in the genre of historical painting: he instead turned his talent to religious imagery. As soon as he was ordained Archdeacon, in 1743, he returned to Parma, where he supplied various churches with altarpieces and frescoes (some reproduced in colour by Riccomini, 1977, pp. 59ff). His professional success is attested by the caliber of the

commissions he received (from the Duchess Luisa Elisabetta, the Certosa of Pavia, San
Filippo in Turin, etc.) and his nomination as Professor in the Accademia di Belle Arti
founded in the city in 1752 (see Allegri Tassoni, 1955, pp. 220ff). Yet not even another
Roman sojourn in 1750-52 persuaded him to reattempt a representation of the scope and
noble rhetoric that distinguish the drawing awarded the first prize in the Clementine
concorso of 1739.

S.R.

62 ANTONIO NESSI

The Martyrdom of the seven Maccabean Brothers

1739, First Class of painting, second prize, inv. A. 344.
red and white chalk, mm. 570×750.
on the lower: *1739 Pittura Prima Classe Secondo Premio Antonio Nessi Romano* C. 58; to the right, partially cancelled, *Pr: 140 Francesco Ferrari Seg. rio.*

The inscription on this drawing, which in 1739 merited a second prize *ex aequo* with Preciado (cf. catalogue entry no. 63) in the first class of painting, informs us that Antonio Nessi was a Roman; in addition, two laconic citations of his altarpieces, in the updated edition of Titi's guidebook to the city published in 1763, qualify him as a pupil of Agostino Masucci. On the basis of these meager references and the handful of pictures associated with his name, it is possible to attempt here a preliminary fleshing-out of his personality as an artist, heretofore ignore in the context of studies on 18th century Roman painting.

The point of departure for a reconstruction of Nessi's career is offered by this youthful essay, the only known drawing by him, which formulates a considerably personal interpretation of the taste promulgated by his master. The red chalk is manipulated with especial ductility in the modelling of the kneeling figure to the right, thence thickened to the soft tonal variations of the woman in the left corner and finally misted into the feathery billows of smoke filling the background. These lushly textural effects reappear in Nessi's oils and frescoes, whereas the atmospheric quality of the distant conflagration replaces the terse architectural outlines that dominate the scenes designed by Peroni and Preciado for this class of painting (here reduced to the mere wraith of a temple and a few columns swathed in unusually peiant drapery). That the discreet filtering of 17th-century graphic modes was innovative rather than an anacronism, when proposed by Nessi, is indicated by features of a different sort like the page-boy's costume worn by the child in the center, which reflects the historicizing nostalgia underlying a fashion that had lately appeared in Roman painting and with some frequence in pictures by Masucci (although the specific motif is taken from his much earlier representation of a *Miracle of St. Vincenzo di Paolo* in the sacristy of the Roman church dedicated to that Saint: Rudolph, 1983, fg. 457). Even the magnificent bronze vessels with vegetation and masks in relief are forged with a neo-Baroque vigour that will characterize objects and ornamentation in the later work of Domenico Corvi and Tommaso Maria Conca (see the latter's *Sacrifice to Bacchus* frescoed in the Villa Borghese, as well as the striking similarity of the head of the woman holding the asp in his *Death of Cleopatra*, on the vault of the adjacent room, to the mother to the left in Nessi's drawing: ibid., figs. 200-201).

Many years separate the Clementine prize from Nessi's first public commissions, of which his *Santa Chiara* altarpiece in San Lorenzo in Panisperna renews with accentuated pathos the devotional imagery of Sebastiano Conca (ibid., fig. 250), and the *St. Luigi Gonzaga* in Santissimo Nome di Maria develops his master's taste in terms of the luminescent colouring that had been introduced by Francesco Mancini (Martini-Casanova, 1962, fig. 14, rather than fig. 999 in Contardi-Romano, 1987, that reproduces an effigy of Innocent XI by another hand, in the sacristy, notwithstanding the caption to the contrary). Although Nessi's frescoed vault in Santa Lucia del Gonfalone has been destroyed (of which the oil sketch, executed in the manner of Giaquinto, is in the Accademia di San Luca collection: Faldi, 1974, pp. 137, 140; Rudolph, op.cit., fig. 521), the one representing *Venus and Aeneas* in the Doria-Pamphilj Palace (ibid., fig. 522) subsists to document his development in the unexpected direction of an illusionism quite extraneous to the

decorative trends of the 1760s in Rome. Indeed the vaporous apparition of the goddess in this fresco is projected against a vast architectural backdrop, whose boldly tilted perspective includes a ruined buttress that denotes Nessi's study of Piranesi's engravings. His imaginative faculty, coupled with a vein of delicate lyricism, as well as his eclectic ability to draw upon a variety of differing sources for inspiration, serve to place Nessi as a precursor of certain aspects of the fascinating production of Giuseppe Cades. In fact, the *bozzetto* mentioned above once went under the name of the latter, and other paintings by this little-known artist will probably come to light through similar attributional verifications.

S.R.

63 FRANCISCO PRECIADO DE LA VEGA (Ecíja 1713 – Roma 1789)

The Martyrdom of the seven Maccabean Brothers

1739, First Class of painting, second prize, inv. A. 345.
red and white chalk, mm. 545×780.
on the lower left border: N. 3 p.ᵃ 1739 *Pittura Prima Classe Secondo premio Francesco Pressiado Spagnolo di Siviglia n.°3 A 50*; to the right: *Francesco Ferrari Seg.rio.*

Perhaps no other participant in the Clementine competitions became subsequently involved in 18th century academic life so intrinsically and durably as Preciado. A member of the Academy of St. Luke from 1748, he was twice elected its *Principe* and for many years held the post of Secretary, as well as a variety of minor offices. The institution still conserves his portrait, painted by his friend Maron toghether with that of Caterina Cherubini, the Roman miniaturist whom he married in 1750 (Incisa della Rocchetta, 1979, cat. 180 and 214, figs. XXVII and 184). In parallel to these activities, Preciado had become in 1758 Director of the Spanish pensioners maintained in Rome by the Real Academia de San Fernando of Madrid (see Alonzo Sánchez, 1961); as early as 1753 that academy had accepted him as an "individuo de Mérito" (Ceán Bermúdez, IV, 1800, p. 122), and ten years later he received the title of *Pintor de Cámera* to the King as well. Lastly, Preciado entered "Arcady" as one of the *pastori* in the prestigious Roman academy, where he was stiled *Parrasio Tebano*.

After having studied with Domingo Martínez in Seville, Preciado moved to Rome in 1733 and completd his training as a painter under Sebastiano Conca. The drawing for which he was awarded in 1739 a second prize, also given to Nessi (cf. catalogue entry no. 62) in the first class of painting, is however differentiated from the graphic style of his master by its polish and accuracy of line, even though it appears partially inspired by the latter's contemporary work (the solidier with helmet and breastplate to the right, for example, repeats in the reverse sense *Aeneas* in Conca's representation of the hero's descent into the Elysian Fields, known in several versions, of which one in the Uffizi, Florence, and another in the Ringling Museum, Sarasota). Other specific citations from Michelangelo (the statue of Bacchus) and Maratti (the Maccabee suspended over the cauldron, modelled on St. Blaise in his altarpiece in Santa Maria di Carignano, Genova) are symptomatic of the academic mentality of this fledgling professor, so similar to that of his rival Peroni (cf. catalogue entry no. 61) that a comparison of their prize-winning drawings shows them to be exercises not only on a given subject but also in a practically identical figurative idiom (the Doric portico; the statue on a high base; the head of the tyrant and his placement on the throne in front of a cluster of scannellated and draped columns; the woman and child in the center, etc.) forged by the convergence of the two major Roman studios headed by Masucci and Conca. Yet a closer perusal of this *koiné* discloses certain traits that distinguish Preciado's artistic personality. In effect, his depiction of the scene appears less sedate than Peroni's, being fragmented into a series of vignettes that, although illustrated with elegance, seem almost culled from a handbook on torture methods. Such particulars are probably imputable more to a flair for lively narrative than to a recondite vein of Iberian cruelty such as emerges, conversely, in the ferocious verism of the slaughter conjured up by the Portughese Strebelé in the peculiar and graceless drawing (Disegni II, A. 345) that won the third prize on this occasion.

During the 55 years he resided in Rome Preciado painted little but worthily, judging by his altarpieces in the churches of San Pasquale Baylon and of the Trinità degli Spagnoli there (Rudolph, 1983, p. 796, figs. 589-590). The some half-dozen canvases he dispatched to Spain were not enough to attract attention to this notable expatriot and, apart from the

144

No. 3. 1729 Pittura Primo Classe Secondo Premio Francesco Preziado spagno da Siviglia A 50 *Francesco Preziado dis.*

brief mention he is accorded in textbooks on artistic literature for his *Arcadia Pictórica en sueño, Alegoría ó poema prosáica sobre la Teoría y Prática de la Pintura* (published in Madrid in the year of his death), his rôle as mentor of more than one generation of Spanish artists still awaits a proper evaluation.

Bibliography: L. Salerno, 1974, p. 352, fig. 34

S.R.

64 JEAN-FRANÇOIS VIGNAL (Monaco in Provence c. 1730 –)

Joseph reveals himself to his Brothers

1750, First Class of painting, first prize, inv. A. 358.
red chalk, mm. 460(530)×705(755).
at the bottom: *Secondo Primo Primo Premio, Prima Classe Gio:Franc.o Vignal de Monaco in Provenza 1750 C; 63 489 124.*

After an eleven year interval, the competitions of the Accademia di San Luca were reinstituted in the Holy Year of 1750 and attracted numerous foreigners. The first prize was divided between Domenico Corvi, from Viterbo, whose drawing is now lost, and Jean-François Vignal from Monaco, of whom nothing is known. The drawing presented here is the only testimony to his talent.

Ferdinand Boyer, in an article on the young Frenchmen who had won prizes at the Accademia di San Luca, emphasizes the quality of his composition but finds the figures to be unacceptable They are, he writes, "heavy, without emotion or variety in the faces, (and) long hair, bushy beards, large animal skins and furs repeat themselves over and over again..." (Boyer, 3, 1957, p. 275). This is harsh criticism and in any case differs from the judgement given in the 18th century. It is true that all the faces are similar and that the artist was not capable of greatly diversifying the expressions, but the gestures demonstrate the feelings sufficiently, and the artist is equally successful in following the theme given. Certainly it is difficult to say anything about his training on the basis of the depiction of the anatomy, but his stroke is precise and the poses correct, if conventional. Paradoxically the interest of this drawing, really lies in its classical accent, with the neutrality of its background, and the clear structuring of the composition as a frieze in three parts. Vignal does not yet succeed in convincing, but will he in the future? It is now time to reconstruct the personality of this artist by discovering his work.

Was he a relation, perhaps the father, of Jean-Baptiste Vignal, born around 1761, who won the first prize in the Grand Prix of Paris in 1781 (P.V.A.R., 9, 1889, p. 78) and came to Rome at the expense of the prince of Monaco (C.D., 14, 1905, pp. 153, 157 and 165)? In the register of the Easter communion, the curate of S. Maria in via Lata mentions in the register of the *Status Animarum* of 1743 a certain "Vignali" who lived in the Mancini palace with the scholars of the Académie de France under the direction of Jean-Francois de Troy. Without doubt we are dealing with one of those who lodged in the palace, having failed to receive a scholarship from the king, who availed himself of the help of powerful patrons. But is this the same artist, coming to Rome at a young age, who entered the competition seven years later? To further complicate this problem of identification, a Roman antiquarian possessed in 1982 a copy of the *Self-portrait* of Jean-Francois de Troy of 1741, preserved in Florence, which bore on the reverse the inscription: "Claude-François Vignaly 1742". Must one suppose an error in the first name or that two different painters, of the same family, were present in Rome in the same years, where a generation later the better known artist, Jean-Baptiste, came to continue his studies?

The *Dictionnaire des peintres* by Bénézit notes a drawing, a *Priest celebrating a Mass*, sold in 1776 with the Mariette collection, which we do not know whether to attribute to Jean-François of to Claude-François (Bénézit, ed. 1976, 10, p. 504).

O.M.

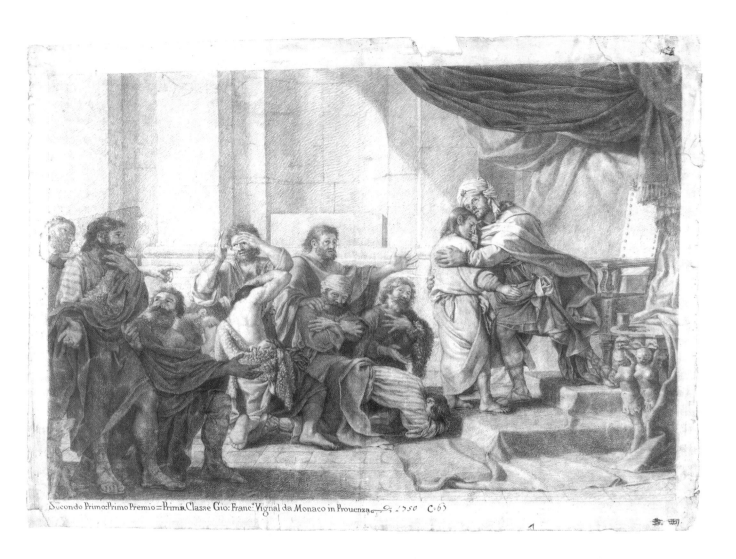

Secondo Primo: Primo Premio = Prima Classe Gio: Franc.º Vignal da Monaco in Prouenza

65 JOSEPH IGNAZ SATTLER (Olmütz 1725 – 1767)

Joseph reveals himself to his Brothers

1750, First Class of painting, second prize, inv. A. 359.
red chalk, mm. 685(740)×485(535).
at the bottom: *Prima Classe Secondo Premio Giuseppe Satler d'Olmitz 1750 A 125.*

Joseph Ignaz Sattler was the son of Philipp Sattler (1688-1738), a painter and sculptor originally from Wenns in Pitztal. After an initial apprenticeship with his father, who in 1723 became a citizen of Olmütz, Sattler moved to Vienna and to Rome with his brother-in-law Johann Christian Handke (1694-1774) to complete his training. In 1750 he participated in the Clementine competition. His drawing won second prize, although in qualitative terms his work was far superior to the composition of Giovanni Francesco Vignal of Monaco in Provence (cf. catalogue entry no. 64), the first prize winner.
Sattler's representation is a grandiose *mise-en-scène*. Joseph, who reveals his identity to the brothers who had sold him as a young boy, is placed, together with Benjamin, in front of the throne in a spacious, open room. The other brothers stand in two groups placed in such a way as to not impede the view of Joseph and Benjamin, who is obviously crying. An exceptional variety of movements characterizes the figures of the older brothers who react with gestures and expressions of shame, devotion and hopeful request. A heavy drapery unwinds from behind the principal group of Joseph and Benjamin, allowing the gaze however to freely sweep towards a portico. On the left, on a high plinth is placed a seated allegorical female figure. The structure and sumptuousness of this scene have nothing in common with what was presently happening in Roman art, which was directed towards a rather tedious classicism, found also in Vignal's drawing which took the first prize. Sattler brings into play, in contrast, a style characteristic of Venice, of Piazzetta and Tiepolo. It is probable that, in his journey from Vienna to Rome, Sattler passed through Venice, where he must have seen and absorbed both the works of the two artists as well as the more modern trends in painting. His ability to create light and airiness, characterize stone and cloth, to produce the glimmer of the polished marble of the columns and the poses of the individual figures in this splendid composition is truly striking.
It would appear that, after having given this proof of his outstanding gifts, Sattler did not remain in Rome for much longer, given that the frescoes in the church in Schönau bear the date 1751.
Bibliography: L. Salerno, 1974, p. 355, fig. 36.

D.G.

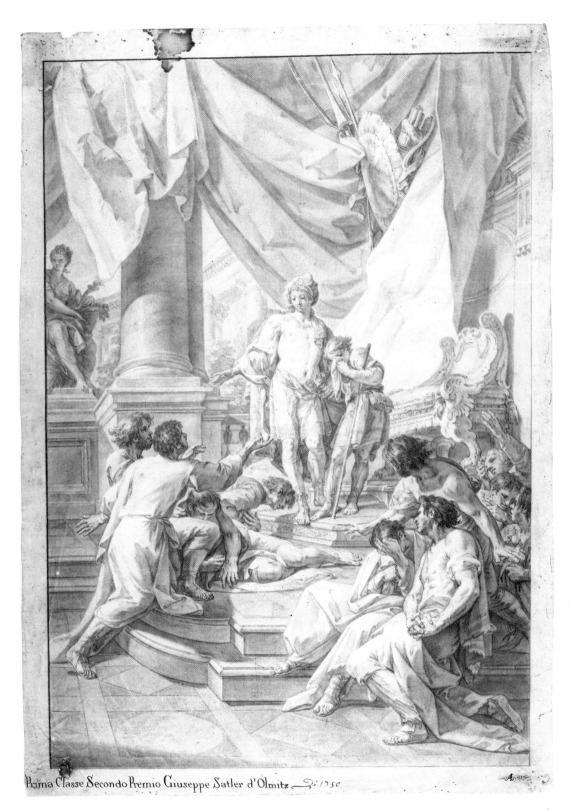

Prima Classe Secondo Premio Giuseppe Satler d'Olmitz ___ D. 1750.	A.

66 JACQUES-FRANÇOIS MARTIN (Paris c. 1728 – 1770?)

Joseph reveals himself to his Brothers

1750, First Class of painting, third prize, inv. A. 360.
red chalk, mm. 605(650)×955(985).
at the bottom: *Prima Classe Terzo Premio, Giacomo Franc. Martin da Parigi 1750 C 66.*

In 1750 a twenty-two year old Parisian (AVR, SS. Simone e Giuda, LSA, 1750, p. 94), Jacques-François Martin, was awarded the third prize in the first class. The originality of the drawing, according to Ferdinand Boyer, shows an attention to local color revealed in the clothes of Joseph, in the sphinxes on the throne and in the suggestion of an exotic atmosphere with "a pyramid in the background, an upright Egyptian statue produced with great precision, (and) some ideograms which are intended to reproduce hieroglyphics" (Boyer, 3, 1957, pp. 275-276). It is true that the stroke lacks force, and one notices some banalities such as the onlooker in the left corner, but the characters, successfully grouped and differing in their positions, form a complex whole which detaches itself from mere realism.

This painter, the son of another Jacques-François, a sculptor and protégé of the comptroller general of finance Jean-Baptiste de Machault d'Arnouville (C.D., 10, 1900, p. 111), came to Rome when fifteen years old at the expense of his father (AVR, Notaio Placido Gaudenzi, *Positiones*, 15 luglio 1752). From a family of artists, the nephew of the famous "Martin delle Battaglie" (Herluison, 1873, p. 285) was at ease among the scholars of the Académie de France. During the Carnival of 1748 he participated with them in the "caravan of the sultan at Mecca" in a costume which had the good fortune of pleasing the Pope, Benedict XIV, himself (C.D., 10, 1900, pp. 142 ff.). Drawn by Joseph-Marie Vien in his costume as a negro eunuch (Gaehtgens-Lugand, 1988, p. 236) he left a beguiling painting as a record of that festivity, in which one sees the procession passing through St. Peter's Square (*Jean Barbault 1718-1762*, 1974-1975, p. 25 ff.). Martin however never became one of the King's pensionnaires despite his patrons and the scheming of his family (C.D., 13, 1904, p.133). The opposition came from the director of the Académie de France himself, Jean-François de Troy, who expressed a severe judgement in his regard in 1746: "He is a very young man who has begun to draw but who has never been (qualitatively) strong enough to win a prize in Paris" (C.D., 10, 1900, p. 118). Neither his victory at the Accademia di San Luca in 1750, nor the patronage of the Auditor of the Rota, the abbot of Canillac, were sufficient to overcome this prejudice.

He settled in Rome where in 1752 he married the daughter of a public clerk, Barbara Ottini (AVR, SS. Simone e giuda, Lib. matr. 1742-1780, fol. 34 v., 18 giugno). Of his artistic production we know nothing. Returning to Paris, he was received on 16 February, 1763 into the Accademia di San Luca of the city where, in 1764 he exhibited numerous works: a *Baptism of St Hippolytus*, a *Battle*, a *The Crowning of Thorns* and an *Adoration of the Shepherds* (Guiffrey, 1915, pp. 383-384). His death probably occurred around 1770 when an auction was held in Paris to sell the furniture of a "deceased Mr. Martin, painter of the Accademia di San Luca" (Trudon des Ormes, 33, 1906, p. 42). His wife was declared to be a widow when she in turn died in February 1790 (Giuffrey, 1885, p. 260).

His extempore test work, *Jacob on the burning Coals*, which was still in the collection of the Roman Accademia di San Luca towards 1902, was, in comparison with the winning drawing (according to the judgement of Augusto Boppe) "far better... more vigorous and treated with greater breadth" (Boppe, 16, 1902, pp. 401-409).

D.M.

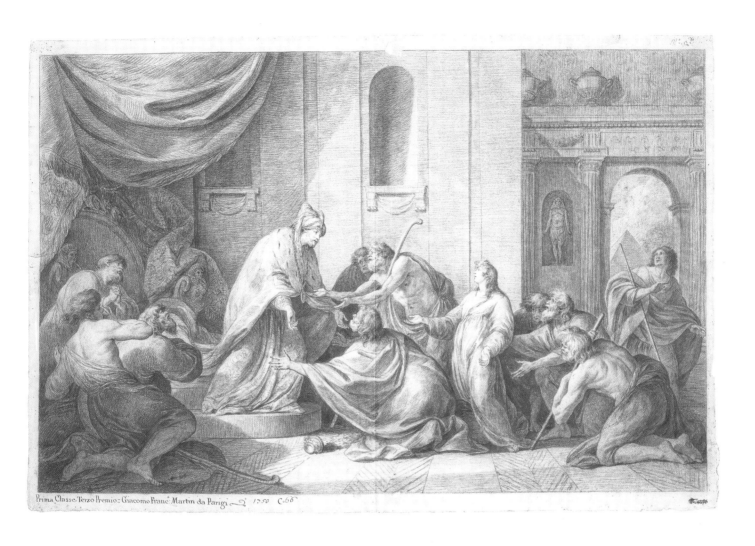

Prima Classe Terzo Premio= Giacomo Franc. Martin da Parigi 1750 C.68

67 NICCOLO LAPICCOLA (Crotone c. 1730 – Rome 1790)

Joseph interprets the dreams of the Pharaoh's two servants in prison

1750, Second Class of painting, first prize, inv. A. 361.
red chalk, mm. 600×815.
on the lower left borde: *1750 Seconda Classe Primo Premio, Nicola Lapiccola da Crotone 492.*

At the age of twenty Lapiccola made his debut in the second class of painting in the Clementine *concorso* of 1750, taking the first prize with a drawing far superior to those of the other contenders and moreover perfectly attuned to one of the most up-to-date currents of taste to surface in Roman painting at mid-century. It was probably more or less the same taste articulated by Domenico Corvi in the sheet, sadly lost, that won the first prize in the first class on the same occasion. At least this seems the most reasonable assumption from what little we know of the event, since Lapiccola's entry actually anticipates the most spectacular inventions of the mature Corvi, who was to become a determinant, if sometimes eccentric, fixture within the Roman School in the following decades (Rudolph, 1982, pp. 1 ff., and particularly his stories of the Blessed Margherita Colonna in the Barberini Palace, of which the canvas reproduced in fig. 11 offers an indicative comparison).

The drawings submitted by Biagio Rebecchini from Osimo (Disegni, II, A. 363) and the Roman Carlo Calzi (Disegni II, A. 364), that won the second and third prizes in the same class, both illustrate the assigned subject in a castigated neo-Raphaelesque manner with a few bulky and rather static figures placed in unadorned cells. Viceversa, Lapiccola imagined the scene as a spectral incantation, enhanced by the dungeon recesses (devised on the lines of Piranesi's recent *Carceri* engravings), whose gloom is shot with incandescence by the liquid play of light. This magical atmosphere is reinforced by the conjuror's gesture of Joseph, a flourish that lays bare the significance of the dreams, evidenced to the beholder by the phantasmagoric apparition of Death over the head of the baker. Lapiccola's impeccable technique is matched by his capacity to invigorate a Rococo idiom derived from Giaquinto (even though he was a pupil of Mancini) and in syntony with the mannered theatricality of Sattler (cf. catalogue entry no. 65).

Shorn of the posturing and elaborately crimped drapery, the four vignettes exhibited here, sketched on the spot during the final test of the candidates for the prizes, show how Lapiccola could rapidly baste a composition in its essentials (Disegni II, A. 362).

He projected the Biblical Story of *Esaú selling his birthright to Jacob* with deshing stokes, progressively reiterated as he experimented the juxtaposition of the figures and their placement within the kitchen setting. This hasty partitioning of the sheet vividly conjures up the extempore process, as if we were witnesses along with the judges to this ultimate verification of the candidate's ability. In the upper scenes two alternative solutions for the rapport between the brothers emerge, whereas the subject is as yet barely deciphrable and only comes into focus through the ambientation in the ones below. To the left Lapiccola reelaborated the composition above with the addition of a fireplace, a large drapery and a jar on the floor. The solution on the lower right side is apparently the definitive one and appears the most satisfactory, due to the expositive clarity of the handshake between brothers and the reorganization of the space, now less cluttered (drapery eliminated, aperture enlarged, reduced scale of figures and accessories) and more pertinent to the domestic aspect of the episode (plates on the mantle, dog sleeping in the corner, etc.). Thus with subtle adjustments Lapiccola moved from the expressive nucleus of the figures to sink his narrative in a distillation of light effect, gestures and details, melded by his dexterous yet sparing use of line.

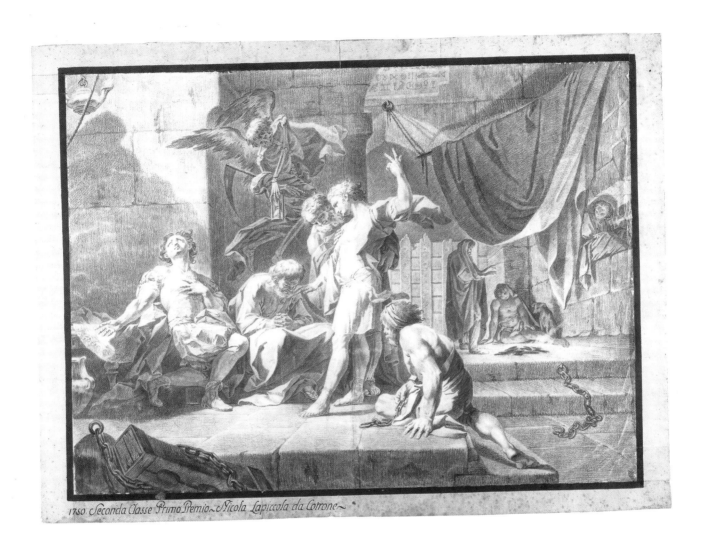

1750. Seconda Classe Primo Premio ~ Nicola Lapiccola da Cotrone ~

After such an auspicious start, the Calabrese painter spent forty years employed in posts (*Pittore dei Sacri Palazzi Apostolici*, Director of the Vatican *Studio di Mosaico*, Custodian of the Capitoline Palaces) that permitted him to diversify his noteworthy talent to the point that his overall image became somewhat blurred, despite the important place he occupied in the Roman School of painting during the second half of the 18th century (see Rudolph, 1985, pp. 204, 206, notes 13, 17, 20-21, 27, for an updated bibliography). He was, above all, an innovator in the field of decorative frescoes, commencing with his activity in the 1760s in the Salone d'Oro of the Chigi Palace and in the Villa Albani; but even his canvases in Santa Caterina da Siena and Santi Apostoli (Rudolph, 1983, figs. 381-382) are of a deft execution and sufficient originality to explain why he was the chosen master of painters, such as Bernardino Nocchi, in transit towards the Neoclassical taste. Yet in the end he remained a loner, it would seem, and even fell out with the Accademia di San Luca that had accepted him as a member in 1766 so much so, that his effigy hanging there is not a self-portrait but rather an anonymous daub (Incisa della Rocchetta, 1979, cat. 181, fig. 163).

Bibliography: L. Salerno, 1974, p. 352, fig. 35.

S.R.

Niccola Lapiccola

68 JOHANN MICHAEL BAADER (Eichstätt 1709 – Kloster Polling 1779)

Copy of the Farnese Flora

1750, Third Class of painting, first prize, inv. A. 365.
black pencil, mm. 540(650)×310(470).
at the bottom: *Terza Classe, Primo Premio, Michele Baader d'Eychstest Joanes Michele Baader tedescho 1750 13 a n. uniformi 14 D.*

The competition assignment of the third class in 1750 was that of "Drawing the statue of the goddess Flora in the Palazzo Farnese". Johann Michael Baader, originally from Eichstätt in Bavaria, and Giacomo Pacilli of Rome won the two first prizes. The preparatory studies of both are drawn from the original.
Together with the Farnese Hercules and the Farnese Bull, the statue of Flora was discovered during excavations sponsored by Pius III in the Baths of Caracalla and was placed in the courtyard of the Palazzo Farnese. Nicolas Dorigny produced an engraving of the statue for the "Raccolta di Statue antiche e moderne" of De Rossi, which was published in Rome in 1704. In a drawing by Louis Chays from 1775 (Berlin, Kunstbibliothek, HdZ 3027; cfr. E. Berckenhagen, Berlin 1970, p. 393-394) the statue is still in place; this document bears witness to the admiration which the famous statue evoked: artists and connoisseurs flocked into the courtyard of the Palazzo Farnese to see and draw it. Transferred to Naples together with the rest of the Farnese collection, the statue is now in the National Museum (inv. no. 6409). Francesco Mori illustrated it in plate 42 of the work by Domenico Monaco, "Les Monuments du Musée National de Naples", published in 1879.
Baader was the son of a miller. He spent some years in Italy and his presence in Rome between 1749 and 1754 is documented. When he participated in the competition of 1750, he was already a fully developed artist. It is not surprising therefore that he was able to acquit the task brilliantly. The statue is perhaps presented somewhat coldly, but in any case with the greatest assurance and accuracy. The extremely delicate gradations of his *chiaroscuro* allow the artist to reproduce the fine modelling of the drapery and the flesh, together with the coldness and the hardness of the polished marble. The objectivity with which the figure seen slightly in profile, is shown, is increased by its being seen before a neutral back-drop. Upon his return to Bavaria, Baader painted numerous altarpieces and frescoes.

D.G.

Terza Classe = Primo Premio = Michele Baader d'Eichstest

Joan. Michele Baader tedesche 1780.

N.° 3.
A
N. 5. uniformi

69 MICHELANGELO MARIA RICCIOLINI (Roma 1718 –)

Elijah orders the Arrest of the false Prophets

1754, First Class of painting, first prize, inv. A. 372.
red chalk, mm. 460(615)×760(895).
at the bottom: *N. VIII p.ma Classe p.mo Premio Michelangelo Maria Ricciolini Romano 1754 c 47 495.*

In 1754 the first prize in the first class of the Clementine competition was awarded to Michelangelo Maria Ricciolini, author of a drawing on a subject set by Marco Benefial, taken from the Third Book of Kings (chapter 18, v. 19): "You should represent Elijah who when the fire from Heaven fell upon his altar, and not that of Baal, orders the people to arrest the false prophets of the idol and to destroy their altar" (A.S.L., vol. 51, pp. 39 v. ff). The work is extremely important as the only artistic testimony of this painter, who was born into a family of artists. His paternal grandfather Michelangelo, whose name he bears, was a minor Marattesque painter present in Rome between 1654 and 1715: his father Nicolò was more famous, and is also represented in this exhibition (cf. catalogue entry no. 11, 14). The present Michelangelo derives some aspects of his expressive morphology from him but he is not in fact likely to be confused with his father because of the differences in their conceptions for the organization of groups of figure. On the whole, this drawing presents itself in an altogether autonomous way, with characteristics which are more clearly 18th century and are neither found in the work of the father, nor in the test work of the competition of the same year executed by Mariano Rossi which took the second prize, indicative of the careful and fair critical evaluation of his contemporaries. An initial idea for this test piece may possibly be identified in the drawing in a private collection (Finarte, Milan, n. 204, 1975, plate LXII, n. 191), here reproduced on a smaller scale, which has been erroneously attributed to Michelangelo's grandfather. To the classical neo-baroque of Rossi, Ricciolini opposes a more modern creation which consists in an aderence to the classical theoretical principles already advocated at the end of the 17th century by Bellori. Notwithstanding the large number of figures, they move in an orderly way through the space and everything is more composed and restrained, while the chromatic-lighting shades of the red chalk are more compact and without vehemence as in the manner of the early 18th century (one should compare this drawing with that of Nicolò Ricciolini or the two examples by Pellino).
The classicism of Ricciolini has its roots in the 16th century tradition, basing itself essentially on Raphael, and even further into the past, on Mantegna, passed through the filter of the 17th century culture of Annibale Carracci and Pietro da Cortona. From the natural arch in the rock to the citation of an ancient monument, such as the Pyramid of Gaius Cestius from Mantegna's *Camera degli Sposi* if not the Mantegnesque *Triumphs*, the young girls singing praises passed from Raphael to Marcantonio Raimondi, to Annibale, to Cortona and Maratta arrive at the figurative style of the 18th century; from the festoons on the altar, grown on the Ara Pacis of Augustus and renewed in history by Mantegna and then profusely in the sixteenth century; from the two central figures so faithful to the protagonists of the School of Athens to the elongated figures dressed in an old-fashioned way taken from the manneristic repertoire; finally, to the angel descending from heaven to light the torch on the altar of Elijah, almost as a *deus ex machina*: all is conceived under the banner of the knowledge of the past, of the "ancient" as a true cause of history, according to an interpretation given in the 17th century by Poussin, the artist upon whom the foundations of protoneoclassicism are laid.
The nature of the education imparted in the Ricciolini household to the young artist is clear *ad evidentiam*. He instinctively understood the deepest significance of the Emilian

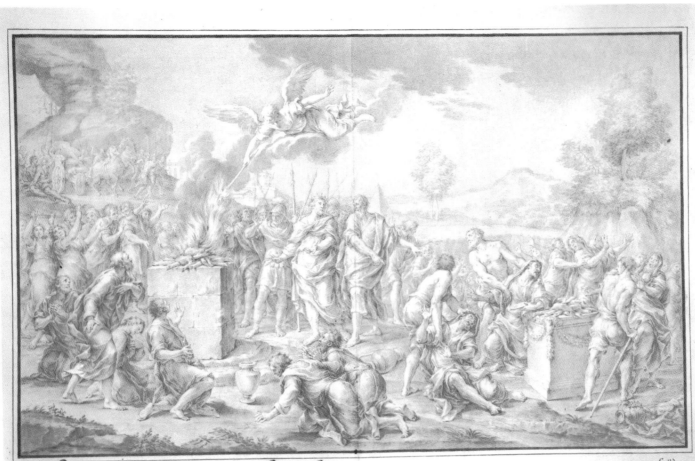

N. VIII. *Pitta Classe pmo Premio Michelangelo Maria Ricciolini Romano 1754* C. 95.

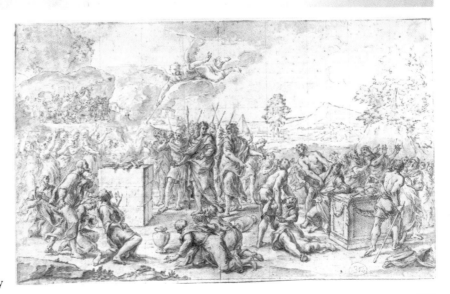

Coll. priv. - Italy

cultural matrix to which both the grandfather Michelangelo and the father Nicolò were particularly sensitive. Surpassing the expressive intention of his father, he profitted from the experience of an artist of Nicolò's generation who had however personally experienced the art of Bologna and had achieved a profitable compromise within the Roman Marattesque environment: Giacomo Zoboli (Modena 1681 – Rome 1767). Here is the real medium for Michelangelo Maria's classicism. From Zoboli he inherited such features as the animated but carefully considered figures, and importantly, the taste for 16th century sources. It seems strange that a young man of his talent did not achieve other successes beyond this academic prize, that his works are unknown, and that his name is not cited in the sources. If we may reconstruct Ricciolini's presumed artistic activity on the basis of development from this single example it can be said that his art would have been interesting for the formation of Luigi Ademollo (1764-1849). Paradoxically, it was actually the father Nicolò, who in the mature phase of his work settled into a more classicizing position, and so benefited from these innovations. In the historical representation of *Giuseppe Colonna taken prisoner by the Turks* (Rome, Palazzo Barberini) of 1764, painted some ten years after this graphic work, Nicolò retrieved the same spatial vastness, the presence of the hillock, the crowd of figures and placement of those who lie on the ground, a homage to the son whose future was shattered, perhaps, immaturely. Clark's hypothesis relating to Michelangelo's role between 1775 and 1779 as a copyist and agent for Gavin Hamilton has still to be confirmed (cf. Clark, 1967, p. 22).

A.P.

70 MARIANO ROSSI (Sciacca 1731 – Roma 1807)

Elijah orders the Arrest of the False Prophets

1754, First Class of painting, second prize, inv. A. 373.
red and white chalk, mm. 575(600)×860(890).
at the bottom: *1754 Prima Classe Secondo Premio. Mariano Rossi di Sciacca in Sicilia.*

All of M. Rossi's work falls within a baroque-classical trend, congenial to the painter's temperament and cultural roots, and enlivened by the expressive tendencies of Roman art in the second half of the 18th century. This is demonstrated throughout his career, including even his mature and fundamental works, such as the enormous fresco for the entrance hall of the Casino of the Villa Borghese, and that representing the *Marriage of Alexander and Roxanne* for the Palazzo Reale of Caserta. These works, equal to his best canvases, such as *St Peter and St Paul led to their Martyrdom* (Rome, Lemme collection) the *Martyrdom of St Agatha* (Rome, Rosa collection, both sketches respectively models for the altarpiece in S. Lucia del Gonfalone in Rome and for an altarpiece possibly for the church of the Benedictines in Catania), or the *Holy Family* of the Roman Galleria Pallavicini, show that Rossi's stylistic direction was unitary and homogenous. He was a promising painter as the competition entry shown here proves, perpetually balancing between the 17th century baroque and a classicism justified by the same 17th century culture, but which the artist did not know how to transform in the more modern direction suggested,

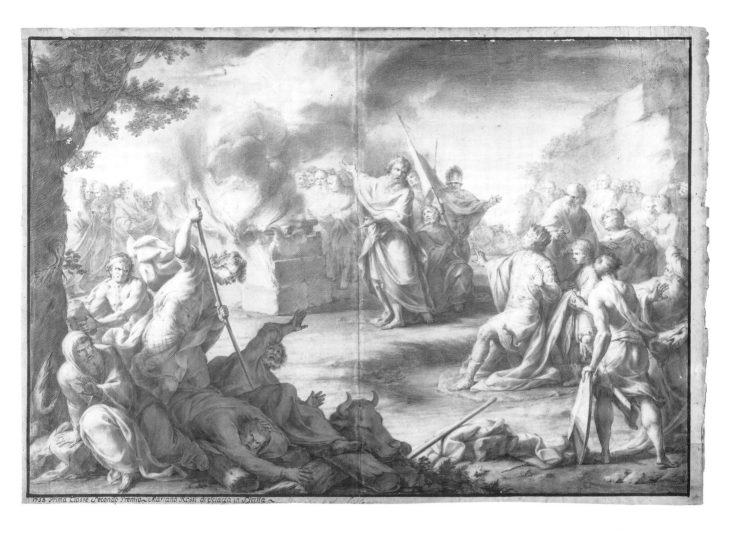

1754. Prima Classe Secondo Premio. Mariano Rossi di Sciacca in Sicilia.

for example, by Batoni. It could be said that Mariano Rossi did not know how to sieze the opportunity to renew his art from within, maintaining the attitude of the provincial who sees the various possibilities offered by painting, and balances himself cautiously between them without having the courage to take a definite stand. This did not prevent him from emerging as an artist of merit though with a sometimes contradictory figurative production, which justifies, in a certain sense, his intention not to expose himself. The tendency to avoid risk-taking is sometimes motivated by a limited creative capacity; this however does not seem to apply to this extremely talented painter who possessed the necessary expressive means. The problem should be more probably sought in his clientele; his work was undertaken for some Sicilian centers where the clients were less exigent, and as a result he produced paintings of lesser validity. During his career, Rossi balanced between the central and a peripherical cultural current, and this perhaps conditioned the expressive quality of his art, preventing him from absorbing the proto-neoclassical components into his spontaneous inclination towards a dynamic and chromatic baroque. With time,

his expressive skill outstripped the theoretical hypotheses. The drawing in question, a graphic work in red chalk, demonstrates how the artist's innate chromatic needs, as well as the aims of his taste for the painterly are expressed through his use of the medium.

The scenic design of the crowded composition implies a conscious study of perspective which underlies the clarity of the figural grouping in three main nuclei, a broad spatiality in the centre of the composition where the dominant theme unfolds, as well as a distant ground which brings an atmospherity to the whole. It is evident that the figurative setting is similar to the design principles later adopted in the vault of the Borghese hall depicting *Marcus Furius Camillus who liberates Rome from Brennus* (1782) where the groups of figures in the foreground frame and echo the center of the composition which is seen slightly from below.

The choice of this perspectival viewpoint is typically Baroque, and Rossi uses it continually, and not only for large fresco decorations which occupy a necessarily extensive surface. Examining any one of his pictorial compositions at random, one notes how the viewing angle, apparently frontal, actually uses a low view point which pushes the figures up and towards the horizon; in order to strengthen this effect it was necessary to precede the figurative nucleus by bringing other figures together in duly enlarged foreground groups. This metric graduation of the figures, which grow smaller in the distance, eventually crowding together as silent, minor observers is still on a 17th century scale, reminiscent of L. Giordano. However the compact stratification of the figural nuclei in the distance bespeaks the logical classical composure of the 18th century, as may be seen in the half figures which appear in the background against a clear sky which recall certain settings out of Domenico Corvi at whom Rossi had also looked carefully in his mature period. The way of entangling the bodies in the left foreground, the same agitated and dynamic capacity for gesticulation, the neat *chiaroscuro* contrasts all belong to the best tradition of the 17th century. Rossi's synthesis of poses and color are typical of the Emilia-Romagna, which had reached him through the teaching of Benefial and his contacts with F. Mancini. However his way of darkening the shadows, whith a resulting heaviness of the figures, (nearly petrified in the two heavy masculine bodies lying by the ox and the tree silhouetted on the left) are typical of Rossi who obtains the same effect with thick and dark colours as may be seen in some figures of the Borghese fresco. The group on the right is more refined and less dramatic, being placed in quite conventional poses which recall Conca or the figures used by Giaquinto in sacred narratives where the figures had to show reverence, respect or amazement at the appearance of the divine. More linked to tradition than he himself realized, he inertly followed the prevailing cultural trends though without contributing to their evolution. The tendency to conserve rather than to change may be seen even in the mimetic repetitiveness of the figures: the pose of the protagonist Elijah at the centre in front of the altar emulates prototypes of Conca, and will be repeated in the *Guardian Angel* and of *St Michael Archangel*, the two pictures for the church of Valverde of the Monastery of the Giummare at Sciacca (1767-68). Nor is this the only example of figural repetition by this artist who, in the meantime, was making himself known with some public works of sufficient merit to warrant, in 1766, his acceptance into the Accademia di San Luca (A.S.L., vol. 56, f. 70); this then made possible his commissions in Turin for the Savoy family and the large fresco cycles mentioned above. In 1754 Mariano Rossi, entering his competition piece in the first class of painting, justly received the second place; a promising young artist, he would prove to be the last vital exponent of the neobaroque.

A.P.

Restoration Report

The drawings published in the present catalogue are been restored by the Istituto Nazionale per la Grafica. The technicians were Carmela Maddalena Albanese (C.M.A.), Paola Brusa (P.B.), Giuseppe Lorusso, Alfredo Sprodi.

ANTONIO CALDANA

The Massacre of the Innocents

Catalogue entry no. 9

Technique
Black pastel and white chalk on grey-blue paper.

State of preservation
Fair. Widespread foxing. The drawing is composed of eight sheets plus two insets, joined with paste. It has an irreversible deterioration in the central parts, having been conserved folded.

Restoration undertaken
Vaporization with water plus ethyl alcohol to open out the central creases; flattening with a light weight. Restoration with Japanese paper of appropriate thickness and glutofix glue in the missing parts. Light renewal of the color with watercolor pastels.

Watermark
Lily inscribed in a circle surmounted by a crown. Paper from central italy, of the 17th century. From Perugia, cf. Briquet n. 7111.

P.B.

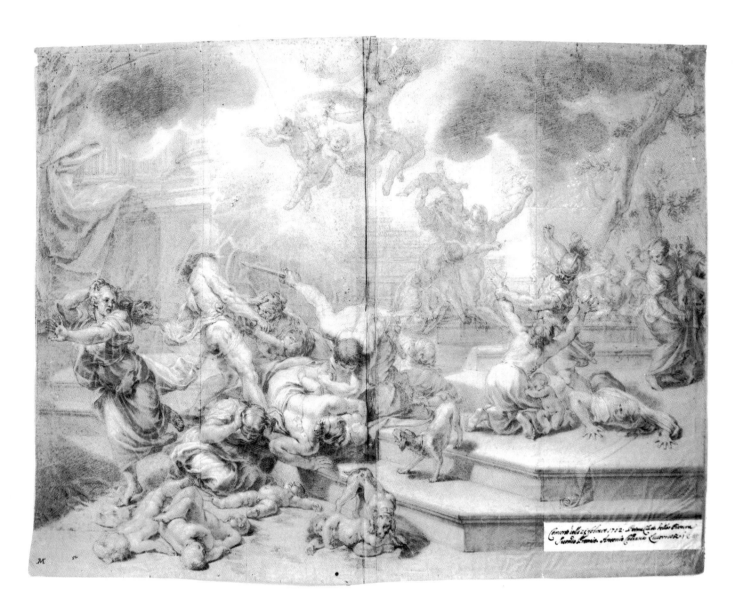

PIETRO PELLINO
Moses striking the Rock
Catalogue entry no. 16

Technique
The drawing in question was done on two sheets of laid paper, of slightly varying tones of blue. The composition was executed by the author with pencil and white chalk.

State of preservation
On first examination the state of preservation of the sheet appeared precarious: a reduction of the drawing itself was clear; the sheet in backlighting was very faded; at the edges there were cuts, tears, organic residues, and small particles of iron were spread over the two sheets. On the reverse there was a notable thickness of glue of organic origin, which had caused the stiffening and yellowing of the paper.

Restoration undertaken
First, the sheet was given a dry cleaning with a very soft brush and rubber dust on the *verso* and *recto* of the sheet. Subsequently the inks were subjected to resistance tests, and once proven stable, the sheets were humidified by capillarity, on a sheet of silk paper soaked in cold water which was then placed against the *verso* of the drawing
In this phase of hydration and relative re-swelling, the two parts which constitute the drawing were separated. The glue residue, fragments of paper, organic residues, and particles of iron present were removed from the *recto* and *verso* of the sheets with a scalpel. A light tamponage was carried out on the still damp sheets to obtain a more accurate cleaning, in particular in the area in which the two sheets were pasted together.
After, the two parts were put together again as before using methyl cellulose. In addition, the various cuts and tears were filled, the various creases reinforced and smoothed out, and the small gaps restored with Japanese paper of the same thickness as the original. On the *verso* the areas conciding with the writing in ferro-gallic ink, already partially perforated by the oxidization of the ink which had corroded the fibres of the paper, were reinforced.
A light renewal of the tones on the restored areas was then undertaken with Windsor and Newton watercolours.
The drawing, thus re-composed, was then dried at room temperature between cards with neutral pH, for long-term preservation, under the pressure of a crystal plate, to obtain a perfect flattening.

C.M.A.

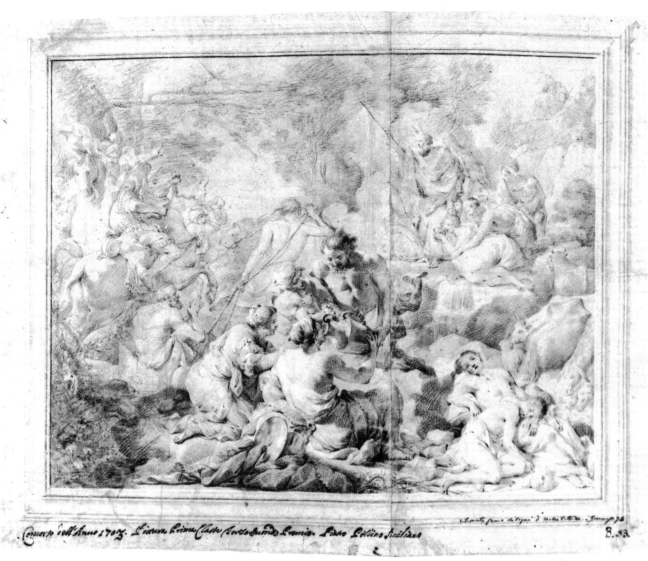

Concorso dell'Anno 1707. Pittura Prima Classe Secondo Premio. Pietro Pollino Siciliano

B.53

PIETRO PELLINO
King Amulius of Alba killed on his Throne by Romulus
Catalogue entry no. 17

Technique
Dark pastel and chalk on blue paper.

State of preservation
Moderate. The drawing was executed on four sheets of equal size glued along the edges. It has a protective support (of 19th century date) consisting of a cloth of unbleached linen attached over the entire *verso* with paste. With the passage of time this has lost much of its consistency, remaining mainly in the corners where it was placed in more than one layer, and has created in consequence a serious deterioration of the paper itself with tears and gaps. Numerous internal fractures and cuts in the paper which are now irreversible, are present because the sheet had been folded. The left part of the composition shows a general darkening of the paper the effect of exposure to light and to the oxidizing effects of the glue penetrating from the *verso*.

Restoration undertaken
Mechanical detaching of the cloth on the *verso*, using a scalpel. Dry cleaning. Flattening by vaporization with water and ethyl alcohol on the central creases, and the light pressure of a glass plate. Restoration of the gaps with appropriate Japanese paper and glutofix glue.

Watermark
Dove place on the mountains inscribed in a circle. Rome 1572, cf. Briquet 12250.

P.B.

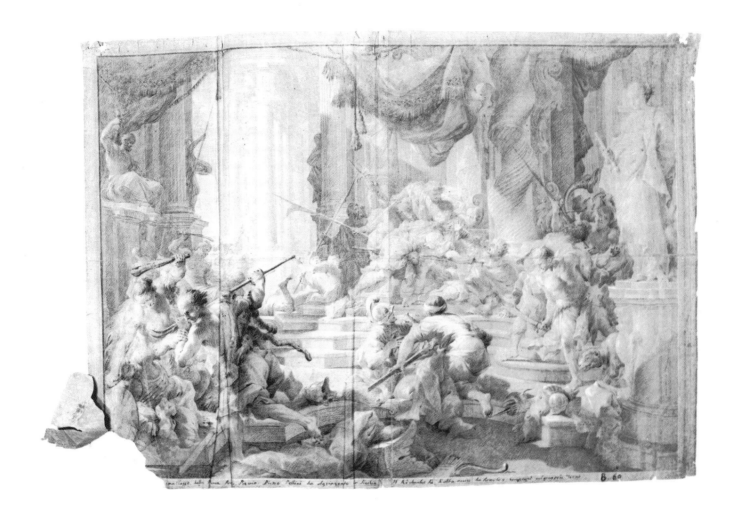

PIETRO PELLINO
Rebecca at the Well
Catalogue entry no. 18

Technique
The drawing in question was executed on a sheet of 18th century laid paper, blue in color, on which the artist produced the drawing in pencil and chalk.

State of preservation
The drawing was in a poor state of preservation; on the surfaces some stains were clear and the strokes of the drawing were fading. There were additionally of numerous gaps, creases and abrasions.

Restoration undertaken
The restoration work involved the following procedure: after a careful dusting of the *recto* and *verso* with a very soft brush and rubber dust, the dry removal of the organic residues present was undertaken with a scalpel. Humidification by capillarity of the sheet followed, resting the drawing on the *verso* on a support of absorbent paper soaked in cold water. This operation allowed the removal of the stains present. After having replaced the support with a sheet of dry and clean absorbent paper, a light tamponage was done in order to remove the excess humidity. The drawing was then dried at room temperature between two pieces of card board with a neutral pH under the pressure of a crystal plate. The suturing of the widely distributed cuts was carried out on the slightly sheet. It was then flattened and strengthened, with particular attention being paid to the deep crease and related cut which are present on the drawing along the entire left side.
For the grafting of Japanese paper on the gaps, a paper was used which was comparable in thickness to the original and methyl cellulose. Finally some retouching of the color was undertaken with Windsor and Newton watercolors, and the drawing was placed between two pieces of card with a neutral pH under the pressure of a crystal plate.

C.M.A.

171

ANTONIO BICCHIERAI

Rebecca at the Well

Catalogue entry no. 20

Technique
The drawing was executed on a sheet of 18th century, ivory colored Italian paper, laid and watermarked. The composition was carried out in red chalk.

State of preservation
The drawing in question was in a precarious state of conservation with clear traces of oxidization and a myriad of organic residues. Old stains were present on the border of the upper right corner and on the lower border; in addition small spots of mold were spread across especially the lower portion.

Restoration undertaken
The following operations were decided upon humidification through capillarity on the *verso* placing the drawing on a sheet of silk paper soaked in cold water; removal with a scalpel of organic residues from the *verso* and *recto* of the sheet. The old stains were weakened by tamponage (on the still damp sheet) with a solution of calcium hydroxide 12%, and the same procedure was undertaken on the small areas where molds were present.
The sheet was humidified again with the same procedure, and a light tamponage was undertaken, to remove all excess humidity. The gaps were then restored with Japanese paper of a thickness and color comparable to the paper of the drawing, and methyl cellulose.
Finally the drawing was placed between two pieces of card board of neutral pH, for long-term preservation, under the pressure of a crystal plate to obtain a complete flattening.

Watermark
Lily inscribed in a circle surmounted by the letter V (Italian paper, 18th century).

C.M.A.

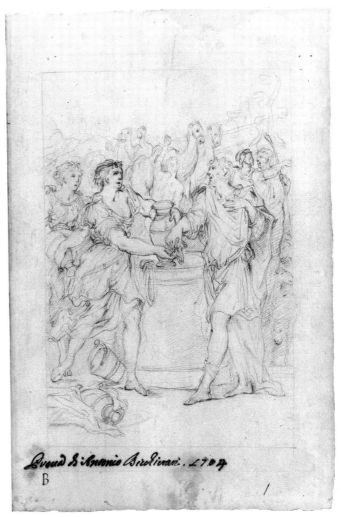

173

FILIPPO EVANGELISTA
The Rape of the Sabine women
Catalogue entry no. 22

Technique
Red and white chalk. Two sheets joined in the middle.

State of preservation
Fair. Widespread foxing. On the *verso* there are numerous 19th century restorations, while on the *recto* numerous abrasions caused by insects have deteriorated the graphic part in small areas.

Restoration undertaken
Light dry cleaning with the partial removal of the old restorations on the *verso*. On the *recto*, restoration with Japanese paper of the appropriate thickness and renewal of the colors with watercolor pastels (Stabile). Light flattening with a plate of glass.

Watermark
Lily inscribed in a double circle surmounted with the letter V. Ferrara 1587 cf. Briquet 7121.

P.B.

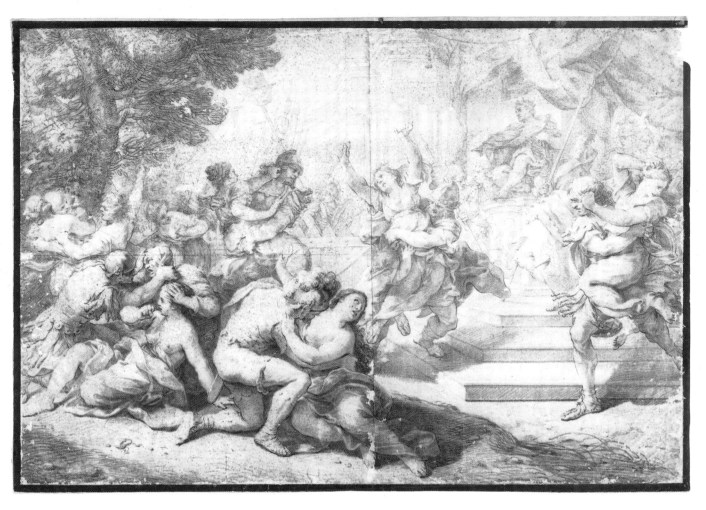

175

CRISTOFORO GIUSSANI

The Sabine Women intervene during the Battle between Romans and Sabines
Catalogue entry no. 25

Technique
Red and white chalk on ivory paper.

State of preservation
Fair, but with some foxing and darkening of the white lead.

Description
The drawing, on one sheet, is in a good state of preservation except for some small dark stains present on the central figures, due to the alteration of the white lead in the presence of atmospheric acidity. The sheet was then stored folded, and this has created an irreversible fracture of the fibres of the paper. On the *verso* there is a 19th century restoration which it was decided opportune to conserve in part.

Restoration undertaken
Dry cleaning with a scalpel of the organic residues both on the *recto* and the *verso*. Removal of the stains on the white lead, changing them into small black stains (lead) by means of a suspension of ether in hydrogen peroxide. This suspension was applied lightly with a N. 0 brush on the small dark areas, transforming the lead sulphide (black) into lead sulphate (white); the operation was repeated after 24 hours, until a complete change was effected. On the corners small restorations were made with Japanese paper and glutofix glue. Finally it was flattened with a plate of glass.

Watermark
Lily inscribed in a double circle and with the initials A, N cf. Briquet N. 7121, Italian paper of 1587 from Ferrara.

P.B.

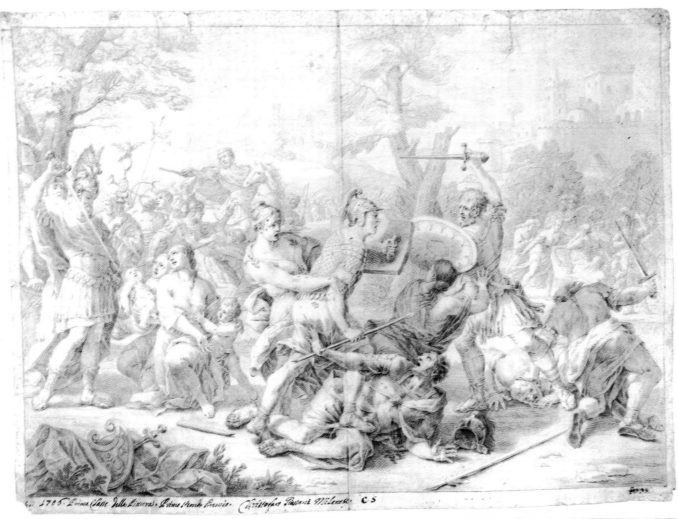

1706. Prima Classe delle Licenze. Prime Seconda Premio. Christofaro Passant Milanese. C S

CLAUDE JACQUARD
The Battle between the Horatii and the Curiatii
Catalogue entry no. 33

Technique
Pastel and white chalk, on grey paper.

State of preservation
Good. Composed of two sheets joined in the middle by a thick layer of paste which has darkened the paper. Around the external edges of the sheets, a heavy 19th century restoration strengthened the badly deteriorated paper causing numerous creases and an irreversible warping due to the traction of the various thicknesses of paper superimposed.

Restoration undertaken
Mechanical removal from the *verso* of the old restoration undertaken with heavy green paper and acid, using a dry scalpel and subsequently with compresses of glutofix glue to soften the paper. Removal of the paper used in the old restoration and flattening of the paper with light vaporization with water and ethyl alcohol. There followed restoration on the *verso* and *recto* with Japanese paper of appropriate thickness, the tone being approximated with watercolors (Windsor and Newton) and pastels (Stabile).

Watermark
Eagle inscribed in a circle. Lucca 1504. cf. Briquet N. 204, Rome 1576, Udine 1578, R. Emilia, 1598, Siena 1594, 207.

P.B.

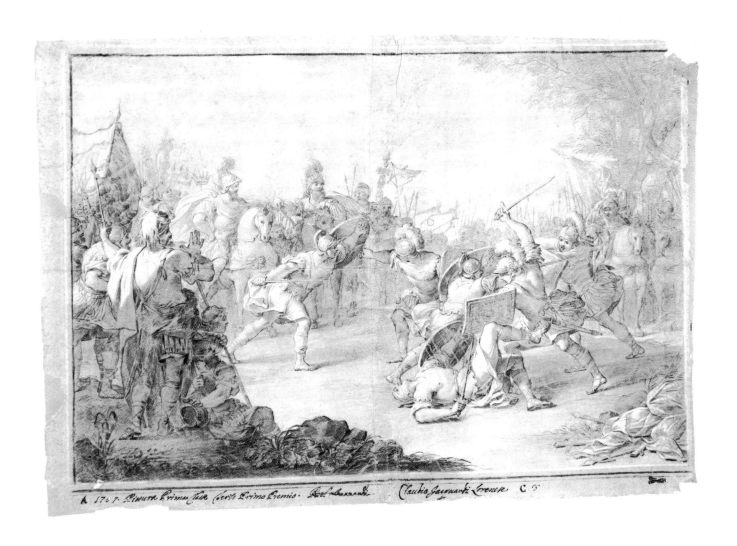

A. 1717. Pictura prima Classe Certe Primo Premis. Real Barcelona. Claudio Jaramarti Lorense. C. 3.

GIOVANNI NICCOLÒ PITTALUGA

The consul Marcus Curius Dentatus in his humble Dwelling, refuses the Gifts offered by the Samnites

Catalogue entry no. 39

Technique
The drawing was executed on a sheet of 18th century, ivory colored Italian paper; the composition was drawn in red and white chalk.

State of preservation
The drawing in question was in a very poor state of preservation. The paper on which it was executed consists of a whole sheet with a 19th century restoration on the back; it is completely backed with several layers of cotton material, in addition to some strips of pale blue paper which had been used as a rough restoration for reinforcement directly on the back along the sides and the upper and lower borders of the drawing, giving the sheet a stiffening along all sides. In addition the sheet showed innumerable fractures and gaps.

Restoration undertaken
Leaving intact the previous restoration on the back, work on the drawing was limited to a light dusting and the removal of organic residues, to the elimination of the glues and residues of paper present in the perimetric areas and corresponding to the various gaps, both on the *verso* and the *recto*. Small restorations and reinforcements were made with Japanese paper of an appropriate thickness to the original and methyl cellulose. It has been thought inopportune to carry out any procedure involving water in order to avoid damage to the drawing. After these operations, some retouching was carried out on the restored gaps, to assimilate the tone of the original paper. Finally, the work was placed between two pieces of card board with a neutral pH, for long-term preservation, and under the uniform pressure of a crystal plate to obtain a complete flattening.

C.M.A.

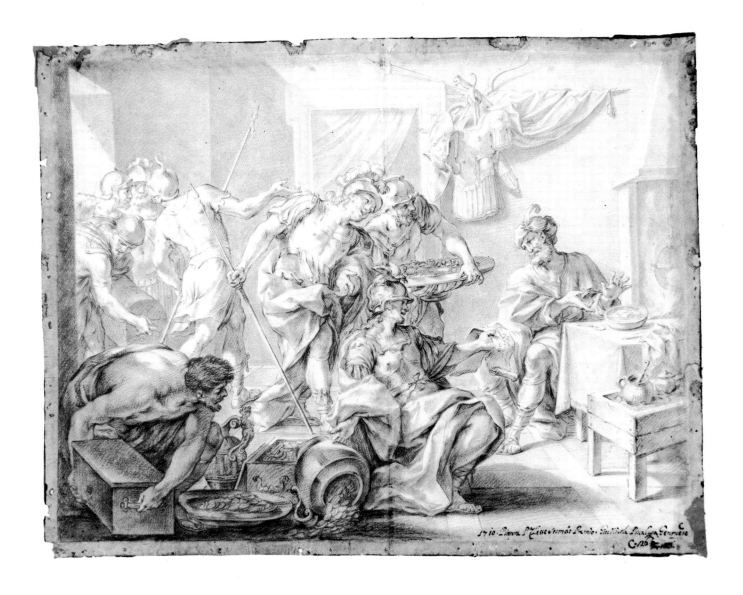

181

ADAM EILAUSER

Sacrifice of Manoah

Catalogue entry no. 43

Technique

The drawing in question was executed on a sheet of 18th century paper which is grey in color. The artist utilized pencil and watercolor.

State of preservation

The drawing was in a very poor state of preservation. Deep creases had damaged the fibre of the cellulose, creating cuts and abrasions, in particular on the left side of the sheet (as from photographic documentation). In addition on the lower part there were organic residues, creases and tears; in the upper right corner there was a gap.

The deterioration of the drawing is clear in the photographic record taken in raking light.

Restoration undertaken

After a careful dusting on the recto and *verso* of the sheet with a very soft brush and rubber dust, the organic residues were removed with the mechanical action of a scalpel. Subsequently humidification by capillarity of the *verso* was undertaken, resting the sheet on silk paper soaked in cold water. The sheet, while still damp, was then tamponed for a more precise cleaning.

Finally the drawing was dried at room temperature, being flattened between two pieces of card board with a neutral pH under the constant pressure of a crystal plate. After the time scheduled, the numerous cuts and tears were restored and the creases were reinforced. The gaps present were restored with Japanese paper of the appropriate thickness, using as the glue methyl cellulose. In addition, small amounts of retouching of the color in the gaps were carried out with Windsor and Newton watercolors, to make the color of the paper used conform to the original.

Finally, the drawing was placed between two pieces of cardboard with a neutral pH, for long-term preservation, under the uniform pressure of a crystal plate, to obtain a complete flattening.

C.M.A.

182

183

BIBLIOGRAPHY

A.S.L. = Archivio storico della Accademia di San Luca

A.S.R. = Archivio di Stato di Roma

A.V.R. = Archivio del Vicariato di Roma

B.S.H.A.F. = Bulletin de la Société de l'histoire de l'art français

C.D. = Correspondance des Directeurs de l'Académie de France à Rome avec les surintendants des bâtiments publiée d'aprés les manuscrits des Archives nationales par M. Anatole de Montaiglon

D.B.I. = Dizionario Biografico degli Italiani

DISEGNI I = I Disegni di figura nell'Archivio Storico dell'Accademia di San Luca, I, Roma, 1988

DISEGNI II = I Disegni di figura nell'Archivio Storico della Accademia di San Luca, II, Roma, 1989

L.S.A. = Liber Status Animarum.

P.V.A.R. = Procès-verbaux de l'Académie Royale de peinture et de sculpture, 1648-1793, publiés... d'après les registres originaux conservés à l'Ecole des Beaux Arts, par M. Anatole Montaiglon, Paris, 1875-1909, 11 vol. (Tables par M. Paul Cornu)

Acquisti dei Musei e delle Gallerie dello Stato, "Bollettino d'Arte", 1963, pp. 363-364

ALLEGRI TASSONI Giuseppina, *L'Abate Giuseppe Peroni e una controversia accademica*, "Aurea Parma', XXXIX, III, 1955, pp. 228-237

ALONSO SANCHEZ Maria Angeles, *Francisco Preciado de la Vega y la Academia de Bellas Artes. Artistas Españoles que han pasado por Roma*, Madrid, 1961

Architectural Fantasy and Reality Drawings from the Accademia Nazionale di San Luca in Rome. Concorsi Clementini 1700-1750, edited by S. Munshover and H. Hager, University Park, PA., 1982

Barbault Jean 1718-1762, Beauvais-Angers-Valence, 1974-1975

BAUDI di VESME Alessandro, *Schede di Vesme. L'arte in Piemonte dal XV al XVIII secolo*, III, Torino, 1968

BEAN Jacob, *17th Century Italian Drawings in the Metropolitan Museum of Art*, New York, 1979

BELLI BARSALI Isa, *Ville di Roma*, Milano, 1970

BELLORI Giovan Paolo, *Le Vite de' pittori, scultori e architetti moderni*, Roma 1672 (Torino, 1976, edited by Evelina Borea, with introduction by G. Previtali)

BÉNÉZIT Emmanuel, *Dictionnaire... des peintres...*, ed. Paris, 1976

BERCKENHAGEN Eckhard, *Die Französichen Zeichnungen der Kunstbibliothek*, Berlin, 1970

Biographie toulousaine, t. 2, Paris, 1823, p. 302

BÖHM Cordula, *Franz Georg Hermann. Der Deckenmaler des Allgäus im 18. Jahrhundert*, Diss. phil., München, 1968

BOLOGNA Ferdinando, *Francesco Solimena*, Napoli, 1958

BOPPE Auguste, *Le peintre Jacques-François Martin et la mascarade turque de 1748*, "Revue d'histoire diplomatique" 16 (1902)

BOREA Evelina, *Benefial Marco*, D.B.I., VIII, Roma 1966, pp. 466-469

BOTTARI Giovanni Gaetano-TICOZZI Stefano, *Raccolta di Lettere sulla Pittura, Scultura e Architettura*, II, Milano, 1822

BOTTINEAU Yves, *L'Art de Cour dans l'Espagne de Philippe V*, Bordeaux, 1960

BOUCHER Francois, cfr. D. Sutton, New York, 1982

BOYER Ferdinand, *Les Artistes français étudiant, lauréats ou membres de l'Académie romaine de Saint-Luc entre 1660 et 1700 d'aprés des documents inédits*, "Bullettin de la Société de l'Histoire de l'art français", 1950, pp. 117-132

BOYER Ferdinand, *Il pittore Charles Natoire premiato all'Accademia di San Luca 1725*, "L'Urbe" XVII, 1954

BOYER Ferdinand, *Les artistes français lauréats ou membres de l'Académie romaine de Saint-Luc dans la première moitié du XVIII siècle*, "Bulletin de la Société de l'histoire de l'art français", 1955, pp. 131-142

BOYER Ferdinand, *Les artistes français lauréats ou membres de l'Académie romaine de Saint-Luc dans la seconde moitié du XVIII siècle*, "Bulletin de la Société de l'histoire de l'art français", 1957, pp. 273-288

Brescia pittorica 1700-1760, Brescia, 1981

BUDDE Jlla, *Beschreibender Katalog der Handzeichnungen in der Staatlichen Kunstakademie Düsseldorf*, Düsseldorf, 1930

BUSHART Bruno, *Asam als Zeichner*, "Cosmas Damian Asam. 1686-1739. Leben und Werk", München, 1986, pp. 51-61

CASALE Vittorio, *Niccolò (e Michelangelo) Ricciolini*, "Verso un Museo della città", cat., Todi, 1981, pp. 242-250.

CASALE Vittorio, *Diaspore e ricomposizioni: Gherardi, Cerruti, Grecolini, Garzi, Masucci ai Santi Venanzio ed Ansuino in Roma*, "Scritti di Storia dell'Arte in onore di Federico Zeri", Milano, 1984, II, pp. 736-755

CEAN BERMUDEZ Juan Augustin, *Diccionario Histórico de los mas ilustres profesores de las Bellas Artes en España*, IV, Madrid, 1800-1894

CHENNEVIERES (de) POINTEL Philippe, *Recherches sur la vie et les ouvrages de quelques peintres provinciaux de l'ancienne France*, Paris, 1862, t. 4, p. 213

CHIERICI Gino, *Luigi Vanvitelli pittore*, 1937

CLAPASSON André, *Description de la ville de Lyon, 1741*, Lyon, 1982

CLARK Antony M., *Introduction to Pietro Bianchi*, "Paragone", XV, 161, 1964, pp. 42-47 (poi 1981, pp. 4853)

CLARK Antony M., *Letter to the Editor*, "The Art Bulletin", XLIV, 3 1963

CLARK Antony, M., *Introduction to Pietro Bianchi*, "Paragone", XV, 161, 1964, pp; 42-47 (after in Id., *Studies in Roman Eighteenth Century Painting*, Washington, 1981, pp. 48-53)

CLARK Antony M., *Imperiali*, "The Burlington Magazine", CVI, 1964, 734, pp. 226-233

CLARK Antony M., *The portraits of artists drawn for Nicola Pio*, "Master drawings", V, 1967, I, pp. 3-23

CLARK Antony M., *Agostino Masucci: A Conclusion and a Reformation of the Roman Baroque*, "Essays in the History of Art presented to Rudolph Wittkower", Londra, 1967, pp. 259-264 (after in: Id., *Studies in Roman Eighteenth-Century Painting* edited by E. O. Bowron, Washington, 1981, pp. 90-102)

CLARK Antony M., in *Painting in Italy in the Eighteenth Century: Rococò to Romanticism*, Chicago-Minneapolis-Toledo, 1970

CLARK Antony M., *Francesco Caccianiga*, D.B.I., 16, Roma, 1973, pp. 3-4

CONTARDI Bruno, *L'angelo di metallo*, 'L'Angelo e la Città', Roma, 1987, pp. 17-36

CRELLY William R., *The painting of Simon Vouet*, New Haven, 1962

CRELLY William, *Pietro Bianchi*, D.B.I. vol. X, 1968, pp. 163-166

CROFT-MURRAY Edward, *Decorative Painting in England, 1537-1837, II, The Eighteenth and Early Nineteenth Centuries*, Feltham, 1970

DACOS Nicole, *Le Logge di Raffaello*, Roma, 1986 (1.a edizione Roma 1977)

DEL PIAZZO Marcello, *Documenti*, 'Il palazzo della Consulta', Roma, 1975

DE MARCHI Giulia, *Mostre di Quadri a San Salvatore in Lauro*, Roma, 1987 p. 349

Dessins du Nationalmuseum de Stockolm, Collection du Comte Tessin, 1695-1770, edited by P. Bjurstrom, Paris, 1970-1971

DI MACCO Michela, *Cultura figurativa e architettonica negli Stati del Re di Sardegna, 1773-1861*, Torino 1980

DIMIER M. Louis, *Les peintres français du XVIII siècle*, Paris, 1928, 1

DREYER Peter, *Notizen zum malerischen und zeichnerischen oeuvre der Maratta-Schule*, "Zeitschrift für Kunstgeschichte", 34, 1971, 3

Eighteenth-Century French Life-Drawing, Selections from the Collection of Mathias Polakovits cfr. J. H. Rubin

ENGGASS Robert, *Early Eighteenth-Century Sculpture in Rome*, University Park, PA., 1976

ESUPERANZI Marta, *Un profilo di Giovanni Domenico Piestrini*, 'Ville e palazzi, illusione scenica e miti archeologici', Roma, 1987, pp. 65-94

FALCIDIA Giorgio, *Per una 'definizione' del caso Benefial*, "Paragone", 343, 1978, pp. 24-51

FALDI Italo, *La Galleria. Dipinti di figura dal Rinascimento al Neoclassicismo*, 'L'Accademia Nazionale di San Luca', Roma, 1974, pp. 79-170

FENYOE Ivan, *Dessins italiens inconnus*, "Bullettin du Musée National Hongrois des Beaux-Arts", 13, 1958

FERRARIS Paola, *La fabbrica della chiesa delle Stimmate di Roma e la statua di San Francesco di Bernardino Cametti*, "Storia dell'Arte", 1989

FERRETTI Corrado, *Memorie storico-critiche dei pittori anconitani dal XV al XIX secolo*, Ancona, 1883

FONTENAY (de) Louis-Abel, *Dictionnaire des artistes*, t. 1, Paris, 1776

French Master Drawings of the 17th and 18th Centuries in North American Collections, catalogue by P. Rosenberg

GAEHTGENS Thomas W. — LUGAND Jacques, *Joseph Marie Vien*, Paris, 1988

GIGLI Laura, *San Marcello al Corso*, Roma, 1977

GILMARTIN John, *The Paintings commissioned by Pope Clemente XI for the Basilica of San Clemente in Rome*, "The Burlington Magazine", CXVI, 1974, 855, pp. 305-312

GIORGETTI VICHI Anna Maria, *Gli Arcadi dal 1960 al 1800. Onomasticon*, Roma, 1977

GRAF Dieter, *Master Drawings of the Roman Baroque from the Kunstmuseumy Düsseldorf. A selection from the Lambert Krahe Collection*, mostra, London and Edimburgh. 1973

GRAF Dieter, *Die Handzeichnungen von Guglielmo Cortese und Giovanni Battista Gaulli*, Kunstmuseum Düsseldorf, Serie III, 2, voll. 2. Düsseldorf, 1976

GRAF Dieter, *Die Handzeichnungen von Giacinto Calandrucci*, Kunstmuseum Düsseldorf, Serie III, 4, voll. 2, Düsseldorf, 1986

GRISERI Andreina, *Francesco Trevisani in Arcadia*, "Paragone", XIII, 1962, 153, pp. 28-37

GUERRIERI BORSOI Maria Barbara, *Un'aggiunta al catalogo di Giacinto Calandrucci*, "Studi Romani", 36, 1988

GUERRIERI BORSOI, Maria Barbara, *Contributi allo studio di Nicolò Ricciolini*, "Bollettino d'arte", nn. 50-51, 1988, pp. 161-185

GUERRIERI BORSOI Maria Barbara, *Ricostruzione documentaria di un edificio barocco distrutto: villa Patrizi a Porta Pia*, 'Carlo Marchionni. Architettura, decorazione e scenografia contemporanea', Roma, 1989, pp. 173-203

GUERRIERI BORSOI Maria Barbara, *Alcune opere di Giuseppe Passeri per i marchesi Patrizi*, 'Carlo Marchionni. Architettura, decorazione e scenografia contemporanea', Roma, 1989, pp. 381-403

GUIFFREY Jules, *Scellés et inventaires d'artistes...*, 3, "Nouvelles archives de l'art français", 2.e série, t. 6, 1885

GUIFFREY Jules, *Histoire de l'Académie de Saint-Luc*, Paris, 1915

HAMACHER Barbel, *Werkverzeichnis Zeichnungen*, 'Cosmas Damian Asam. 1686-1739. Leben und Werk', München 1986, pp. 310-325

HAZLEHURST F. Hamilton, *The Wild Beasts Pursued: The Petite galerie of Louis XV at Versailles*, "The Art Bulletin", LXVI, n. 2, 1984, pp. 224-236

HERLUISON Henri, *Actes d'état-civil d'artistes françaises*, Paris, 1873

HOJER Gerhard, *Cosmas Damian Asam und die Wurzeln seines Stiles in Rom. Der Concorso Clementino von 1713*, "Weltkunst" 50, 1, 1980, pp. 114-118 e 214-218

Il Settecento a Roma, Roma, 1959

INCISA della ROCCHETTA Giovanni, *La collezione dei ritratti della Accademia di San Luca*, Roma, 1979

IVANOFF Nicola, *Guido Ludovico di Vernansal...*, "Critica d'arte" 1960

IVANOFF Nicola, *Un profilo di Ludovico Dorigny*, "Arte antica e moderna", 6, 1963

JACQUOT Albert, *Le peintre lorrain Claude Jacquard*, "Réunion des sociétés des Beaux-Arts des départements, 20 (1986), p. 707

LANZI Luigi, *Storia pittorica della Italia*, Bassano, 1808

LATTUADA Serviliano, *Descrizione di Milano, I-III*, Milano, 1737-38

Les Collections du Comte d'Orsay: dessin du Musée du Louvre, LXXVIII Exposition du Cabinet des Dessins, Musée du Louvre, Paris, 1983

LO BIANCO Anna, *Pier Leone Ghezzi pittore*, Palermo, 1985

LONGHI Roberto, *Un appunto su due opere del Benefial*, "Paragone", VII, 1956, 195, pp. 68-70

LORET Maciej, *Gli artisti polacchi a Roma nel Settecento*, Roma-Milano, 1929

MANCINI Paolo, *La Madonna del Divino Amore in Campo Marzio*, Roma, 1976

MARIETTE Pierre-Jean, *Abecedario...*, Paris, t. 2, 1854

MARTINI Antonio - CASANOVA M. Letizia, *SS. Nome di Maria*, Roma, 1962

Master Drawings of the Roman Baroque from the Kunstmuseum Düsseldorf. A Selection from the Lambert Krahe Collection, cat. and intr. by D. Graf, London, 1973

Memorie del Pontificio Collegio Armeno 1883-1958, Venezia, 1958, p. 64

Memorie per le Belle Arti, Vita di Gaetano Lapis pittore di Cagli, 1787, p. 1

MENA MARQUES Manuela, *Disegni italiani dei secoli XVII e XVIII della Biblioteca Nazionale di Madrid*, Milano - Roma, 1988

MENATO Giuliano, *Contributi a Luigi Dorigny*, "Arte Veneta", 21.1967

MESURET Robert, *Le morceau de concours d'Antoine Rivalz à l'Académie de Saint-Luc*, B.S.H.A.F., 1954, pp. 94-97

MESURET Robert, *Les expositions de l'Académie royale de Toulouse de 1751 à 1791*, Toulouse, 1972, p. 357, n. 3763

MICHEL Olivier, *L'apprentissage romain de François Joseph Lonsing*, "Mélanges de l'Ecole Française de Rome", t. 84, 1972, 2.

MICHEL Geneviève e Olivier, *La décoration du Palais Ruspoli en 1715 et la redécouverte de "Monsù Francesco Borgognone"*, "Mélanges de l'Ecole Française de Rome", LXXXIX, 1977, 1, pp. 265-340

MICHEL Olivier, *"Monsú Giacomo" et "Monsú Cristoforo"*, "Romische Historische Mitteilungen", 26. Wien, 1984.

MIDDELDORF Ulrich, *William Kent's Roman Prize in 1713*, "The Burlington Magazine", XCIX, 649, 1957, p. 125

MISSIRINI Melchiorre, *Memorie per servire alla storia della Romana Accademia di San Luca*, Roma,, 1823

MOIR Alfred, *Regional Styles of Drawing in Italy: 1600-1700*, Santa Barbara, 1977

MORONI Gaetano, *Dizionario di erudizione storico ecclesiastico*, Venezia, 1848, XLVII

MORTARI Luisa, *Museo Civico di Rieti*, Roma, 1960,

Natoire Charles-Joseph: peintures, dessigns, estampes et tapisseries des collections publiques françaises, Troyes - Nimes - Rome, 1977

NEWCOME-SCHLEIER M., *Disegni genovesi dal XVI al XVIII secolo*, Firenze, 1989

NOACK Friedrich, *Bicchierai Antonio*, Ms. Bibliotheca Hertziana, Roma

NOACK Friedrich, *Die Brüder Asam in Rom*, "Kunstchroniyk", N. F. 23, 1911-12, pp. 129-131

NOVELLI M. Angela, *Balestra Antonio*, D.B.I., 5, Roma, pp. 547-549, 1963

OEFELE, Felix Freiherr von, *Adversariorum Boicorum, Complexus Artifices, Mascine Pictores*, Mns. Bayerische Staatsbibliothek, München, 5, VI, fol. 139/40

OJETTI Raffaele, *Antichi Concorsi dell'Accademia*, "Atti e Memorie della Accademia di San Luca", I, 1911, pp. 4-25

ORANSKA J. *Szymon Czechowicz 1689-1775*, Poznan, 1948

Padova, guida ai monumenti e alle opere d'arte, Venezia, 1961

PAMPALONE Antonella, *Disegni italiani dal XVI al XVIII secolo*, Aldega Gallery, Roma, 1980

PAMPALONE Antonella, *Le omelie di Clemente XI versificate da Alessandro Guidi*, "Studi sul Settecento romano. Committenze della famiglia Albani", Roma, 1985

PASCOLI Lione, *Vite de' Pittori, Scultori ed Architetti viventi...*, Roma 1730-1736, Treviso, 1981

PETRAROIA Pietro, *Contributi al giovane Benefial*, "Storia dell'Arte", 1980, 38-40, pp. 371-380

PIETRANGELI Carlo, *Alla ricerca di una serie di dipinti ottoboniani*, "Strenna dei Romanisti", XLI, 1980, pp. 396-406

PINETTE Matthieu, *La 'Terre' ou 'Cérès nourrissant Triptolème' par Natoire*, "La Revue du Louvre et des Musées de France", XXXIII, 1983

PIO Nicola, *Le vite di Pittori, Scultori ed Architetti in compendio da numero di duecentoventicinque*, 1724, Ms. Biblioteca Vaticana, Cod. Capponi 257 (edited by C. and R. Enggass, Città del Vaticano, 1977)

PIROTTA Luigi, *La Insigne Accademia Nazionale di San Luca*, "Studi Romani", 5, 1955

Polonia, Arte e Cultura dal Medioevo all'Illuminismo, Roma-Firenze, 1975

PROSPERI VALENTI RODINÒ Simonetta, *Drawings from the Collection of Nicola Pio in Rome*, "Master Drawings", XXI, 1983, 2, pp. 135-151

PROSPERI VALENTI RODINÒ Simonetta, *Un progetto di Antonio Bicchierai per la cupola della sala ovale*, 'Committenze della famiglia Albani. Note sulla Villa Albani Torlonia', Roma, 1985, pp. 237-243

RATTI Carlo Giuseppe, *Delle vite de' pittori, scultori ed architetti genovesi e dei forestieri che in Genova hanno operato dall'anno 1594 a tutto il 1765*, Genova, 1797

RICCI Amico, *Memorie storiche delle arti e degli artisti della marca di Ancona*, Macerata, 1834

RICCOMINI Eugenio, *I fasti, i lumi, le grazie. Pittori del Settecento parmense*, Parma, 1977

RIOPELLE Cristopher, *Notes on the Chapel of the Hopital des Enfants-Trouvés in Paris*, "Marsyas", XXI, 1981-1982

ROLI Renato – SESTIERI Giancarlo, *I disegni italiani del Settecento. Scuola Piemontese, Lombarda, Genovese, Bolognese, Toscana, Romana e Napoletana*, Treviso, 1981

ROTA JEMMI Roberta, *L'Arte a Parma dai Farnese ai Borbone*, Parma, 1979

ROSENBERG Pierre, *A propos d'un dessin d'Antoine Rivalz*, "La revue du Louvre", 1975, pp. 182-185

ROSENBERG Pierre, *The Age of Louis XV; French Painting 1710-1774*, 1975

ROSENBERG Pierre, *A propos des tableaux vénitiens conservés dans les Musées Russes: deux Pellegrini inédits*, "Arte Veneta", XXXVII, 1983

ROSENBERG Pierre, *French Master Drawings of the 17th and 18th Centuries in North American Collections*, 1984

RUBIN Joseph H., *Eighteenth-Century French Life-Drawing. Selection from the Collection of Mathias Polakovits*, Princeton, 1977

RUDOLPH Stella, *Primato di Domenico Corvi nella Roma del secondo Settecento*, "Labyrinthos", I, 1-2, 1982, pp. 1-45

RUDOLPH Stella, *La pittura a Roma nel '700*, Milano, 1983

RUDOLPH Stella, *Il punto su Bernardino Nocchi*, "Labyrinthos" IV, 1-2, 1985, pp. 200-231

RUPPRECHT Bernhard, *Die Bruder Asam. Sinn und Sinnlichkeit im bayerischen Barock*, Regensburg, 1980.

SALERNO Luigi, *La collezione dei disegni: composizioni, paesaggi, figure*, "L'Accademia Nazionale di San Luca", Roma, 1974 pp. 323-367

SANTUCCI Paola, *Ludovico Mazzanti 1686-1785*, L'Aquila, 1981

SCATURRO Alberto, *La vita e l'arte di Mariano Rossi*, Bologna, 1958

SCHAAR Eckhard – Graf Dieter, *Meisterzeichnungen der Sammlung Lambert Krahe*, Düsseldorf, 1969

SCHNAPPER Antoine – GUICHARNAUD Héléne, *Louis de Boullogne, 1654-1733*, "Cahiers du dessin français", nn. 1 e 2, Paris

SCHROETER Elisabeth, *Die Villa Albani als Imago Mundi. Das unbekannte Fresken und Antikenprogramm im Piano Nobile der Villa Albani zu Rom*, 'Forschungen zur Villa Albani', Berlin, 1982, pp. 185-299

Sebastiano Conca 1680-1764, Gaeta, 1981,

Seicento. Le siècle de Caravage dans les collections françaises..., Paris, 1988

SERULLAZ Maurice, *Recherches sur quelques dessin de Charles Natoire*, "La Revue des Arts", 1959, pp. 65-70

SESTIERI Giancarlo, *Per Mariano Rossi*, "Paragone", XXXI, 359-361, 1980

SESTIERI Giancarlo, *Nuovi contributi al Luti disegnatore*, "Prospettive", 33-36, 1983-1984, pp. 283-286

STARACE F., *Luigi Vanvitelli e le immagini antiche*, 'Luigi Vanvitelli e il '700 europeo', Napoli-Caserta, 1973, Napoli, 1978

STUART-JONES Henry, *A Catalogue of the Ancient Sculptures Preserved in the Municipal Collection of Rome, The Palazzo dei Conservatori*, Roma, 1926 e 1968

SUTTON Denis, *François Boucher*, New York, 1982

SUSINNO Stefano, *I ritratti degli accademici*, 'L'Accademia Nazionale di San Luca', Roma, 1974

The Age of Louis XV French Painting 1710-1774, cfr. Pierre Rosenberg

The Oxford Annotated Bible with the Apocrypha, edited by H. May and B. Metzger, New York, 1965

THIEME-BECKER, *Allgemeines Lexikon der Bildenden Künstler*, Leipzig, 1907 *ad voces*

THOISON Eugène, *Les Vernansal*, "Réunion des sociétés des beaux-arts des départements" 25 (1901)

TITI Filippo, *Descrizione della pitture, sculture e architetture esposte al pubblico in Roma*, Roma, 1763

TITI Filippo, *Studio di Pittura, Scoltura et Architettura nelle chiese di Roma 1674-1763*, edited by B. Contardi and S. Romano, Firenze, 1987

TROTTMANN Helene, *Die Zeichnungen Cosmas Damian Asams für den Concorso Clementino der Accademia di San Luca von 1713*, "Pantheon", XXXVIII, II, 1980, pp. 158-164

TROTTMANN Helene, *Cosmas Damian Asam. 1686-1739. Tradition und Invention im malerischen Werke*, Nuremberg, 1986

TRUDON DES ORMES A., *Contribution à l'état-civil des artistes fixés à Paris de 1746 à 1778*, "Mémoire de la Société de l'histoire de Paris", 33 (1906)

URREA FERNÀNDEZ Jesus, *La Pintura Italiana del siglo XVIII en Espana*, Valladolid, 1977

VASI Mariano, *Itinerario istruttivo di Roma*, Roma 1791

VERTUE George, *Vertue Note Books. IV*, 'The Twenty-Forth Volume of the Walpole Society 1935-36', Oxford, 1936

Villa e Paese, Dimore nobili di Tuscolo e di Marino, Palazzo Venezia, Roma, 1980

VIÑAZA Cipriano Conde de la, *Adiciones al Diccionario de Cean Bermudez*, t. 3, Madrid, 1894

WILSON Michael, *William Kent, Architect, Designer, Painter, Gardiner, 1685-1748*, London-Boston-Melbourne-Henly, 1984

ZANDRI Giuliana, *San Nicola da Tolentino*, "Le chiese di Roma illustrate", n.s. 19, 1987

NAMES OF ARTISTS

CONTENTS

Palmer Museum of Art Staff

James C. Moeser
Dean, College of Arts and Architecture
Director, University Arts Services

Kahren Arbitman
Director

Charles R. Garoian
Assistant Director

William Hull
Director Emeritus

Olga K. Preisner
Curator

Randy Ploog
Assistant Curator

Ok Hi Lee
Registrar

Ronald Hand
Exhibition Designer

Lucinda King
Museum Store Manager

Barbara Weaver
Secretary to the Director

Betsy Warner
Secretary

Robert E. Fry
Chief of Security

Janet Bernosky
Graduate Assistant

Michael Tomor
Graduate Assistant

Michael Biddison
Graduate Assistant